# Semblance and Event

**Technologies of Lived Abstraction**

Brian Massumi and Erin Manning, editors

*Relationscapes: Movement, Art, Philosophy,* Erin Manning, 2009

*Without Criteria: Kant, Whitehead, Deleuze, and Aesthetics,* Steven Shaviro, 2009

*Sonic Warfare: Sound, Affect, and the Ecology of Fear,* Steve Goodman, 2009

*Semblance and Event: Activist Philosophy and the Occurrent Arts,* Brian Massumi, 2011

# Semblance and Event

## Activist Philosophy and the Occurrent Arts

Brian Massumi

The MIT Press
Cambridge, Massachusetts
London, England

For information about special quantity discounts, please email special_sales@ mitpress.mit.edu.

This book was set in Stone Sans and Stone Serif by Toppan Best-set Premedia Limited. Printed and bound in the United States of America.

Library of Congress Cataloging-in-Publication Data

Massumi, Brian.
Semblance and event : activist philosophy and the occurrent arts / Brian Massumi.
   p.   cm. — (Technologies of lived abstraction)
Includes bibliographical references and index.
ISBN 978-0-262-13491-0 (hardcover : alk. paper)
1. Experience. 2. Events (Philosophy) 3. Time in art. I. Title. II. Title: Activist philosophy and the occurrent arts.
B105.E9M375   2011
144'.3—dc22
                                                              2011003566

10  9  8  7  6  5  4  3  2  1

with Erin
life unlimited

# Contents

## Series Foreword

*"What moves as a body, returns as the movement of thought."*

Of subjectivity (in its nascent state)
Of the social (in its mutant state)
Of the environment (at the point it can be reinvented)

*"A process set up anywhere reverberates everywhere."*

The Technologies of Lived Abstraction book series is dedicated to work of transdisciplinary reach inquiring critically but especially creatively into processes of subjective, social, and ethical-political emergence abroad in the world today. Thought and body, abstract and concrete, local and global, individual and collective: the works presented are not content to rest with the habitual divisions. They explore how these facets come formatively, reverberatively together, if only to form the movement by which they come again to differ.

Possible paradigms are many: autonomization, relation; emergence, complexity, process; individuation, (auto)poiesis; direct perception, embodied perception, perception-as-action; speculative pragmatism, speculative realism, radical empiricism; mediation, virtualization; ecology of practices, media ecology; technicity; micropolitics, biopolitics, ontopower. Yet there will be a common aim: to catch new thought and action dawning, at a creative crossing. Technologies of Lived Abstraction orients to the creativity at this crossing, in virtue of which life everywhere can be considered germinally aesthetic, and the aesthetic anywhere already political.

*"Concepts must be experienced. They are lived."*

—Erin Manning and Brian Massumi

# Acknowledgments

It is difficult to express the extent to which a thinking and writing process echoes with other voices, in concord, counterpoint, and at times happy cacophony. It would be impossible to express my gratitude and indebtedness to all who have contributed, in their many welcome manners, to this project's taking shape. I wouldn't know where to begin. The book's roots intertwine with the distant origins of the earlier *Parables for the Virtual*, nearly ten years its junior, itself in entangled gestation nearly as long before that. Neither would I know how to end, so wreathed is this book's completion in the germinating tendrils of an embarrassing number of concurrent books in progress, most of which will doubtless die on the proliferating branch. My thanks, first of all, go to Erin Manning, for living day to day with my inability to begin or end and for understanding—and helping me to truly understand—the joy that can come with being always in that proliferating middle. It is also due to her that my middling has become endowed with a milieu. Her founding the SenseLab, and her generously imaginative tending of its growth and transformations, has given me an environment for thought-in-action whose contribution to my life and work has been inestimable. Thank you, Erin, for the intensity of thought, creative joy, and "concern for the event" you bring to everything you do, and most of all to the life we share. My heartfelt thanks as well go to the SenseLab's participants, past and present, students, activists, artists and professors, local and international, without whose own generous contributions of ideas and energy the SenseLab could never have borne fruit. A collective thanks goes to the commenters and questioners I have encountered along the long and intertwining path—from the students I have had in Canada, the United States, and Australia over the course of my peripatetic teaching career, to participants in many a seminar and lecture in a

splay of locations. Your traces inhabit these pages. I would like to extend individual thanks to those who have so generously taken the time to provide me with their feedback on the drafts: Lone Bertelsen, Erik Bordeleau, Christoph Brunner, Kenneth Dean, Didier Debaise, Sher Doruff, Jonas Fritsch, Thomas Lamarre, Erin Manning, Arjen Mulder, Anna Munster, Andrew Murphie, John Protevi, Felix Rebolledo, Steven Shaviro, Isabelle Stengers, and the evaluators for the MIT Press. Finally, to my son Jesse: thank you for not taking me seriously and keeping me on my toes.

Earlier versions of chapters 1, 2, and 3 appeared in the following publications:

Chapter 1: *The Pragmatist Imagination: Thinking about Things in the Making*, ed. Joan Ockman (Princeton: Princeton Architectural Press, 2000), 160–167 (under the title "The Ether and Your Anger: Towards a Pragmatics of the Useless").

Chapter 2: *Inflexions: A Journal for Research-Creation*, no. 1 (2008), available at www.inflexions.org/volume_4/issues.html#i1. An earliera bridged version appeared in Joke Brouwer and Arjen Muller, eds., *Interact or Die!* (Rotterdam: V2/NAi, 2007), 70–97.

Chapter 3: *Diagram Work*, ed. Ben van Berkel and Caroline Bos, special issue of *ANY* (Architecture New York), no. 23 (1998): 42–47.

An earlier version of portions of chapter 4, first movement, appeared in Joke Brouwer and Arjen Mulder, eds., *Information Is Alive: Art and Theory on Archiving and Retrieving Data* (Rotterdam: NAi Publishers, 2003), 142–151 (under the title "The Archive of Experience").

This work was generously supported by a research grant from the Social Sciences and Humanities Research Council of Canada.

# Introduction: Activist Philosophy and the Occurrent Arts

Something's doing (James 1996a, 161). That much we already know. Something's happening. Try as we might to gain an observer's remove, that's where we find ourselves: in the midst of it. There's happening doing. This is where philosophical thinking must begin: immediately in the middle (Deleuze and Guattari 1987, 21–23, 293).

What's middling in all immediacy is "an experience of *activity*" (James 1996a, 161). "The fundamental concepts are activity and process" (Whitehead 1968, 140). "Bare activity, as we may call it, means the bare fact of event or change" (James 1996a, 161).

In bare point of fact, that is where everything, not just philosophy, begins. "Activity and change" *are* "the matter of fact" (Whitehead 1968, 146). "'Change taking place' is a unique content of experience" (James 1996a, 161). *The* unique content of experience: "the sense of activity is in the broadest and vaguest way synonymous with life. . . . To be at all is to be active. . . . We are only as we are active" (James 1996a, 161–162). To begin to think life, we must begin in the middle with an activist sense of life at no remove: in the middling immediacy of its always "going on" (James 1996a, 161).[1]

Whitehead's term for his own activist philosophy at no remove from life's immediacy is "process philosophy." For Whitehead, activity, as event or change synonymous with life, entails a further concept. "The notion of *potentiality* is fundamental for the understanding of existence, as soon as the notion of process is admitted. . . . Immediacy is the realization of the potentialities of the past, and is the storehouse of the potentialities of the future" (Whitehead 1968, 99–100; emphasis added). To be at all is to be active in a "production of novelty" consisting in the "transformation of the potential into the actual" (Whitehead 1968, 151). The "principle of

unrest" from which an activist philosophy departs requires a concept of potential qualifying process as the production of the new: in a word, "becoming" (Whitehead 1978, 28).

"'Creativity' is the principle of novelty" (Whitehead 1978, 21). To be at all is to become, actively creative. "Process for its intelligibility involves the notion of a creative activity belonging to the very essence of the occasion." The transformation of the potential into the actual is a "process of self-creation." "Such transformation includes the immediacy of self-enjoyment" (Whitehead 1968, 151).

The simple gesture of starting again from the beginning—that is, in the midst—has led to a rapid cascade of concepts. From something doing to the bare fact of activity; from there to event and change; then on to potential and the production of the new; coming to process as becoming. Then, a major twist. The straight run encounters turbulence: process as becoming is not just creative activity, it turns out. It is *self-creation*. More than that, the self-creation is "enjoyed." The principle of unrest eddies into something we would be forgiven for suspecting is not unlike an aesthetic appreciation: an enjoyment of creativity. How is this "at no remove"? How is this immediate? Doesn't it imply self-reflection? Doesn't self-reflection imply the luxury of the contemplative distance on the world? Isn't that exactly what is excluded by the bare activist fact that we always find ourselves smack in the middle of its unrest? The paradox of an immediate "self-enjoyment" of experience, "belonging to the very essence" of its every occasion, is the complicating knot around which this approach to philosophy ties its concepts. It inscribes a certain duplicity into the very heart of its thinking and of the world.[2]

The duplicity is in fact an artifact of the immediacy. It is simply that each occasion of experience comes into itself amid activities that are not its own, already going on. The coming event takes a dose of the world's surrounding "general activity" and selectively channels it into its own "special activity" (Whitehead 1967a, 176). Its special activity is its occurring in the singular way that it does, toward the novel change in which it will culminate. There is an inaugural moment of indecision between the already-going-on-around and the taking-in-to-new-effect, before the culmination of this occurrence has sorted out just what occasion it will have been. This "primary phase" of the occasion of experience is the middling moment of bare activity with which process philosophy is pivotally concerned. *Bare activity*: the just-

beginning-to-stir of the event coming into its newness out of the soon to be prior background activity it will have left creatively behind. The just-beginning is on the cusp of the "more" of the general activity of the world-ongoing turning into the singularity of the coming event. Every event is singular. It has an arc that carries it through its phases to a culmination all its own: a dynamic unity no other event can have in just this way. The unity of the occasion is the just-this-way in which the phases of the arced unfolding hold together as belonging to the same event.

All this is felt. Both the coming-into-its-own out of a prior moreness of the world's general always-going-on, and the unity of the holding-together of phases arcing to a culmination in just this singular way, are felt. The general feeling of the world's more-than of activity going on, and the singular feeling of that activity specifically coming to this, just so, are immediate dimensions of experience's occurring. They are dual immediacies of process.

The first dimension—the experience's just-beginning-to-stir in a more-than of its own coming activity—is the *relational* dimension of the event's occurring. It is the event under the aspect of its immediate participation in a world of activity larger than its own. This bare activity of coming experience finding itself in the midst must, in some sense of the word, be perceived. Otherwise it would effectively come to nothing. To be a some-thing-doing effectively is to be felt: to register (if only *in effect*). In what way bare activity is effective and felt, even though it lies at the very threshold of experience just coming into itself, is a major question which runs throughout this book. It is a question worrying every discussion, even where the term bare activity is not itself brought out. Everywhere it is already there, where it always is: at the cusp.

The second dimension—the experience coming out of bare activity into itself just so—is the *qualitative* dimension of the event's occurring: its thus-ness. This registers as the event's immediate enjoyment of the specialness of its holding itself together in just the way it comes to do. This cannot but be felt. Each phase of the event must in some way perceive the pertinence of the phase before it, in order to gather the prior phase's momentum into its own unfolding. Even as it does this, it is already anticipating a subsequent phase, to which it will in turn relay the momentum of the event's occurrence. The phases of occurrence overlap as they relay each other following an arc of felt becoming. In the overlap and relay, they

co-perceive their mutual inclusion in the same event. They co-feel their belonging to each other in co-occurrence. If this were not the case, their multiplicity would not make "an" event. The event would not hold together as one. It would lack dynamic unity. It would dissipate before it could singularly culminate.

The qualitative dimension of the event is the how it happens, co-felt, in the immediacy of its now unfolding. How-now. The qualitative how-now of the event is the feeling it has of participating in itself. It is the feeling of its unfolding *self-relation*. If this "self-enjoyment" by the event of its own becoming is a form of reflection, it is not only at no remove from the event; it is an essential factor in its occurrence. It is because an event "enjoys" itself in this arcingly immediate way that it is able to follow through with itself. And it is because it follows through with *itself* that it qualifies as self-creative.

The duplicity with which Whitehead's process philosophy is pivotally concerned is this constitutive doubling of the event into co-occurrent relational and qualitative dimensions. William James's own brand of activist philosophy—"radical empiricism"—is struck by the same duplicity. The basic tenet of *radical empiricism* is that everything that is experienced is real in some way and that everything real is in some way experienced. If "change taking place" is really the basic matter of fact of the world, then the radical empiricist must hold that "change itself is . . . immediately experienced" (James 1996a, 48). James discusses the experience of change in terms of relation. Disjunctive relations involve an experience actively "passing out" of the initial "quasi-chaos" to take a direction of its own, "terminating" its movement in a way all its own, to its own separate effect (James 1996a, 63). Disjunction is separative transition, across a threshold of becoming. Conjunctive relation is transitional continuity of becoming (62). Conjunctive relation is how the before and after of a threshold passed mutually include each other in the same event, as "pulses" of the same change. Conjunctive and disjunctive relations both concern change. For radical empiricism, they are both real and immediately experienced.

Disjunctive relations are felt as a self-distancing coming out of an initial condition of participation in the quasi-chaotic something-doing that is the general condition of activity in the world. Conjunctive relations are felt as a "tendency" or "striving" (166–167) that continues across thresholds often marked by resistances and obstacles. "The word 'activity' has no imaginable

content whatever save these experiences of process, obstruction, striving, strain, or release." These are "ultimate qualia" (James 1996a, 166–167). It is artificial to oppose disjunctive relations to conjunctive relations. How could each occasion of experience not involve both: a disjunctive coming-out of prior participation, and a quality of continuing-across enabled by that separation? Strains, obstructions, and resistances mark the continued formative pressure of the quasi-chaotic manyness of the oceanic somethings-doings all around on the singular "drop" of experience in the self-creating (James 1996b, 231–232). Ingressions of bare-active relation pulse the event, modulating its onward phasing. Every event is a *qualitative-relational* economy of process, "full of both oneness and manyness" (James 1996a, 93–94):

The continuities and the discontinuities are absolutely co-ordinate matters of immediate feeling. The conjunctions are as primordial elements of "fact" as are the distinctions and disjunctions. In the same act by which I feel that this passing minute is a new pulse of my life, I feel that the old life continues into it, and the feeling of continuance in no wise jars upon the simultaneous feeling of a novelty. They, too, compenetrate harmoniously. (95)

The relational-qualitative duplicity at the heart of activist philosophy is a *differential*, not a dichotomy. It concerns coincident differences in manner of activity *between* which things happen. The coming-together of the differences *as such*—with no equalization or erasure of their differential—constitutes a formative force. It is this force that provides the impulse that the coming experience takes into its occurrence and appropriates as its own tendency. Although the activity differentials are never erased, they do "compenetrate" to "harmonious" result. Between them, they co-compose a singular effect of unity resulting from how it is that they come differently together. An integral of action and experience—a dynamic unity of self-enjoying occurrence—emerges from the energetic playing out of their impulsive difference.

Rather than a dichotomy, the relational-qualitative duplicity in the midst of which activist philosophy begins is a principle of co-composition between coincident manners of occurring. As a principle it is specifically designed to disable the traditional dichotomies haunting Western philosophy. The differential involved cannot, for example, be overlaid on the subject-object dichotomy. The duplicity concerns activity and the potential for the appearance of novelty astir in it. Neither potential nor activity is object-like. They are more energetic than object-like (provided that no

presuppositions are made as to the physicality of "energy" or the modes of causality involved in the energizing of events). For the basic category they suggest is just that: occurrence. Neither object nor subject: event.

Activist philosophy's emphasis on the occurrent makes it a fundamentally *nonobject philosophy*. Deleuze enters the fold of activist philosophy when he says that "the event of alteration" is "one with the essence or the substance of a thing" (Deleuze 1988b, 32). This is another way of saying there is no essence or substance to things other than the novelty of their occurrence. "I have, it's true, spent a lot of time writing about this notion of event: you see, I don't believe in things" (Deleuze 1995, 160). He believes in the world—as process (Deleuze and Guattari 1983, 2–5; Deleuze and Guattari 1987, 20). Whitehead is on much the same page: "a well-marked object is not an inherent necessity for an event. Wherever and whenever something is going on, there is an event" (Whitehead 1964, 78). Nature itself, the world of process, "is a complex of passing events" (Whitehead 1964, 166). The world is not an aggregate of objects. To see it that way is to have participated in an abstraction reductive of the complexity of nature as passage (Whitehead 1964, 74–98). To "not believe in things" is to believe that objects are derivatives of process and that their emergence is the passing result of specific modes of abstractive activity. This means that objects' reality does not exhaust the range of the real. The reality of the world exceeds that of objects, for the simple reason that where objects are, there has also been their becoming. And where becoming has been, there is already more to come. The being of an object is an abstraction from its becoming. The world is not a grab-bag of things. It's an always-in-germ. To perceive the world in an object frame is to neglect the wider range of its germinal reality.

Activist philosophy is not a subjectivist philosophy either. It does not presuppose a subject, only "something" going on. Beginning with event-activity rather than the status of the subject makes activist philosophy a fundamentally *noncognitive philosophy*. Rather than asking what's doing, cognitivist approaches ask what the subject can know of the world, as if the subject does not come to itself already in the midst but rather looked upon the world at a reflective remove that it is philosophy's job to overcome. The cognitivist paradigm equates the subject with the knower, and the object with the known. Whitehead remarks that to begin there is to get off to a false start (Whitehead 1967a, 175). As James vigorously argues,

if you start by presupposing a subject-object divide, there is no way of preventing the separation from deepening into an abyss. How can the subject cross the divide to reattach itself to the objectivity "out there" on the other side? Doubt takes over. What if there is no other side? What if it's all illusion? Descartes curls up into the safety of his stove, coming out only when his God is ready to vouchsafe a connection to reality for him (Descartes 1996, xxii). Less divinely baked philosophies invent ingenious ways of tightrope walking the abyss, or go through contortions to deny it is there. For James, these amount to so much acrobatics. An essential divide is presupposed the moment the categories of knower and known are overlaid upon the subject and the object, and no amount of subsequent maneuvering, however ingeniously contortionist, will smooth it over. The problem is that any way you twist it, the knowing is still in the subject and the known is still right where it was on the other side. What can guarantee that they correlate to each other? With all certainty, says James, nothing. Any purported solution is smoke and mirrors. Cognitivist philosophies may purport to walk a graceful line between the subject and the object, but what they really do is take a run at making a "self-transcending" magic leap across the chasm (James 1996a, 52). They are "saltatory": desparate attempts to magically jump an abyss of their own assuming. Or failing that to make it disappear with a flourish of the metaphysical wand (James 1978, 233, 245–246).

From the perspective of activist philosophy, philosophy should not overcome the cognitivist problem. The best approach is: don't go there. Not going cognitive requires only a slight displacement, James explains. Consider the subjective and the objective as ways in which portions of experience—pulses of process—relate to *each other* (James 1996a, 196). What cognitivist philosophy grapples with as an essential divide, activist philosophy sees as "successive *takings*" by experience, in experience, of itself (James 1996a, 105). Here there can be no fundamental doubt. Doubt as hard as you can, and all you have done is emphatically illustrate one of the ways experience is wont to take itself back up into itself, self-formatively. You have found yourself in doubt—no doubt a real event. Doubt took effect. A doubter you just effectively became. Activist philosophy is thoroughly realist. It affirms the reality of any and all takings-effect. Its question is not whether something is real or not. It is not out to disqualify, or eliminate. Rather, it asks what aspects of process an event's

taking-effect exemplifies. This effective realism even applies to the subject and object distinction, the conventional formulations of which it is so wary.

Activist philosophy does not deny that there is a duplicity in process between subjective and objective. It accepts the reality of both. Rather than denying them, activist philosophy affirms them otherwise, reinterpreting them in terms of events and their taking-effect. Specifically, it understands them in terms of the relaying between events, in their "successive takings." This makes the problem of the subjective and the objective fundamentally a question of time, as implicating a multiplicity of events. Grappling with the problem of the subject and object becomes a way of developing activist philosophy's take on multiplicity and time, a concept whose centrality is implicit from the start in activist philosophy's emphasis on change.

The way that activist philosophy affirms the subjective and objective as aspects of the process of change is to say that process exhibits a formative duplicity. This links the definition of objective and subjective to the rela-tional-qualitative duplicity discussed earlier as co-composing dimensions of process. The distinction between separative/disjunctive and conjunc-tive/continuing aspects of process was another take on that duplicity of process, providing another angle of attack on the same problem. The subject/object distinction is yet another take on it.

Whitehead defines objectivity in terms of *activity* that has been left over in the world by previous events of change and that can be taken up by a next event for taking-in to its self-creation. The object is the "datum" in the etymological sense. It is the "given": that which is actively found already in the world, to be taken for formative potential. The "subject" is what finds itself in the midst of these processual leavings, taking them up as the world's gift of potential for its own taking-form. The "subjective" is not something preexisting to which an event occurs: it is the self-occurring form *of* the event. The dynamic unity of an occasion of experience is its "subjective form." Actually, there is no "the" subject. *There is no subject separate from the event.* There is only the event as subject to its occurring to itself. The event itself is a subjective self-creation: the how-now of this singular self-enjoyment of change taking place. (For all these points, see Whitehead 1967a, 175–190, and 1978, 41, 52.)

This way of defining the objective and the subjective dimensions of the world of process places the objective at the cusp of the occasioning relation

of participation. The objectivity of an experience is that quantum of the surrounding activity that the coming occasion of experience selectively takes up into itself as it separates off to phase into the occasion of its own becoming. The object as such does not preexist this relay between occasions any more than the coming subject preexists its finding-itself-in-the-midst. It is *taken for* an object by the next occasion's becoming. Given potential is objectively determined by how it is effectively taken up, as a relay experience feels its way into its occurrence. The objective belongs to the immediate past of just this occasion. But it just as immediately belongs to that occasion's proximate future. The coming occasion's passing will bequeath the potential-grabbing change its own activity has created to successor experiences, for their self-creative taking. The subjective is the passing present, understood not as a point in metric time but rather as a qualitative duration—a dynamic mutual inclusion of phases of process in each other, composing a "span" of becoming (this is James's "specious present") (Whitehead 1968, 89; on the durational span of an occasion, Whitehead 1978, 125 and James 1996a, 131; on the immediate past and the immediate future, Whitehead 1967a, 191–200).

This definition of the subjective and objective lays the groundwork for the processual definition of the knower and the known, but it does not map directly onto it. Technically speaking, for activist philosophy, the *end* of the experience knows its *beginning* (James 1996a, 57). All that a self-creating occasion of experience ultimately "knows" of the world's activity is how it has taken up a portion of it into its own becoming. "What" this will have been exactly retains a certain indeterminacy as long as the becoming is still in process. The "what" of an experience is only fully definite at its culmination. The knower, according to James, is the end of the experience's becoming. What it "knows" is its own beginning, retroactively. An experience determinately knows what it's been only as it peaks—which is also the instant of its "perishing" (Whitehead 1978, 29; Whitehead 1967a, 177). The only subject there is in the completed sense is a "superject": the "final characterization of the unity of feeling" at an experience's peaking (Whitehead 1978, 166). The "creative advance into novelty" runs from the objective vagueness of a quasi-chaos of activity already going on, to a terminal definiteness of an experience subjectively "satisfying" its enjoyment of itself in a final fulfillment knowingly felt (on vagueness, see Whitehead 1968, 109).

*Pure*: The word will return throughout this book in a refrain, doubtless to the discomfort of many a reader schooled in the critique of its conventional associations of moral superiority, particularly as regards race. It is used here in an unconventional sense, borrowed from James. "Pure" is James's qualifier for the bare-active first flush of emergent experience. The just-emerging of experience is pure in the very specific sense that it is "virtually both subjective and objective" (James 1996a, 130). The general going-on of activity in the world has yet to sort itself out as what the special activity already brewing will determinately become. The dynamic unity of the coming event is still a work in progress. Since that forming dynamic unity will define the subjective form of the experience, what the subject will be is still an open question. As long as the subject lacks final definition, what its objects will have been in the end is also indeterminate. As is its objective bequest to subsequent experience. What is "given" is what will prove in the end to have been taken in. In the end, it is what will have passed on, potentially to be taken-in again. Pure in this context does not imply a hierarchy of value. It draws a question mark. It designates the open question of what experience's self-creative activity will yield in the dynamic pulse of its process. Pure here is not an eliminative concept either. It marks the processual co-presence of a self-creating subject of experience with what will prove to have been its objects, together in the making. "Pure" experience is not in the least reduced or impoverished. It is overfull. It is brimming "virtually or potentially" (23). It is the embarrassment of processual riches in which every experience finds itself in its incipiency. "It is a *that* which is not yet any definite *what*, tho' ready to be all sorts of whats" (93). Whitehead's term for it is "pure feeling." Philosophy, for him, is nothing less than a "critique of pure feeling" (Whitehead 1978, 113). In the pages that follow, whenever the word pure is used, the reader should think of the displacement that activist philosophy effects in relation to the notions of subject and object and the paradigms of cognition within which they are normally embedded. The crucial point is that it does this out of respect for the richness of experience in the making. In this connection, it is especially important not to equate "pure" experience with "raw" experience.

"Raw" experience carries connotations of a state of precultural grace unsullied by language. A "prelinguistic" Eden uncomplicated by learning

and the "higher" cognitive functions it inculcates. This is not at all the concept here. The concept is rather that all "higher" cognitive functions come back through the middle. They are only active to the extent that they reactivate in the quasi-chaotic midst of something doing again. They come back through, bare-actively, in all immediacy, as recreative factors of experience rearising. They are "judgments" that come in all immediacy as *direct perceptions*. They concern, for example, causal relation, similarity, categorizations, qualitative evaluations, linguistic associations, and even symbolic figurings. Peirce calls them "perceptual judgments," admitting that it is something of a misnomer because they occur without a separate act of judgment (Peirce 1997, 93–94, 242–247). They come, he says, "as if" there had been a judgment but too immediately for one to have actually been performed. They are judgments without the actual judgment: direct perceptions of the world's acquired complexity, incoming, flush with the bare-active firstness of experience feeling its way into a next event. This "feedback of higher forms" back into and through pure experience is summed up in the formula *practice becomes perception* (Massumi 2002, 30, 189–190, 198–199, 293n17; see also Massumi 2010a on "priming"). Chapters 2 and 4 of this book deal extensively with this factor of pure experience, analyzed under the term *thinking-feeling*.

The displacement from cognition, with its Cartesian stovepipe dream of foundational clearness and distinctness, to the messy middling goings-on of pure experience in all its potential and complexity, has far-reaching pragmatic consequences. This is because the cognitive subject-object dichotomy itself has far-reaching consequences. It extends itself into a division between ways of knowing, and from there into a hierarchy between modes of practice. This is especially evident in the division between disciplines of knowledge that are in a position to make a claim to "objectivity" and those that are not. The traditional form this bifurcation of knowledge practices takes is the chasm between the "two cultures," scientific and humanistic. The same division recurs within the disciplines on each side of that massive divide, between empirical methods (in a decidedly nonradical sense) and speculative or theoretical approaches (dismissed by the other side as "merely" subjective). This divide repeats as a distinction between modes of practices, even practices that do not define themselves primarily as knowledge practices, such as political practices. Here, the dichotomy

recurs as an opposition between "fact-based" or "commonsense" approaches and "experimental," "idealistic," or "utopian" approaches, with a clear implication of the superiority of the former.

Activist philosophy refuses to recognize these divisions as fundamental, or to accept the hierarchy they propagate. Its own fundamental duplicity, that of the relational/participative and the qualitative/creatively-self-enjoying, suggests a different schema. The relational/participatory aspect of process could fairly be called *political*, and the qualitative/creatively-self-enjoying aspect *aesthetic*. These aspects are not treated as in contradiction or opposition, but as co-occurring dimensions of every event's relaying of formative potential. They do not parse out in a way that maps onto the existing disciplinary landscape and the associated ways of conventionally bifurcating practices. We saw earlier how the disjunctive/separative and conjunctive/continuing aspects of process played through this duplicity. Another spinoff distinction playing through it for activist philosophy is between the *pragmatic* and the *speculative*. Instead of denoting a parting of the ways, however, this distinction is used to express their coming together. Hyphens are in order: *aesthetico-political, speculative-pragmatic*.

The speculative aspect relates to the character of potential native to the world's activity, as expressed eventfully in the taking place of change. The pragmatic aspect has to do with how, in the taking-definite-shape of potential in a singular becoming, the relational and qualitative poles co-compose as formative forces. Pragmatic doesn't mean practical *as opposed to* speculative or theoretical. It is a synonym for composition: "how" processual differentials eventfully play out as co-composing formative forces. This pragmatic playing out is always speculative in the sense that what will come of the process is to some degree an open question until its "final characterization" of itself at its point of culmination. En route, it is speculatively anticipating what it will have been. That speculation is entirely active. It is the "how" of the experience getting where it's ultimately going with itself. The co-composing of formative forces constitutes in each exercise of experience a novel *power of existence*: a power to become.

By this thinking, the discipline called art does not have a monopoly on creative composition. And the domain called politics does not have a monopoly on real existential change. There is no less an aesthetic side to politics than there is a political side to art. Practices we call doing politics and practices we call doing art are all integrally aesthetico-political, and

every aesthetico-political activity is integrally speculative-pragmatic. Every mode of practice, however its domain is conventionally classed, is aesthetico-political/speculative-pragmatic, each in its own inimitable way.

It is here that the constructive questioning begins. It consists in finding ways to understand any given mode of activity in these experiential terms, starting from an ontological primacy of the relational-qualitative and respecting the singularity of the activity's unfolding—although the word "ontological" no longer fits. Process is only perishingly about being. But it is everywhere and always about powers of existence in becoming. The concerns of activist philosophy are *ontogenetic* more than ontological (Simondon 2005, 24–26 and passim).

The speculative-pragmatic cast of activist philosophy gives it an in-built affinity with one conventional classification of practices, those sharing its name: "activism." Activist philosophy, as it is explored in this book, addresses itself as much to activisms in the familiar sense, in any domain in which they stir, as it does to art or philosophical practices in their existing disciplinary frames. The affinity is especially close with activist practices that see themselves as simultaneously cultural and political, as these are already grappling in their own way with the aesthetic-political/speculative-pragmatic polarities. This book in large part works from practices that according to traditional classifying schemes would fall into the domain of art or philosophy. But it does this to open art and philosophy to each other, and in a way that opens their opening onto to each other out into a wider activist understanding of the relational-qualitative processes moving through them. The ultimate speculative-pragmatic wager of the book is that if this opening-out succeeds, subsequent takings-up of its tendency might open out of its own practice, that of writing, into other activist arenas in the more usual sense of the word. If the book can be considered to have one central concern, it is this: the *politicality* of process, in whatever initial midst. The politicality of a pulse of process is the manner of potential it passes on for self-creative successor effect.

With this in view, the book at certain points suggests concepts specifically addressing the taking-up of process. If one exercise of experience bequeaths its activity in residual form for a successor's taking up, might not that taking up be anticipated, in a fostering way, by how the experience is determined to occur to itself? How can an occasion of experience so determine itself as to leave traces of its activity apt to provide propitious

conditions for the next exercise's arcing toward the production of its own novelty of successor self-enjoyment? How, from its just-beginnings in bare activity, can an experience modulate its own self-formative tendency's going beyond itself, toward a potentializing of other events? Since foundational clearness and distinctness are (fortunately for creativity) out of the equation, it is a given that no event can lay down the law in a way that essentially predefines its succession. But are there still ways in which an experience can *orient* what comes? In what way can an event constructively include formative potential for what lies beyond in its own constitution?

The question of how the beyond of an occasion's self-enjoyment is effectively included in its constitution is the question of *importance* so central to Whitehead's philosophy (Whitehead 1968, 1–19). The question of importance is also the question of *expression*, or what is effectively passed on by an occasion's passing (Whitehead 1968, 20–41). Importance and expression are not add-ons to experience. They are not "merely" subjective. They are what bridge the subjective and objective aspects of the world, in its rolling effectively on. They are fundamental categories of the world's becoming. They are ontogenetic factors, constitutive of the politicality of process.

In what follows, the question of how the makeup of an occasion of experience effectively and constructively includes its own beyond is approached through the concept of *techniques of existence*. A technique of existence is a technique that takes as its "object" process itself, as the speculative-pragmatic production of oriented events of change. Techniques of existence are dedicated to ontogenesis as such. They operate immediately qualitatively-relationally. They make no gesture of claiming "objectivity," nor do they pride themselves on their grasp of common sense. At the same time, they reject being characterized as "merely" subjective. They are *inventive* of subjective forms in the activist sense: dynamic unities of events unfolding. So implicated are they with the politicality of event-formation that they qualify whatever domain in which their creativity is operative as an *occurrent art*.

The concept of the *diagram* is adopted from Peirce and Deleuze to think about what techniques of existence do pragmatically-speculatively. According to both Peirce and Deleuze, what they do is abstract. Diagramming is the procedure of abstraction when it is not concerned with reducing the world to an aggregate of objects but, quite the opposite, when it is

attending to their genesis. To abstract in this fuller sense is a technique of extracting the relational-qualitative arc of one occasion of experience—its subjective form—and systematically depositing it in the world for the next occasion to find, and to potentially take up into its own formation. The subjective form of an experience is the dynamic form of how the potentials for change initially found in the bare-active midst come to play out in its occasion. In addition to the initial conditions of given potential, recharges of potentials en route must also be factored in. These are chance intrusions: resistances, obstacles, and enablements. The event of experience self-modulates under pressure from these infusions of activity. To follow itself through to its culmination, the occasion under way must sense their potential on the fly, and creatively take it into its continued unfolding, as added impetus to its becoming.

The diagram as technique of existence is a way of informing the next occasion of these potentials for self-formation: "The greatest point of art consists in the introduction of suitable abstractions" (Peirce 1997, 226). It should not for a moment be forgotten that all of this concerns experience. In experience is to be found the *genesis of things*. By abstraction, Peirce writes, "I mean such a transformation of our diagrams that characters of one diagram may appear in another as things" (ibid.). What we call objects, considered in the ontogenetic fullness of process, are lived relations between the subjective forms of occasions abstractly nesting themselves in each other as passed-on potentials. They are the inter-given: the systematic form in which potential is relayed from one experience to another. "Objectification itself is abstraction" (Whitehead 1985, 25).

The abstract is lived experience. I would almost say that once you have reached lived experience, you reach the most fully living core of the abstract. . . . You can live nothing but the abstract and nobody has lived anything else but the abstract. (Deleuze 1978b)

This, then, is a book about *technologies of lived abstraction*.

Major issues will have to be left in suspense as this introduction completes its own short-lived arc. One is the concept of the virtual, much maligned in some quarters today. The other is the issue of experience as it applies to nonhuman forms of life—and even to matter itself.

The concept of the virtual is taken up at length in the course of the book under the guise of semblance. *Semblance* is another way of saying "the experience of a virtual reality." Which is to say: "the experiential

reality of the virtual." The virtual is abstract event potential. Semblance is the manner in which the virtual *actually appears*. It is the being of the virtual as lived abstraction. As used here, "semblance" is free of the connotations of "illusion" in Adorno's and Lacan's uses of the term.

The virtual cannot be understood as a "space" of potential—it is, after all, *event* potential. It cannot be treated as a realm apart without being entirely denatured as a speculatively-pragmatically useful concept. It is in no way an idealist concept. And it is in no way in opposition with actualism. The activist philosophy advanced here is in a way a thoroughgoing actualism, taking the term actual at its etymological word: "*in act.*" For activist philosophy, everything real gets into the act, and everything in the act is real according to its own mode of activity.

As taken up here, Deleuze's "virtual" corresponds to Whitehead's "pure potential." The activity of pure potential for Whitehead is to make "ingress" into the occasion of experience, as an ontogenetic force collaborating in the dynamic taking-determinate-form of the experience (the event's "concrescence"). The activity of potential making ingress is "energizing" (Whitehead 1967a, 182–183). At ingress, the potential arcs through the experience's energized tending toward an aimed-at fulfillment. The potential runs through the arc of the experience's unfolding, infolded into it. It infolds in the form of a tendential direction, or vector of self-formation. At ingress, the potential is abstract in that it has yet fully to occur to the experience's actual tending. As an aim, or, as James would say, a terminus, it is abstract again, because the moment of its fulfillment is the instant when all is processually said and done. The experience self-expires on reaching it, so that it actually will have experienced its potential only as an onward lure—a reaching-toward something that disappears between the closing fingers of the experience even as they grasp it. But it does remain a "*some*thing": not entirely determinate to the end. It's not over until it's over, and what is tended-toward can inflect itself up until the final instant. Thus one of the roles of the concept of the virtual, or of pure potential, is to make *surprise* a universal, constitutive force in the world's becoming. The universality of surprise as a constitutive force makes the process of the "actualization" through which potential runs an existential drama. Actualization, for Deleuze, is the existentializing "dramatization" of pure, abstract potential (the virtual "Idea"; Deleuze 2004a, 94–116).

The virtual is a limit-concept of process and experience. It comes once aboriginally with ingressive initiative, and again at the end, with the

perishing. It marks the outside limits of the in-act of process *and* dramatically runs through it limit to limit. The virtual limits are conjointly felt in the arcing of the experience toward the novelty of its taking final effect. The virtual is abstractly lived as the experience runs through itself, from one limit of its unfolding to the other.

Sometimes at the culmination of the experience, the drama appears for itself. It is *seen*. Not actually, if that means corresponding to a sense impression striking the body's visual apparatus. Actually: as in *in act*. This appearing of the drama of an experience's self-enjoyment in the act is the semblance. Say you catch sight of a mouse out of the corner of your eye. You don't so much see the mouse as you *feel* the arc of its movement with your eyes. You feel the movement continuing out of the immediate past when it was just outside your visual field, coming in. If the movement is felt to be toward you, the feeling of the immediate past includes the immediate future of *your* movement taking off in the opposite direction. You don't actually "see" the vector of the mouse's movement, or your own. You immediately experience the dynamic unity of the event—mouse incoming, you outgoing—phasing forward in the form of a felt line of approach. This direct perception of the arc of an event gathering up its immediate past and scurrying it forward toward an immediate postrodent future is an example of a semblance. If the arc of the event is seen, it is seen *nonsensuously,* as an abstract line (on nonsensuous perception, Whitehead 1967a, 180–183; on abstract line, Deleuze and Guattari 1987, 9, 197, 280, 296, 496–498). It is seen as in an immediate abstraction in a specious present of fear.

The feeling of seeing the abstract line of the event is a vision-effect. It is an effect of the event-triggering tension inherent to the human-mouse differential. It expresses that differential in an abstract perception of the dynamic unity of the event, as you feel you saw it with your eyes, or perhaps eyed it into feeling. In other words, the dynamic form of the event is *perceptually felt*, not so much "in" vision as *with* vision or *through* vision: as a vision-effect. It is a lived abstraction: an effective virtual vision of the shape of the event, including in its arc the unseen dimensions of its immediate past and immediate future. The lived abstraction of the event is an *amodal* perception, in the nonsensuous shape of a line, of change taking place. It is direct perception of an event. (Deleuze's "time-image" is the prime example in his work of the appearing of the virtual in what would here be termed a semblance of an event; Deleuze 1989, 68–97 and passim).

Amodal, nonsensuous: these are ways of saying that the effective perception of the shape of the event was not actually in any particular mode of sensory perception. When a semblance is "seen," it is virtually seen. How else could the virtual actually appear—if not *as* virtual? Seeing a semblance is having a virtual vision. It is a seeing-through to the virtual in an event of lived abstraction.

There is a curious excess of experience in the event. Since the semblance is amodal, in principle it could have been perceptually-felt in any mode. This means that when it is seen, its appearing virtually in vision betokens a potential variation on the experience as it could have appeared as an other than visual sense-effect, for example as a sound-effect. If you think about it, you probably "actually" heard more of the event than you saw, since a perceptible but as yet unattended-to scurrying preceded the animal's entering your visual field. There is no reason why the continuing of the event into the immediate future could not have appeared avowedly as a sound-effect. In fact, for some people with a dominance of hearing, it would have. Thus the problem of the virtual is indissociable from the question of the *abstract composition of the senses,* in excess of their actual exercise. It is primarily in this connection that the concept of the virtual appears in this book: as a way of thinking about how techniques of existence, in co-composing powers of existence, recompose the senses; and in recomposing the senses, catch an excess reality of the virtual in the act, for diagrammatic relay toward new occasions of experience reinventing how lived abstraction can be felt in our embodied animal life. The aesthetico-political production of novelty is the excess invention of experiential *forms of life.*

The trick to the productive speculative-pragmatic use of the concept of the virtual is never to separate it from the in-act. It takes a fair bit of conceptual calisthenics to achieve this, but it's well worth the exercise. The key is always to hold to the virtual as a coincident dimension of every event's occurrence. Again: don't take this as a dichotomy but as a creative differential, one essentially ingredient to every experience to the extent that every experience is an occasion of lived abstraction.

As a limit-concept, the virtual cannot be thought without paradox—and without working to make the paradox conceptually productive. There are a number of key junctures at which activist philosophy, like any metaphysics, must affirmatively make do with paradox. This is an essential moment

in a philosophy's self-formation. It is the moment a philosophical thought process verges upon the limit of what it can think. To make that limit-experience productive, the thinking must then turn back before it breaks apart like a spaceship entering a black hole. It must inscribe that self-saving inflection in itself, in the form of new concepts or new variations on old concepts. This must be done in a way that does *not* try to resolve or dismiss the paradox. It is done by taking the paradox seriously as a limit, turning back from it, and taking the necessity of turning back constructively to heart. The limit-experience of paradox turns around into an impulse for continuing the philosophy's self-creative advance. It has been taken-in as a self-modulation of the thinking-process. It is no longer worried over as a logical contradiction. It has been actively converted into a creative factor that is liminally immanent to the process. It has become a positive factor. This affirmation of *noncontradiction* as a self-formative necessity is an essential feature of a creative philosophy's signature activity.

The paradox of the virtual—that it is never actual but always in some way in-act—is closely associated with the paradox of immediate self-reflection entailed by the concept of self-enjoyment discussed earlier. The semblance is the event reflecting itself, directly and immediately, in lived abstraction. There are other paradoxes to be grappled with as well. There is, for example, a paradox of relation for activist philosophy.

Relationality was linked to the notion of the differential just alluded to. It was said that an effect was sparked *across* differences. The differences concern the mode of activity of what will have been the formative factors of the coming experience's occurring to itself. The effect comes *between* the different factors. The experience takes off from them, as it takes itself into its own event. The event shows itself, for the dynamic unity it has come to be. It does not show the differentials from which it has taken off into its own unfolding dynamic unity. But neither does it efface them. It resolves them into its own appearance. They recede into the flash of its occurrence. They are left behind by the event they condition, which takes off from, so that they show only in that take-off effect.

Take a flash of lightning. Its appearance is conditioned by an electro-magnetic differential. The differential does not show. What shows is the dynamic unity of the differential's playing out. The flash comes of that playing-out, but shows for itself. The effect lifts off from its conditions into

its own appearance. It is an extra-effect: a dynamic unity that comes in self-exhibiting excess over its differential conditions. In the immediacy of its own event, the event of lightning is absolutely, self-enjoyingly absorbed in the singularity of its own occurrence, and that's what shows. All occasions of experience exhibit this "sheer individuality" amid diversity (Whitehead 1967a, 177). An event of experience is a "little absolute" of occurrent self-enjoyment, conditioned yet self-creating (James 1996b, 280).

The event transpires *between* the differential elements that set the conditions for it. The electromagnetic gradient field that resolves itself into the occurrence of lightning is a complex field phenomenon. The field envelopes the distances between a multitude of elemental particles, bringing them into an energizing tension. The flash is the eventful resolution of the tension. It is how the field shows, in excess to itself, as an extra-effect. The exhibited extra-effect is an expression of that multitude of particles having come together just so, enveloped in tension. The intensive envelopment of the contributing elements constitutes a *relational field*—but only for the strike of this event. Had the lightning not occurred, it would have been because the contributing factors had not come together in just this way. The relation and the flash of eventful resolution are one. The flash is the *being of the relation* (Simondon 2005, 63). Had the flash not occurred, the relation would effectively not have been. It would not have resolved itself into an effect. In activist philosophy *to be is to be felt*: to effectively register. To be is to be in effect. To be is to get into the act, even though the act is the whole show, and what the performance resolves to show recedes.

The paradox of relation can be summed in the term *relation-of-nonrelation*. Elements contributing to an occurrence come into relation when they come into effect, and they come into effect in excess over themselves. In themselves, they are disparate. If they are in tension, it is precisely as a function of the differential between their positions. It is as a function of their distances from each other. The factors do not actually connect. Their distance is enveloped in a field effect that is one with the tension culminating in the strike of an event. The event effectively takes off from its elements' contribution to it. As an extra-effect, it does not connect to them as its "cause." It comes into its own sheer individuality of occurrence: its little-absoluteness. The phrase relation-of-nonrelation is a way of holding together, in the concept of the event, the differential status of its conditioning elements and the dynamic unity of their sheer occurrence as a little

absolute. It is a synonym of "conditioned by a disparate multitude *and* individually-absolutely self-creative" (on relation and disparateness see Simondon 2005, 31, 34–35, 205–209).

The main point to be derived form this is that relation in activist philosophical sense is *not connective*. The paradox of the relation-of-nonrelation excludes what is commonly called interaction or interactivity from qualifying as relational (see chapter 2). Extensive use of the concept of relation-of-nonrelation is made at various points in this book (for example, in the discussion of experiential "fusion," also called synchresis, in chapters 2 and 4). There is also a related point about expression. Expression is always extra-effective. The subject is the subjective form, or dynamic unity, of the extra-effecting event. There is no subject prior to or outside the expression. The being of the subject is the *extra-being* of the occurrent relation (it is Whitehead's superject; on extra-being, Deleuze 1990, 7).

If we apply this concept of the relation-of-nonrelation to what occurs between occasions of experience, we are led to treat the experiences themselves as differentials. The consequence is that occasions of experience *cannot be said to actually connect to each other*. They may be said to "come together" only in the sense of being mutually enveloped in a more encompassing event of change-taking-place that expresses their differential in the dynamic form of its own extra-being. That occasions of experience do not actually connect is Whitehead's doctrine of "contemporary independence" (Whitehead 1967a, 195–196). It means that the relation between different experiences is purely effective: on the creative level of effect. Their relation is the creative playing out of a nonrelation effectively expressing the inexpungeable difference between the sheer individuality of events of experience, by virtue of which each is a little absolute.[3]

This might sound lonely. It is certainly not touchy-feely. But Whitehead affirms it as a necessary condition for creativity. The nonrelation of relation is what makes "elbow room" in the world for an experience to come absolutely into its own production of novelty, uncramped by the constraint of connectively fitting in (Whitehead 1967a, 195). This preserves the emergence of novelty, rather than conformity to the present, as the principle of activity. It also makes all the world expressive. Purely self-expressive. It means the world of change is *made* of self-creative expression. This has obvious advantages for an aesthetico-political activist philosophy oriented toward a creative autonomy of forms of life.

A further consequence of these considerations is that different occasions of experience relate only *immanently*: by their mutual participation in the world's bare activity, in which they all find themselves in their incoming potential, and into which they perish as they peak. The quasichaos of bare activity is immanent to each occasion in the sense that it inaugurally in-forms them of what potentials are astir for their creative taking-in. Bare activity wells up into the event's self-forming. This leads to another paradox, one concerning the notion of immanence. When an occasion of experience perishes into the world of bare-active potential from which it arose, it contributes its self-formative activity to the world, for potential uptake into a next occasion's unfolding. It transcends itself back into the immanence out of which it came (Whitehead 1967a, 237; Whitehead 1968, 167). It makes a bequest to process continuing beyond itself, in the form of its own self-fulfillment.

The notion of non-connective relation encapsulated in the phrase relation-of-nonrelation changes the meaning of "participation." While at first sight participation may seem to have evaporated, it has actually redoubled. It comes once in the fielding of the multiplicity of contributory elements. The multitude of atmospheric particles—each of which can be considered an occasion of experience in its own right—create the conditions for the strike of lightning by entering into a commotion of mutual interference and resonance. Each actively participates in the production of the whole-field effects that energize the night sky for the coming event. The whole-field effects are a dynamic expression of each contributory element's remote participation in every other's activity. The singularity of each element's activity is fused in the general field activity whose tension potentiates the event, and against which the added novelty of the flash stands out, in the contrasting brightness of its own special activity. The participation of the conditioning elements occurs *at a distance*: between the elements; across the intervals actually separating them. The event comes strikingly into itself against the background of what has now become its contrasting field of emergence. It sheers off from its field of emergence, into its own absolute individuality of occurrence. The event has partaken of the potential bequeathed it by the general background activity. This sheer partaking of potential is the second participation involved in the concept of the relation-of-nonrelation. Here, participation is partitive (disjunctive or separative), in occurrent answer to the fusional participation

of the fielding (which is conjunctive in the envelopmental sense of a dynamic mutual inclusion). The event, seen in this striking light, is doubly participatory—but nowhere connective. It is nonlocal. Its conditions are fielded at a distance, and the dazzle of its culmination distances itself from the field of its emergence, in striking contrast to it (on ontogenetic contrast, see chapter 3).

The concept of the relation-of-nonrelation is that of *nonlocality* of relation. Relation is nonlocal in two co-implicated senses, corresponding to the two modes of participation involved: 1) the fielding of potential comes of the intervals between elements and 2), the sheering away of the event into the unity of its own occurrence asserts a parturitional interval between itself, as extra-effective being, and the background of potential creating the conditions for its birth. What participation means must be rearticulated in light of the double nonlocality of relation. One of the stakes in that rearticulation will be the notion of causality. The flash of lightning is *conditioned*, more than it is *caused*. It self-causes, given its conditions. To say that it is caused would imply a genetic passivity. The paradigm of the relation-of-nonrelation finds activity everywhere, in different modes (in fielding and striking; in general activity and special activity; and most especially, in the bare activity hinging them).

Returning to the paradox of the virtual, that paradox is captured in the continuation of a phrase by James cited earlier: "full of both oneness and manyness, *in respects that don't appear*" (James 1996a, 93–94). If the world is made of expression, the implication of James' phrase is that there are aspects of the world that are expressed without actually appearing. The concept of the semblance is a way of making this paradox productive. It is designed to deal with the complication that, for example, what is seen with or through vision, without actually being seen in vision, is nevertheless perceptually felt, in effect. The semblance is the form in which what does not appear effectively expresses itself, in a way that must be counted as real. The example given above was the nonsensuous perception of the mouse-line. The mouse-line was composed by a differential participation of the senses in each other. The variety of the contributory sense modes went actively unseen in the abstract sight of the rodent-inflected vectoring of experience. But there is also semblance of sorts in the lightning, even though it is actually seen sensorially, in the sense that the appearance of its dynamic form is accompanied by an actual impingement of light rays

upon the retina. The visibility of the lightning brought the commotion of elemental activity filling the night sky into vision, without it actually showing. It got into the act, but was lost in the show. The flashiness of the lightning was the brilliant tip of an atmospheric iceberg full of both oneness and manyness, whose field respects showily disappeared into the ontogenetic background. The lightning is the appearing tip of a more expansive event that never shows in its entirety. The fullness of the event's conditioning and occurrence is perceptually felt, in the dynamic form of how what actually appears steals the show. Even if the event's conditioning elements and culmination are actual, the *entirety* of the event is virtual: doubly nonlocal, nonsensuously present, registering only in effect, and on all three counts really abstract.

In one semblant way or another, for lightning or for mice, a concept of the effective reality of what doesn't appear is essential to a philosophy oriented to a thinking of process. The reason is simple: the main things that don't actually appear—yet are always expressed in some way in that which does appear—are the past and the future. Atmospheric fielding of the elements was the immediate past of the lightning strike. The mouse-line abstractly continued into the immediate future of unwanted encounter or escape. Process—event, change, production of novelty, becoming—all imply duration. They are time concepts. Past, present, future are always co-implicating. They are mutually included in each other. But they include each other as different: as different dimensions of the dynamic unity of the experience's occurring, which by definition cannot appear with equal billing (that is to say, sensuously). A semblance expresses this essential disparity in the difference that it makes perceptually felt between sensuous experience and nonsensuous reality. A semblance is always an expression of time, though its nonsensuousness gives it an aftertaste of eternity. The classic example is the lived semblance of the world of childhood that Proust's madeleine triggered into appearing without actually appearing. Although actually unappearing, the semblance of the past was really felt, with a self-creating spontaneity that imposed it as a fact of experience. The semblance is a lived expression of the eternal matter-of-fact that is time's passing.

Paul Klee speaks of the task of composing semblances—making dimensions of experience that don't appear appear nevertheless in the dynamic unity of an expressive act—as what defines aesthetic activity:

It is not easy to arrive at a conception of a whole which is constructed from parts belonging to different dimensions. And not only nature, but also art . . . is such a whole. For . . . we lack the means of discussing in its constituent parts, an image which possesses simultaneously a number of dimensions. . . . But, in spite of all these difficulties, we must deal with the constituent parts in great detail. . . . Our courage may fail us when we find ourselves faced with a new part leading in a completely different direction, into new dimensions, perhaps into remoteness where the recollection of previously explored dimensions may easily fade. To each dimension, as, with the flight of time, it disappears from view, we should say: now you are becoming Past. But perhaps later at a critical—perhaps fortunate—moment we may meet again on a new dimension, and once again you may become Present. (Klee 1950, 15, 17)

To compose, we must deal with the "constituent parts"—contributory factors of activity—in great detail. But the more detail with which we grasp them, the more apt they are to fade into a remoteness where they recede into nonrelation. Yet they may also advance into new experiential dimensions, forwarding experience into new directions for composition. The diagram, as explained above, is a word that activist philosophy uses to name a speculative-pragmatic procedure for navigating this complexity of experience's passing, taking special aim on the "critical" moments. These are the junctures where one moment of experience's passing passes into another, informing it of (in-forming it with) the potential to become again: technique of existence. Klee's reference to art *and* nature in this connection implies that they are both compositional realities, that their compositions involve a diagrammatic experience of becoming, and that this becoming of experience is aesthetic in its multidimensionality.

This brings us to the final question, that of experience in nonhuman forms of life, and in nonliving matter itself. It was already asserted that the world was made of expression. In this context, this is the same as saying that the world is made of experience. If the world is made of experience, there is perception everywhere in it. For activist philosophy, the question of the nonhuman revolves around the question of nonhuman perception. In what way can we say that what we have a tendency to separate out as "dumb matter" in fact perceives and is therefore, by the precepts of activist philosophy, experientially self-creative?

This question is only tangentially touched on in this book (for more, see Massumi forthcoming). It will have to suffice to say that Whitehead defines perception as "taking account" (Whitehead 1967a, 234–235;

Whitehead 1967b, 69–70). Taking account means an event inflecting the arc of its becoming as a function of its feeling the influence of other events, either in its initial conditions or en route. An electron is an occasion of experience for Whitehead. It "takes account" of the electromagnetic field of the nucleus of the atom in the dynamic form of its orbit and in its quantum character (the unity of the dynamic form expressed as its orbit and energy level). The electron registers the "importance" of its fellow creatures of the nucleus, and expresses it in the dynamic unity of its own pathmaking. The trees along a river take account of the surrounding mountains in how they are able to take in the rain washing down from them, negotiating with their shadows for their growth, or availing themselves of the mountain's protection from the wind. The life of a tree is a "society" of occasions of experience whose taking-account of other events—weather events, geological events, the earth's gravitation, the sun's rising and setting—contributes to a continuing growth pattern. Tree rings are one of the ways in which this growing lived abstraction is seen for itself. Our taking in the pattern at a glance is a semblance of a life. But even outside any encounter with human perception, the electron, the mountains, the tree involve perceptions. They *are* perceptions in themselves: they *are* how they take account, in their own self-formative activity, of the world of activity always and already going on around.[4]

Whenever we see, whenever we perceptually feel, whenever we live abstraction, we are taking in nonhuman occasions of experience. We are inheriting their activity, taking it into our own special activity as a *human* form of life: as a society of occasions of experience contributing to a continuing growth pattern it pleases us to call our human self. What we perceptually feel to be our "humanity" is a semblance of that life. Like all semblances, it is created through specific techniques of existence, in this case, of historic proportions. And like all semblances, it appears most for itself at the moment of its perishing (Foucault 1970, 422). The "human" is a singularly historical virtual reality appearing *through* the animal body it also pleases us to call human. "Humanity" is a growth ring expressing a certain episode in the historic route of the collective life of our animal body.

Like all animal forms of life, the human has a technique of existence whose role is to selectively channel the nonhuman activity always going on all around into its own special activity. That technique of existence is

the body itself. The senses are procedures of the body as technique of existence. The body is the seat of bare activity: the region of indistinction between the human and matter where something doing is always already just stirring, before it starts to take definitive experiential form. We do not see the electrons traveling down our optic nerve. We see what our body makes of their activity. We take their activity into our own, producing an event of seeing—certainly a novelty for an electron. In the arcing of the event toward the production of its novel outcome, physical matter, life matter in general, and human life-matter are actively indistinguishable. The body is the intensive milieu of active-matter indistinction in the midst of which a human experience comes to finds itself.

Experience always invents. Every perception is a creative activity culminating in the production of an event of change. A perception is its own event. Its "content" is one with the dynamic form of its coming to fulfillment. What a perception invents is essentially itself. It is self-creative. There is nothing "outside" to which it corresponds or that it reflects or represents. All perception is immanent—in the case of animal life, to the bodily milieu of its own becoming. When we see an "object" "out there" we are seeing a semblance of our own life's passing, immanent to its own occurrence. If we focus exclusively on the chunkiness of the object as it slothfully presents itself in the flow of change, we are living the abstraction that the world comes in fundamentally inertial chunks of what we are habitually tempted to call matter *as opposed to* life, or what we like to think of as the concrete as opposed to the abstract (Manning and Massumi, forthcoming a). This is Whitehead's "fallacy of misplaced concreteness," which he considers the bane not only of most approaches to philosophy, but also of classical science, not to mention common sense (Whitehead 1967b, 51–52, 58). Deleuze restates it in the following way: "The opposite of the concrete is not the abstract, it is the discrete" (Deleuze, 1978a). The discrete: the slothful just-being-there of an inactive chunk of matter.

"In truth, the notion of the self-contained particle of matter, self-sufficient within its local habitation, is an abstraction." (Whitehead 1968, 138). There is, in bare matter of fact, "no possibility of a detached, self-contained local existence" (ibid.).

The doctrine I am maintaining is that neither physical nature nor life can be understood unless we fuse them together as essential factors in the composition of "really

real" things whose interconnections and individual characters constitute the universe. . . . In conceiving the function of life in an occasion of experience, we must discriminate the actualized data presented by the antecedent world, and the non-actualized potentialities[5] which lie ready to promote their fusion into a new unity of experience, and the immediacy of self-enjoyment which belongs to the creative fusion of these data with those potentialities. (Whitehead 1968, 150–151)

Such is lived abstraction. "Abstraction expresses nature's mode of interaction and is not merely mental. When it abstracts, thought is merely conforming to nature—or rather, it is exhibiting itself as an element in nature" (Whitehead 1985, 26). As for the body, "it is part of the external world, continuous with it," made of the same "matter" (or processual matter of fact). It partakes of the same general activity:

In fact, [the body] is just as much part of nature anything else there—a river, or a mountain, or a cloud. Also, if we are fussily exact, we cannot define where a body begins and where external nature ends. Consider one definite molecule. It is part of nature. It has moved about for millions of years. Perhaps it started from a distant nebula. It enters the body; it may be as a factor in some edible vegetable; or it passes into the lungs as part of the air. At what exact point as it enters the mouth, or as it is absorbed through the skin, is it part of the body? At what exact moment, later on, does it cease to be part of the body? Exactness is out of the question. (Whitehead 1968, 21)

The only thing that is certain is that the body will have partaken. It will have taken something of the world's general activity into its own special activity of expressing potential in life-advancing change taking place. Matter, "considered in abstraction of the notion of life," leads to an impasse. "We are left with the notion of an activity in which nothing is effected" (Whitehead 1968, 148). Nothing doing. "Vacuous actuality" (Whitehead 1978, 29). Inactivist philosophy.

Ultimately, the thinking of speculative pragmatism that is activist philosophy belongs to nature. Its aesthetico-politics compose a nature philosophy. The occurrent arts in which it exhibits itself are politics of nature.

The one-word summary of its relational-qualitative goings on: *ecology*. Activist philosophy concerns the ecology of powers of existence. Becomings in the midst. Creative change taking place, self-enjoying, humanly or no, humanly and more (on the more-than-human, Manning forthcoming a).

# 1 The Ether and Your Anger: Toward a Speculative Pragmatism

Pragmatism is often understood to err on the side of the objective. Its dictum that something is "true because it is useful" (James 1978, 98) is easily caricatured as a philosophical apotheosis of American instrumentalism. Objects, it would seem, figure in the world according to their ends: their potential to perform utilitarian functions. The world is a boundless collection of exploitable resources through which the rugged individual moves at will: user in a used world. The extreme objectivism of assuming that the world is a preconstituted collection of objects defined by their functional "cash-value" (James 1978, 32, 169) swings seamlessly into the frontier subjectivism of the purposive human actor partaking freely of its resources. As a result, pragmatism will just as often be understood as erring on the side of the subjective. Concepts such as William James's "pure experience" seem to confirm the objectivism even in their apparent appeals to an ineffable subjective essence. Without the mooring in utility, the subject would be swept away in the "stream."

As James takes pains to suggest in the preface to *The Meaning of Truth*, it is necessary to understand pragmatism in the context of the allied theory of radical empiricism in order to appreciate its force. *Essays in Radical Empiricism* seems at first to confirm the emphasis on end-objects. "What knowing actually and practically amounts to [is a] leading-towards, namely a terminating-in percepts" (James 1996a, 25). A "leading-towards," however, is already much more open-ended than a "use," as is a "percept" in comparison to a functional object. That a radical empiricism will not be either a subjectivism or an objectivism is immediately announced in James's specifications that the terminating occurs "through a series of transitional experiences which the world supplies" but that neither the experience nor the percept arrived at are to be understood in terms of a subjectively

contained consciousness (James 1996a, 25). What is radical about radical empiricism is that there are not on the one hand objective-transitions-leading-to-functional-ends and, on the other, experiences-and-percepts corresponding to them in the subject. Classically, objects and their associated operations are in the world while percepts registering them are in the subject. What James is saying, by contrast, is that *both are in the transition.* Things and their experience are together in transition. There is no oscillation in the theory between extremes of objectivism and subjectivism because the object and subject fall on the same side of a shared movement. The question is what distinction *their movement makes,* according to which they will fall on the same side. The answer will be surprising to those who equate pragmatism with instrumentalism.

James uses the simple example of describing a building to a skeptical friend (James 1996a, 54–56). There is nothing you can say that can verify your description. There is no sure way for your friend to know that you're not being inaccurate or deceitful unless you walk together to the building and you point out convergences between what you had said and what you both are now experiencing. The truth of the experience is the fulfilled expectation. So far, it's all pretty pedestrian. But for James, the demonstrative pointing-out is less an external referencing of an object by a subject than an indexing of two subjects to the same phase in the "ambulatory" movement. The demonstrative puts the subjects in sync, as two poles of the same fulfillment. It is less indicative of an object than performative of a sharing. The object does not figure "in itself." It figures differentially, as approached from disjunct perspectives (skepticism and the desire to convince) linked in a moving-toward. The object figures again as bringing those subjective poles of the movement into phase. Their difference of approach is resolved in the collective ability to point and say, "That's it!" The demonstrative exclamation marks the operative inclusion of the object in the movement, as a trigger of its elements' entering into phase. The "object" is an exclamation point of joint experience.[1] In that punctuating role, it is "taken up" by the movement. The object, along with the concerned "subjects," figure as differential poles integrating into a unity of movement. The unity lasts as long as its demonstrative performance. It is an event: a rolling of subjective and objective elements into a mutual participation co-defining the same dynamic.

In the aftermath of the event, the unity resolves back into differentials, and the movement continues, relatively de-defined again: it is possible that

disagreement will arise later about what was demonstrated at that point. The movement may then retrace its steps to repeat the demonstration, exclaiming a different integration and a redefinition. The object is taken up by the movement again but in a new capacity, as an object no longer only of skepticism but of dispute. Whether the object is strictly the "same" as taken up differentially by the movement the second time as it was the first is not a question of concern to pragmatism. What is of interest is that unfolding differentials phase in and out of integrating events in which they figure as dynamically interlinked poles—that there is a punctuated oneness in a manyness ongoing.

Once the emphasis is placed on the transitional-definitional nature of the "terminus," it is clear that the identity of the event's elements cannot predate their integration. What the object will definitely have been, and what precisely will have been role of the subjects, is clear only in retrospect after each integration—by which time they are already in transit to another terminus. Already all over again in the making. James will go so far as to say that what constitutes a subject and an object varies. An element that was a subject at one terminus may be taken up as an object in the next, or function as both at the same time (James 1996a, 13–15, 56–57). This is obvious when you remember that as a perceiver you are always perceivable by another, in whose experience you figure as an object. Or that an object may be retaken up as a memory, crossing from objective to subjective status (James 1996a, 61).

Subject and object are given *operative* definitions by pragmatism. They are not placed in any kind of metaphysical contradiction or opposition. They are defined additively (James 1996a, 9), according to their multiple takings-up in events, in a continuing movement of integration and decoupling, phasing and dephasing, whose dynamic takes precedence over their always provisional identities. Subject and object are grasped directly as variations—not only of themselves but of each other. Their open-ended ability to cross over into each other is the very "stuff" of the world (James 1996a, 4). As it is of experience. The phrase "the world of experience" is a redundancy.

These Jamesian moves already undermine any equation of pragmatism with a "naïve" instrumentalism, turning it decisively toward a philosophy of the world's continuing self-invention. This turn to a creative philosophy allies pragmatism with Bergson and Whitehead more than to any other currents.[2] In places, James makes the turn even more sharply. Ninety-nine

times out of a hundred, he writes, the ideas we hold true are "unterminated perceptually," and *"to continue* . . . is the substitute for knowing in the completed sense" (James 1996a, 69). A usefully terminated experience in which the identity of the elements in play definitively crystallize into a clearly objective or subjective role even for an exclamatory moment is the exception. The world usually only brinks on definitive self-punctuations.

Ether-waves and your anger, for example, are things in which my thoughts will never perceptually terminate, but my concepts of them lead me to their very brink, to the chromatic fringes and to the hurtful words and deeds which are their really next effects. (James 1996a, 73)

The trigger-object is rarely arrived at as a terminus. The world (experience) normally contents itself with brinking on "really next effects." A terminus is like a basin of attraction that draws you toward it, as by a gravitational pull, but no sooner spins you off, as by a centrifugal force. The world doesn't stop at your anger. An angry word or deed snowballs into an unfolding drama sweeping you and all around you along. You are always really living in a centrifugal hurtle to a next effect.

We live, as it were, upon the front edge of an advancing wave-crest, and our sense of a determinate direction in falling forward is all we cover of the future of our path. It is as if a differential quotient should be conscious and treat itself as an adequate substitute for a traced-out curve. Our experience . . . is of variations of rate and of direction, and lives in those transitions more than in the journey's end. (James 1996a, 69)

Rather than arriving at end-objects, or fulfilling objective ends, we are carried by wavelike tendencies, in a rollover of experiences perpetually substituting for each other. "We live forwards," but since we have always already rolled on, "we understand backwards" (James 1996a, 238): *participation precedes cognition.* This is the sense of James's famous saying that we don't run because we are afraid. We are afraid because we run.

Since we are always at the brink, we are too busy rolling on to doubt the running reality. The question of the truth or falsehood of the crests and troughs through which we pass—whether they are "merely" subjective, mere appearances or illusions—doesn't even arise.

These [transitional] termini . . . are self-supporting. They are not "true" of anything else, they simply *are,* are *real.* They "lean on nothing." . . . Rather, does the whole fabric of experience lean on them. (James 1996a, 202)

In the end (or more precisely, in the never-ending) the pragmatic truth is not fundamentally defined by a functional fit between a will and a way, or a propositional correspondence between subjective perceptions and a self-same object. Rather, it has to do with a "self-supporting" of experience brinking, on a roll to really-next-effects. What we experience is less our objects' confirmed definitions, or our own subjectivity, than their going-on together—their shared momentum. Being swept up by the world consti- tutes a *lived belief* in it: an immediate, moving, embodied, participatory belief.[3] Belief is not propositional ("that is [what it is]"). It is the undoubt- able rush of fear, anger, or expectation whose object has already zoomed past before it is fully defined ("so that was it!"). "Definitely felt transitions . . . are all that knowing can possibly contain or signify" (James 1996a, 56). Riding the wave, we are in "a *that* which is not yet any definite *what*, tho' ready to be all sorts of whats; full of both oneness and manyness, but in respects that don't appear" (James 1996a, 93–94). This, James writes,

is what I call pure experience. It is only virtually or potentially either object or subject as yet. For the time being, it is plain, unqualified actuality, a simple *that*. (James 1996a, 23)

It is only when our idea [our expectation of perceiving something] has actually terminated in the percept that we know "for certain" that from the beginning it was truly cognitive of *that*. We were *virtual* knowers before we were certified to have been its actual knowers, by the percept's retroactive validating power. (James 1996a, 68).

The surprise answer to the question of what distinction subjects' and objects' shared movement makes is *virtual-actual*. "As yet" (on the crest) subject and object are undetermined. They are only virtually subject or object. Actually, they are what they will have been. The subject and the object fall into definition on the same side of the actual-virtual distinction: the actual side. That is, they fall in retroactively (in the trough). Their actual definition is a kind of experiential doppler effect immediately reg- istering their already having passed, in the momentary calm before the next wave rolls up. Subjects and objects are not preconstituted foundations for purposive movement yielding useful effects. They *are* effects: move- ment-effects, directly registered passings-on that are also phasings-out.

How can James turn subjects and objects into phasings or effects and also say that we have an immediate, undoubtable belief in the world? Because even if you do not have a founding relation between a subject and

an object, you still have an effective, if passing, relation of experience to itself. "Thoughts are made of the same stuff things are" (James 1996a, 37); "The starting point *becomes* a knower and the terminus an object meant or known" (James 1996a, 57; emphasis added); "The first experience knows the last one" (James 1996a, 58) retrospectively. Thought and thing, subject and object, are not separate entities or substances. They are irreducibly temporal *modes of relation of experience to itself.* The wave crest is an interference pattern between the forward momentum, or prospective tending, rolling on from its starting point in a last terminus toward an already anticipated end-object, and the backwash of the really-next-effect by virtue of which the starting point retroactively becomes a knowing subject. In experience, what goes along comes around. The world rolls in on itself, over its own expectations of reaching an end. It snowballs, start to terminus. The world is self-supporting in the sense that it feeds on its own momentum, folding its movement around on itself, always "additively" (James 1996a, 110), the end of every roll a return to the beginning, only more so: further on, spinning off virtual subjects and objects, like flakes in its actual wake. Everything in the world of experience is contained in this self-augmenting movement. There is no opposition or contradiction, only the productive paradox of a self-contained becoming. A becoming-more and -many through the same momentum: many-more one-ward.

This brings us to James's pivotal definition of what constitutes a radical empiricism, and when coupled with pragmatism, precludes it being an instrumentalism: *the primacy of relation.* The world revolves around its momentous relation to itself. Relations, James insists, are as real as the terms in relation (subjects, objects, sense data). And relations are themselves experienced.

The relations that connect experience must themselves be experienced relations, and any kind of relation experienced must be accounted as "real" as anything else in the system. (James 1996a, 42)

The parts of experience hold together from next to next by relations that are themselves part of experience. The directly apprehended universe needs, in short, no extraneous trans-empirical connective support, but possesses in its own right a concatenated or continuous structure. (James 1978, 173)

An example: giving. Our commonsense way of thinking about a relation like giving would be to analyze it into its terms, or decompose it into parts, and then put it all back together again. In this case, you decompose the

giving into a giver (A), a gift (B), and a recipient (C). In theory, you should be able to reconnect A to B (giver to gift) and B to C (gift to recipient) and get the giving again. But what you actually get is two successive holdings: A holding B, then C holding B, with nothing to hold the holdings together. What holds the holdings together isn't in the terms, or their part-to-part connections. What holds the holdings together is a oneness-in-manyness of a moving on. It is what runs through the parts and their holdings, without itself being held; what is unmissably experienced without being seen. *That*—the relation—is not in the giver. Nor is it in the gift. Nor the recipient. It is what runs through them all, holding them together in the same dynamic. It is integrally many things: "concatenated and continuous." It is whatever tendency impels or compels the giving. It is the desire to please another, or to bind another to oneself. It is an obligation, which obliges in return. For a giving is never solitary. It calls for more. It is serial, ongoing. It is in the conventions that define the timing and sequence, what gift is desirable or appropriate, and when. It is also in the sensual qualities of the gift (unromantically, its "sense data"). It is the fragrance or the sparkle. It is all of these things, folded into and around each other to form an experiential envelope, a field, "full of oneness and manyness in respects that don't appear"—incorporeal medium holding the gift up for the giving, and holding the successive holdings to the same event. Holding-up/holding-together, integral unseen medium of suspension: *that* does it.

The suspension-event is an incorporeal envelope of *sociality*. The gift relation is not fully personal or objective. It is immediately social—in a way singularly independent from the particular nature of the terms in social relation. The giver or recipient may be male or female, young or old, or what not. The gift may be flowers or diamonds, or what not. The *that* holding the holdings together is a multiplicity of *what-nots*, a ready-to-be-all-kinds. The relation is a suspension of the particular definitions of the terms in relation. If it is as real as they are, its reality is of a different order: an implicate order, of ready-to-be-things folded eventfully into each other. If the implicate order is of the order of an event, then like every event, really-next-effects will unfold from its happening: to be continued.

Again, "really-next-effect" means "transition takes precedence." The gift is defined as the object of the giving by the event of the offer's passing unbroken into an acceptance. Reciprocally, the giver and the recipient are defined as the subjects of the giving by the object's eventfully having

passed. The radically empirical point is that the all-around lived medium, or experienced envelope of relation, is a ready-to-be (virtual) coexistence of terms held in a nondecomposable unity of movement that determines what they will have been in passing. That translates into the conceptual rule of thumb that the terms in relation belong to a different order than their relation. Terms in relation, parts of the whole, serially unfold over the course of events. But they do so by virtue of an infolding, or implicate, order holding them, wholing them, fielding them in the same event. *The logic of coexistence is different from the logic of separation. The logic of belonging is different from the logic of being a part.*

This means that to get the whole picture (including the real, suspended ways it doesn't appear), you have to operate with both logics simultaneously: the conjunctive and the disjunctive. "Radical empiricism is fair to both the unity and the disconnection" (James 1996a, 47). It translates metaphysical issues of truth and illusion, subject-object correspondence, into issues of *continuity* and *discontinuity*.

These are basically pragmatic issues: when and how to make a break, and in making a break field a relation, and to what really-next-effect. (You can never take back a gift. It incorporeally binds you to another, and in so doing irreversibly cuts into your having been apart.)

Together, radical empiricism and the pragmatic theory of truth lead to an odd constructivism in which experience is at the same time self-standing and self-contained, and always to be invented according to passing logics of break and relation. For it is always only in passing that things prove useful: as provisionally as ether waves, as ephemerally as your anger, as corruptibly as a gift. Things' only a priori function is of *becoming*.

Approaching things this way saves you fussing over the cognitive status of your experience. Disbelieving, are you? Feeling a tad illusionary? Don't worry. Everything is as real as its next-effect. Just concentrate on the break and relation that will make a next-effect really felt. In any such event, as you always are, you are already redundantly implicated in the world of experience.

You do not run purposively through the world because you believe in it. The world, surprisingly, already runs you through. And that, really felt, *is* your belief in it. Virtual participation, really, brinking on truly, precedes

actual cognition. This is what James means when he says "we live on *speculative* investments" (James 1996a, 88; emphasis added). We find ourselves "invested" in the world's running through our lives because at every conscious moment our participation in it has just come to us newly enacted, already and again, defying disbelief with the unrefusable feeling of a life's momentum. The "speculation" is the thinking-feeling of our active implication in the ever-rolling-on in the world to really-next-effects.

Break-and-relate to make felt an effect: a definition of *art*. Pragmatism, as augmented by radical empiricism's virtual friendly relationism, ends up allying not with instrumentalism or any vulgar functionalism, but with art (living art, arts of life). It has less to do with end-use than with transitional expression: creative philosophy. The truth is not "out there." It is in the making.

## 2   The Thinking-Feeling of What Happens: Putting the Radical Back in Empiricism

**V2_Institute for the Unstable Media***   What is central to interactive art is not so much the aesthetic form in which a work presents itself to an audience—as in more traditional arts like painting, sculpture, and video installation art—but the behavior the work triggers in the viewer. The viewer then becomes a participant in the work, which behaves in response to the participant's actions. Interactive art needs behavior on both sides of the classical dichotomy of object and viewer. Paintings or installations also trigger certain behaviors—from contemplation to excitement—but they themselves do not change as a result of the behavior they inspire in their audiences. It's one-way traffic; there's no exchange. This raises several questions. First, since an interactive work aims to evoke a behavior in the audience, can it really do without a form that is "interesting" and therefore in some way aesthetic? Is putting a sign up saying "You may touch the work" or "You may interact with the work" enough? When is the interaction "interesting" enough to keep the audience interacting? Can or should this interaction generate the sort of aesthetic experience that we associate with the phenomenon of art? Or is interactive art about a different kind or type of experiences compared to more traditional art forms?

**Brian Massumi**   I'm glad you're raising these questions. I think that there is a real need right now to revisit the aesthetic in relation to interactive art. It's clear that saying "You may interact with the work" is not enough. More and more things in our lives are saying that, and we don't call them

* I would like to thank Arjen Mulder for creating the context for this conversation by formulating the opening issues. I would also like to apologize to him for his becoming a fictional character in the course of the subsequent semblance of a conversation. Any grumpiness that character might have displayed is in no way a reflection on him but only of my own combativeness with myself.

art. We often don't even call them interesting in any strong sense—more like entertaining. If "Please interact" were enough to define a category, it would be gaming, not art. Beyond gaming in the strict sense, there is a gaming paradigm that has moved into other domains.[1] You see it massively in communications but also in marketing, design, training, education. Places where it becomes serious and useful. Interactivity can make the useful less boring and the serious more engaging. It is performance-enhancing. It's big business. It rarely has pretensions to art. This makes the question of what it is in interactive art that makes it art all the more insistent.

**V2**  So then how do you approach that question—particularly in a way that allows you to define what distinguishes interactive art from traditional arts?

**BM**  I personally don't see how the question can be approached without returning to the question of form. And that requires reconnecting with aesthetics. That's not a popular position in new media art. There is a wide-spread attitude that aesthetic categories belong to the past. Many people would say they just don't apply, for the reasons you listed: interaction is two-way, it's participatory, and it evokes a behavior rather than displaying a form. I've heard it said in no uncertain terms that form is dead. That we just can't think or speak in those terms any more. It's almost an injunction. I don't mean to say it's not a serious question. It's identifying a real problem. How *do* you speak of form when there is the kind of openness of outcome that you see in a lot of new media art, where participant response determines what exactly happens? When *the* artwork doesn't exist, because each time that it operates the interaction produces a varia-tion, and the variations are in principle infinite? When the artwork pro-liferates? Or when it disseminates, as it does when the work is networked, so that the interaction is distributed in time and space and never ties back together in one particular form?

To begin with, you have to get past the idea that form is ever fixed, that there is any such thing as a stable form—even in traditional aesthetic practices like figurative painting, or even in something as mundane as decorative motif. The idea that there is such a thing as fixed form is actu-ally as much an assumption about perception as it is an assumption about art. It assumes that vision is not dynamic—that it is a passive, transparent

registering of something that is just there, simply and inertly. If vision is stable, then to make art dynamic you have to add movement. But if vision is already dynamic, the question changes. It's not an issue of movement or no movement. The movement is always there, in any case. So you have to make distinctions between kinds of movement, kinds of experiential dynamics, and then ask what difference they *make*.

**V2**　In what way is there movement in vision? Your bringing up decorative motif in this connection makes me think of an author of interest to both of us, the philosopher of art Susanne Langer. Are you referring to her theories of perceptual movement in art?

**BM**　Exactly. Langer reminds us that we see things we don't *actually* see. We all know it, but we tend to brush it off by calling it an illusion, as if something is happening that isn't real and doesn't have anything important to say about experience. But isn't "something happening" the very definition of real? The question is what exactly does the inconvenient reality that we see things we don't actually see say about the nature of perception? Well, it changes everything. Langer starts from the simple example of the kind of spiraling, vegetal motifs you see in a lot of traditional decorative arts. She states the obvious: we don't see spirals, we see spiral*ing*. We see a *movement* that flows *through* the design. That's what it is to see a motif. The forms aren't moving, but we can't not see movement when we look at them. That could be another definition of real: what we can't not experience when we're faced with it. Instead of calling it an illusion—this movement we can't actually see but can't not see either— why not just call it abstract? Real and abstract. The reality of this abstraction doesn't replace what's actually there. It supplements it. We see it *with* and *through* the actual form. It *takes off* from the actual form. The actual form is like a launching pad for it. We wouldn't see the movement without the design actually being there, but if we only saw the actual design we wouldn't be seeing what it is we're seeing—a motif. The actual form and the abstract dynamic are two sides of the same experiential coin. They're inseparable. They're fused, like two dimensions of the same reality. We're seeing double.

**V2**　And that's different from seeing an object—say, the leaves themselves that suggested the motif? Weren't you were saying that this tells us something about the nature of perception?

**BM** Yes, the next question is if the same thing happens in so-called natural perception of objects. It's clear that it does. For example, to see an object is to see volume. We don't infer volume. We *see* the voluminousness of an object, directly and immediately, without having to think about it. We don't say to ourselves, "Let's see, there's a surface facing me, I would wager that there is a backside to it, which means it's a 3D object and therefore I could walk around it and see and touch the other side." We don't say this to ourselves because we don't say anything to ourselves. We just see. We see what's before us directly and immediately *as* an object. We see the "backedness" of it without actually seeing around to the other side. That's precisely what makes it a perception of an object, rather than a deduction about a surface. We are really but implicitly—abstractly—seeing the object's voluminousness. The perceived shape of an object *is* this abstract experience of volume. Part of it, anyway, because we also directly and immediately see an object's weightiness. We see weightiness through texture, for example. Voluminousness and weightiness are not in themselves visible. But we can't not see them when we see an object. In fact, we see them *in the form of* the object. Form is full of all sorts of things that it actually isn't—and that actually aren't visible. Basically, it's full of potential. When we see an object's shape we are not seeing around to the other side, but what we are seeing, in a real way, is our *capacity* to see the other side. We're seeing, in the form of the object, the *potential* our body holds to walk around, take another look, extend a hand and touch. The form of the object is the way a whole set of active, embodied potentials appears in present experience: how vision can relay into kinesthesia or the sense of movement, how kinesthesia can relay into touch. The potential we see in the object is a way our body has of being able to relate to the part of the world it happens to find itself in at this particular life's moment. What we abstractly see when we directly and immediately see an object is *lived relation*—a life dynamic.

Once again, we don't see it *instead of* what we think of as being the actual form of the object. We're seeing double again. But this time, we're seeing the actual form "with and through" that set of abstract potentials. The reason we're directly seeing an object and not just a surface is because we can't not see what we're seeing without also experiencing voluminous-*ness* and weight*iness*—the object's invisible *qualities*. Seeing an object is seeing through to its qualities. That's the doubleness: if you're not

qualitatively seeing what isn't actually visible, you're not seeing an object, you're not seeing objectively. "Objectification itself is abstraction. . . . Abstraction expresses nature's mode of interaction and is not merely mental" (Whitehead 1985, 25–26). Deleuze drives the point home: "the abstract *is* lived experience. . . . you can live nothing but the abstract" (Deleuze 1978).

Certain currents in embodied perception take this to heart. Alva Noë, for example, concludes that all visual perception is "virtual" (Noë 2004, 50, 66–67, 134–135). Seeing, he says, is a kind of action. Only, I would say, without the actual action—with the action appearing in potential. We never just register what's actually in front of our eyes. With every sight we see imperceptible qualities, we abstractly see potential, we implicitly see a life dynamic, we virtually live relation. It's just a kind of shorthand to call it an object. It's an *event*. An object's appearance is an event, full of all sorts of virtual movement. This is real movement, because something has happened: the body has been capacitated. It's been relationally activated. It is alive in the world, poised for what may come. That is also "seen"—there's a sense of aliveness that accompanies every perception. We don't just look, we sense ourselves alive. Every perception comes with its own "vitality affect," to use a term of Daniel Stern's (Stern 1985, 53–61; Stern 2010).

That's why we see movement in a motif. The form naturally poises the body for a certain set of potentials. The design calls forth a certain vitality affect—the sense we would have, for example, of moving our eyes down a branch of rustling leaves, and following that movement with our hands. But that life dynamic comes without the potential for it to be actually lived. It's the same lived relation as when we "actually" see leaves, it's the same potential. But it's *purely* potential. We can't live it out. We can only live it in—in this form—implicitly. It's like the motif has taken the abstraction that is the leaf and made it appear even more abstractly. So abstractly, it can't go any further than this appearance. The body is capacitated, but the capacity has nowhere else to go. It's in suspense. Langer calls this a "semblance" (1953, 45–68 and passim). The concept also appears in strikingly similar ways in Walter Benjamin's early work on art and aliveness (Benjamin 1996b, 1996c).

A semblance takes the abstraction inherent to object perception and carries it to a higher power. It does this by suspending the potentials presented. Suspending the potentials makes them all the more *apparent* by

holding them to visual form. The relays to touch and kinesthesia will not take place. These potentials can *only* appear and can only appear visually. The event that is the full-spectrum perception is and will remain virtual. A life dynamic is presented but virtually, as pure visual appearance.

This produces another level of vitality affect. It feels different to see a semblance. Even in something so banal as a decorative motif, there is the slightly uncanny sense of feeling sight see the invisible. The action of vision, the kind of event it is, the virtual dimension it always has, is highlighted. It's a kind of perception *of* the event of perception *in* the perception. We experience a vitality affect of vision itself. This is like the doubleness of perception I was talking about becoming aware of itself. A kind of direct and immediate self-referentiality of perception. I don't mean self-reflexivity, which would be thinking about a perception as from a distance or as mediated by language. This is a thinking of perception in perception, in the immediacy of its occurrence, as it is felt—a *thinking-feeling*, in visual form.

Semblances, by whatever name—pure appearances, self-abstracting perceptions, thinking-feelings—occur in so-called natural perception. That's a misleading category if ever there was one—as if seeing a leaf motif were somehow less natural than seeing a leaf. Still, there is an important difference. The perception of any object also involves the thinking-feeling of a semblance. It's just that the semblance is backgrounded. An object is a semblance to the extent that we think-feel things like its backedness, volume, and weight. But that thinking-feeling slips behind the flow of potential action that the objectness suggests. We let the vitality affect, the "uncanny" apprehension of the qualitative dimension, pass unnoticed. Instead, we orient toward the instrumental aspect of the actions and reactions that the perception affords. The self-reflexivity of the experience is backgrounded. The sense of relational aliveness disappears into the living. The "uncanniness" of the way in which the object appears *as* the object it is—as if it doubled itself with the aura of its own qualitative nature—disappears into a chain of action. We live out the perception, rather than living it in. We forget that a chair, for example, isn't just a chair. In addition to being one it looks *like* one. The "likeness" of an object to itself, its immediate doubleness, gives every perception a hint of déjà vu. That's the uncanniness. The "likeness" of things is a qualitative fringe, or aura to use a totally unpopular word, that betokens a moreness to life. It stands in the

perception for perception's passing. It is the feeling in this chair of past and future chairs "like" it. It is the feeling in this chair that life goes on. It presents, in the object, the object's *relation* to the flow not of action but of life itself, its dynamic unfolding, the fact that it is always passing through its own potential. It's how life feels when you see it can seat you. In Antonio Damasio's terms, it's the "feeling of what happens," that background feeling of what it's "like" to be alive, here and now, but having been many elsewheres and with times to come.[2] Art brings that vitality affect to the fore.

All of this suggests a way of bringing art and "natural" perception together while still having a way of distinguishing them. In art, we see life dynamics "with and through" actual form. Or rather, we always see relationally and processually in this way, but art makes us see that we see this way. It is the technique of making vitality affect felt. Of making an explicit experience of what otherwise slips behind the flow of action and is only implicitly felt. Of making the imperceptible appear. In everyday perception, the same thing occurs. There is an artfulness in every experience. Art and everyday perception are in continuity with one another. But in everyday experience, the emphasis is different. It is all a question of emphasis, an economy of foregrounding and backgrounding of dimensions of experience that always occur together and absolutely need each other. Art foregrounds the dynamic, ongoingly relational pole. Everyday experience foregrounds the object-oriented, action-reaction, instrumental pole. That pole comes across as stable because it offers our action perches—"affordances" in J. J. Gibson's vocabulary (1986, 36, 137–138). We attend to the perchiness, and let the other side of that same coin, the passing-relation side, slip behind the use we can exact from the perception. Art brings back out the fact that all form is a full-spectrum *dynamic form* of life. There is really no such thing as fixed form—which is another way of saying that the object of vision is virtual. Art is the technique for making that necessary but normally unperceived fact perceptible, in a qualitative perception that is as much about life itself as it is about the things we live by. Art is the technique of living life *in*—experiencing the virtuality of it more fully. Living it more intensely. Technique of existence (chapter 3).

This also suggests a way of dealing with the question of interaction in art, and why the question of whether or not it is art comes up so insistently. Despite the term inter*activity*, the emphasis is rarely on the dynamic form

of the experience in all its dimensions. It is the form of the technical object that is emphasized, for what it affords. The emphasis is on the perches it offers for a relaying from action to reaction and back again. It is supposed to be all about social relation, but the dynamic form of the experience tends to get reduced to the instrumental affordance as concretized in the actual form of the technical object. It gets reified in an objective function. The technical object is action-packed. But the sense of action is constrained, subordinated to functional circuits of action-reaction that are to a large extent predetermined to respond to what are taken to be existing needs or wants.

Inter*action* is just that: a going back and forth between actions, largely reduced to instrumental function. The lesson of the semblance is that lived reality of what is happening is so much more, qualitatively. It includes an "uncanny" moreness to life as an unfolding lived relation in a world whose every moment is intensely suffused with virtuality—an abstractly felt "backside," or voluminousness, of life itself. When what is concentrated on are instrumentalized action-reaction circuits, what gets foregrounded is the element of nextness in the flow of action. The voluminousness of the experience, its all-aroundness and going-for-moreness, shrinks from feeling.

That is why I make a distinction between interactivity and relation. I use the word *interactivity* to designate an instrumentally contracted dynamic form that tends to shrink to the parameters of its objectively embodied instrumental function. I use the word *relation* to refer to the full spectrum of vitality that the dynamic form really includes, potentially, abstractly self-expressed in its semblance. Interactivity backgrounds its own artistic dimension when it concentrates on the function of the instrument to the detriment of the semblant expression. That's what has happened when we hear the comment, all too common, from interactive art participants that the experience felt like a video game. You often feel there's a trick you need to find and master, and once you've done that, you lose interest because you've got the feel of it and know how it "works." When something loses intensity instead of becoming more compelling when you get the feel of it, it is a sure sign that it is operating more on a level of predefined objective function than fully lived relation.

I'm not saying that all interactive art does this. It's just that this is the trap that is automatically laid for it, the problem it has to grapple with by its very nature. The problem is: in what way is this different from a game?

Is this doing something that mainstream informational capitalism isn't already doing, ever so profitably, by generalizing the gaming paradigm? What's new or different or intensely feeling or vitally voluminous or virtually freeing about it? Paradoxically, the intensity of the dynamic form of the experience comes out most effectively when action-reaction circuits are artfully suspended or (even better in this context) when the action line itself is accompanied by a continuous semblance of itself, an ongoing perception of its singular eventfulness doubling the functional perception of the affordances offered and taken. The production of a perception of perception suspending or abstractly doubling action-reaction is an idea that Deleuze develops at length in connection to an older dynamic form in his *Cinema* books (1986, 1989).

**V2**  It sounds like you've boxed interactivity into a corner. If interactive art is about concrete action and art is more about abstract perception, then it sounds like it can't ever really aspire to art. The way you've approached the question also seems to resuscitate some very old ideas about art—for example, the classical idea that it is "disinterested." The modernist version of that idea is that art has to be about "estrangement." Isn't your idea of suspension of causal action-reaction chains just rehabilitating these notions? That neglects a major motivation behind a lot of new media art. A lot of people consider the traditional ways of doing art to be passifying precisely because they suspend. That artistic gesture is critiqued for creating a false sense of art's "autonomy." Elitism is another word many people would use for that, and for art's aura. Interactive art is meant to take art out of its ghetto, out of the gallery, out of the frame, and into life. And you're saying it misses the liveness. Interactivity is often looked on as liberating because it does this. For a lot of practitioners, that's the whole point of it. How would you respond to this kind of criticism?

**BM**  I entirely endorse attempts to bring life into art and art into life— although I'm not sure if I subscribe to all of the assumptions about art and about life that often go with explanations of why and how this should be done. For example, I think the notion of framing in these kinds of critique is often very reductive. But before I go into that, I think it's important to remind ourselves that there can be a kind of tyranny to interaction.

Interactivity is not neutral with respect to power. In fact, according to Foucault, among the most invidious of regimes of power are the ones that

impose an imperative to participate, particularly when the imperative is to express yourself "truly" or "authentically." You are constantly interpellated. You are under orders to be yourself—for the system. You have to reveal yourself for who you are. In fact, you become who you are in expressing yourself. You are viscerally exposed, like a prodded sea cucumber that spits its guts. You are exposed down to your inmost sensitive folds, down to the very peristaltic rhythms that make you what you are. This is generative power, a power that reaches down into the soft tissue of your life, where it is just stirring, and interactively draws it out for it to become what it will be, and what it suits the system that it be. This is what Foucault calls "positive" power or "productive" power. It produces its object of power interactively through its own exercise. That object of power is your life. Not just your behavior, not just your labor—your life. It's what Foucault calls "biopower" (2008). It's a soft tyranny.

You see it everywhere today. The telltale sign is the positive feedback loop. For example, you buy things with your credit card, presumably to satisfy needs or desires in your life. Needs, desires: you purchase at your soft points. That visceral act is actually an interaction: you have just participated in a data-mining operation. Your input feeds a marketing analysis apparatus, and that feeds a product development machine. The system eventually gets back to you with new products responding to the input, and with new ways to reach you, massage your rhythms, air out your viscera, induce you to spend. New needs and desires are created. Even whole new modes of experience, which your life begins to revolve around. You have become, you have changed, in interaction with the system. You have literally shopped yourself into being. At the same time, the system has adapted *itself*. It's a kind of double capture of mutual responsiveness in a reciprocal becoming.

This is just a quick example to make the point that interactivity can be a regime of power. It is often thought that the limitations of interaction within predetermined parameters of functioning, of the kind I was just talking about, can be easily overcome by making the interaction evolutionary through feedback. My example of biopower is precisely an example of an evolutionary interaction. It is simply not enough to champion interactivity. You have to have ways of evaluating what modes of experience it produces, what forms of life those modes of experience might develop into,

and what regimes of power might arise from those developments. The power element is always there, at least on the horizon. You have to strategize around it. You have to strategize how not to make prodded sea cucumbers of your participants, at the same time as you don't want to just let them stay in their prickly skins. Simply maximizing interaction, even maximizing self-expression, is not necessarily the way. I think you have to leave creative outs. You have to build in escapes. Drop sinkholes. And I mean build them *in*—make them immanent to the experience. If the inside folds interactively come out, then fold the whole inside-outside interaction in again. Make a vanishing point appear, where the interaction turns back in on its own potential, and where that potential appears for itself. That could be a definition of producing an aesthetic effect. The semblances I was talking about earlier could be a definition of aesthetic effect.

Understood in the way I'm talking about, an aesthetic effect is not just decoration. I started with a decorative example, but the point I wanted to make was not that art is decorative but rather that even decorative art is a creative event, however modest. It creates a semblance. A semblance is a placeholder in present perception of a potential "more" to life. The framing of it determines the intensity or range or seriousness of that potential.

Take the way a simple object is doubled by its own "likeness." You don't just have an experience of the single present thing. You at the same time experience what it's like to experience its presence. That "likeness" marks the object as a variation on itself. You perceive what it's like because in your life there have been other appearings "like" this one, and you implicitly anticipate more will come. The likeness is the invisible sign of a continuing. This puts a certain distance between the object and itself. A kind of self-abstraction. The thing stands for itself, and for difference *from* itself over time. Because in time it will appear episodically, under variation. It holds these variations-on in the present, which is why it is a kind of immediate, lived abstraction. This haloes the object with certain genericness, extending what it is beyond its own particularity. The thing is both itself and a placeholder in life's process for others like it. The semblance is the leading edge, in the present, of future variation, and at the same time a doppler from variations past. It is the thing's perceived margin of changeability, the thinking-feeling of potential appearings of particulars

belonging to the same genre, appearing in the same style. A semblance is a direct perception of a life *style*. It is like an intuition of the thing as a life motif—a pattern of varied repetitions.

Each repetition will be different to a degree, because there will be at least microvariations that give it its own singular experiential quality and make it an objective interpretation of the generic motif. The semblance makes each particular a singular-generic. It is because it presents difference through variation that it is a thinking-feeling of a margin of changeability. You could even say of indeterminacy, since likenesses can overlap and contaminate each other. A chair is like itself and the next chair. But it is also like a sofa, from the perchabilitiy point of view. How far the "likeness" goes is determined by the body's relation to the thing. It's not cognitive per se, like a recognition or deduction. It's integral. A thinking at one with a feeling: a thinking-further fused with a feeling of what is. But the fusion is asymmetrical because the feeling of what is zeroes in on what can be settled in the present, while the thinking-further pulls off-center and away toward more, so that together they make a dynamic, never quite at equilibrium. This gives the present perception its own momentum, even though it can't presently signpost exactly where it's going. It's more an open-ended tending-to than a reflection-of or a reflecting-on. It's a posture—if you can call a disposition to moving in a certain style a posture. It's a dynamic posture. The "likeness" will smudge strictly logical categories to the extent that the body tends-to, moves on, transfers habits, reflexes, competencies, and thinking-feelings from one thing to the next, expands its repertory of dynamic postures by mixing, matching and alloying them, explores its own living potential, strikes new postures—invents new ways of affording itself of the world, in collaboration with the world, with what the world throws before it. A singular-generic is not a general category, anymore than it's just a particular. It's not positioned in a way that pigeonholes it. It's on the move—it's on a *dis*positional continuum. There is no such thing as site-specific. The very word conjures up the notion of "simple location" that Whitehead identified as the basic error of modernity (Whitehead 1967b, 49, 58, 91).

At any rate, thought and imagination are the leading edges of this exploratory expansion of potential, because they can wander from the particular present posture even without actually leaving it. And without being limited to the potential next steps that it most presents, that it makes

most available or automatic. They raise the smudge factor exponentially. A thing felt is fringed by an expanding thought-pool of potential that shades off in all directions. It's like a drop in the pool of life making ripples that expand infinitely around. William James spoke in those terms. He said experience comes in "drops" (James 1996b, 231–232).

The semblance, or pure appearance, of a thing is a kind of processual distance it takes on itself. When in the course of everyday life we march habitually and half-consciously from one drop of life to the next, we don't attend to the ripples. We see *through* the semblance to the next, not letting it appear with all its force. It's like the thing falls back from the distance it potentially takes on itself. It closes in on itself. It falls from its distance on itself into itself. As a result, it appears banal, so paltry a thing that we just pass on to the next thing, hardly noticing what the last one was "like." Only the most available and automatic ripple ring of potential appears, and often even then barely at the threshold of awareness. In his writings on art, Deleuze often says that to really perceive, to fully perceive, which is to say to perceive artfully, you have to "cleave things asunder" (Deleuze 1995, 86), You have to open them back up. You have to make their semblance appear as forcefully as possible. You have to give the thing its distances back. He quotes Francis Bacon: you have to make a Sahara of it (Deleuze 2004b, 82, 128). You do this, in Bacon's words again, as a "matter of fact." Not as a matter of principle. Not as a matter of opinion. Not in accordance with purely logical categories, progressions, and relations. Not to represent. Not to reflect. Instead, as an event. In a drop of lived relation that has a style all its own, that exemplifies its own singular-generic logic, and is as really appearing as it is infinitely expansive.

This sundering of things is what I meant by "suspension." It's the opposite of "disinterestedness," if you interpret that to mean neutrality or a subjective posture of noncommittal. The semblance is not subjective. As I tried to explain, it makes the object an object. There is no subject, apart from the singular aliveness appearing in the object's generic wake. The subject is life. *This* life. *"A"* life, as Deleuze would say (Deleuze 2007, 384–89). So the process I'm talking about can't ever be contained by any elitism because it always potentially exceeds, at very least on its outermost fringes, any standard of taste or coolness that a particular social grouping might succeed in imposing on it. It's the opposite of all that. It's intensifying. Enlivening. Potentializing.

It's artificial to talk about this only in relation to single things. Every thing appears in a situation, along with others. The situation itself is a life-drop. A bigger drop, with its own ripples of potential that overlap with those of its constituent things but can also diverge from them, subtract them from itself or alloy them in other configurations. Every appearance is at a crossroads of life. At the limit, what appears isn't just a drop or a pool, but a whole ocean, with calm stretches and turbulence, ripplings that cancel each other out and others that combine and amplify, with crests and troughs, killer surf-breaks and gentle lappings at the shores of other situations. For James, the fact that experience comes in drops doesn't mean it can't also come with "oceanic" feeling.

What interactive art can do, what its strength is in my opinion, is to take the *situation* as its "object." Not a function, not a use, not a need, not a behavior, exploratory or otherwise, not an action-reaction. But a situation, with its own little ocean of complexity. It can take a situation and "open" the interactions it affords. The question for interactive art is, How do you cleave an interaction asunder? Setting up an interaction is easy. We have any number of templates for that. But how do you set it up so you sunder it, dynamically smudge it, so that the relational potential it tends-toward appears? So that the situation's objectivity creatively self-abstracts, making a self-tending life-movement, a life-subject and not just a setup. How, in short, do you make a semblance of a situation? These are technical questions, essentially about framing, about what it means to frame an event situationally or house a dispositional life-subject. You can get there technically—in fact whatever the nature of the object involved, it is always a question of technique—but when you do it's not because you've build a better-functioning machine. It's because you've built into the operation shifts in emphasis from interaction to lived relation. You're creating ways of making the lived relation really appear. You're operating on the qualitative level of thinking-feeling, where you are pooling styles of being and becoming, not just eliciting behaviors.

There are practices, of course, that already do this implicitly to one degree or another, usually in a more determinate way, more narrowly focused on ensuring regular and dependable affordances, functional or instrumental perchings, rather than by sundering and fringing. What is architecture, if not "site-specific" life-design? What is an institution, if not a distributed architecture of experience? Architecture and institutions are

two dynamically connected poles on a processual continuum between positioning and disposition, settling the present and disseminating settlement. A practice that pries open existing practices, of whatever category, scale, siting, or distribution, in a way that makes their potential reappear at a self-abstracting and self-differing distance from routine functioning, in a potentialized semblance of themselves—variational practice of that kind could be called (to borrow the felicitous term Rafael Lozano-Hemmer applies to his own approach to interactive art) a *relational architecture* (Massumi 2000). A relational architecture is oriented toward the disseminating end of things, toward potential expansion, but is anti-institutional. It unsettles. It pushes the dispositional envelope of the processual continuum just mentioned.

That's the angle from which I would encourage a rethinking of interactive art—from the premise that its vocation is to construct a situation or go into an existing situation, and open it into a relational architecture. Ways of doing that, the nuts and bolts of making potential reappear, are what Erin Manning and I in our collaborative work call *techniques of relation* (Manning 2009b, 42, 86–93, 105; Manning and Massumi, forthcoming b). The techniques of existence discussed throughout this book are techniques of relation. We use the word technique in a sense inspired by Gilbert Simondon, whose account of technical invention is couched in similar terms of emergent relational potential and becoming, in a way that places the technical object and art in the same orbit without reducing one to the other (Simondon 1989, 179–201). The difference, of course, is that the regulatory principles of the technical process in the narrow sense are utility and salability, profit-generating ability. Art claims the right to have no manifest utility, no use-value, and in many cases even no exchange-value. At its best, it has *event-value*.

This is precisely what makes art political, in its own way. It can push further to the indeterminate but relationally potentialized fringes of existing situations, beyond the limits of current framings or regulatory principles. Aesthetic politics is an exploratory politics of invention, unbound, unsubordinated to external finalities. It is the suspensive aspect of it that gives it this freedom. The suspension of the most available potentials, the potentials already most comfortably embodied, well housed and usefully institutionalized gives a chance for more far-fetched potentials to ripple up. Aesthetic politics is "autonomous" in the sense that it has its own

momentum, it isn't beholden to external finalities. It bootstraps itself on its own in-built tendencies. It creates its own motive force in the dynamic form in which it appears. Practices that explicitly define themselves as political and do not claim the artistic label can be characterized as aesthetic politics to the extent that they similarly strive to bootstrap far-fetching event-value and make it really, tendentially appear in a present situation. This kind of practice has been with us, not continuously but in drops and smudges, since at least the Situationists, and it gained new momentum in our own time in the antiglobalization movement post-Seattle.

Artistic practices that explicitly attempt to be political often fail at it, because they construe being political as having political content, when what counts is the dynamic form. An art practice can be aesthetically political, inventive of new life potentials, of new potential forms of life, and have no overtly political content. I would go so far as to say that it is the exception that art with overtly political content is political in the sense I'm talking about here. When it is, it's because care has been taken not only to make sense but to make semblance, to make the making-sense experientially appear, in a dynamic form that takes a potential-pushing distance on its own particular content.

The work of Natalie Jeremijenko and the Bureau of Inverse Technology stands out in this regard. In recent interactive projects, Jeremijenko has attempted to not only to encourage participants to reflect on environmental issues, focusing in this case on human-animal relations, but she has used the interactions to slip participants into perceiving, in one case, like a fish. The ideational content was doubled by a perceptual becoming. The thinking-feeling-like-a-fish was the semblance in the situation, pointing beyond it. A quality of experience was built in that could potentially lead to thoughts, sensations, and further perceptions that might fold out, toward follow-on in other situations that neither the participants nor the artist could foresee (never having been an environmentally aware fish before).

An aesthetic politics defies the law of the conservation of energy. It can get more creative energy out of a situation than it puts into it. It's inventive in a more radical way than a technical invention in the usual narrow sense. It's not the gadgetry or setup that's creative, even if nothing like it has ever been seen before. The setup is creative to the extent that an emergent experience takes off from it that has its own distinctive lived quality, and because of that its own self-differing momentum.

**V2**  It's quite a stretch to go from a decorative motif to a worldwide political movement, not to mention human fish. Some might accuse you of explanatory overkill. For one thing, all of the main examples you've given are visual. One orientation that is almost universally shared in new media art is a turning away from the visual in favor of the tactile or haptic. This is considered a political gesture because the visual has long been critiqued as a form of dominance under the name ocularcentrism. How does the perspective you're advancing position itself with respect to that? How can you generalize from simple visual examples to interactive art that tries to access other dimensions of the body, against the domination of vision?

**BM**  Vision has gotten bad press. When people talk about the visual, what they are actually talking about is almost always a certain mode of what in perception studies is called cross-modal transfer—a certain way that different senses interoperate. How, for example, does classical perspective painting create an experience of depth? By composing lines and colors in such a way as to trigger a direct experience of the potential I was talking about in relation to object awareness in so-called natural perception: the potential to advance, move around, bring backsides into view, and touch. This is a direct *visual* experience. But vision has been crafted in such a way as to wrap potential kinesthesias and tactilities *into itself*. It's a semblance, just as the object itself was, but with the objective potential suspended, because you can't actually advance and touch. It's object-perception, without the object. The object was already an abstraction, in the sense that what made it appear as an object and not a one-sided surface was what didn't appear, or only virtually appeared—the relays to other sensings. Perspective painting doesn't "trick" object-perception. It activates it otherwise. The experience of depth is not an optical "illusion." It's a real experience of depth, minus the depth. The experience of depth has been made to take off from its usual experiential framing and enter a different frame.

What perspective painting does is tap into the abstraction already at the basis of object perception, and carry it to a higher power, where the object itself, and not only touchings of it and movings-around it, are abstracted, that is to say, really appear virtually, in pure appearance. That pure appearance occurs *through* an actual object—the canvas, frame, and pigment setup. But the painting as actual object in its own right disappears into the abstraction it taps. When you are experiencing painted depth, you aren't looking at a canvas, you are seeing a scene. You're seeing *through* the canvas

into an abstraction that has taken off from it, and is a qualitatively different perceptual event. Your perception has been siphoned into the semblance, the canvas's ghostly perceptual double. The semblance can't happen without a perch in objecthood. But when it happens, it is in uncanny excess of actual objectivity. Of course the uncanniness effect weakens with time, as people's perception habituates. At first, it is directly apparent, and not only that, it hits like a force—think of the first cinematic images that had audiences fleeing before the virtual advance of a train. A semblance isn't just like a force. Its "likeness" *is* a force, an abstract force of life. Lumière's moving images were literally capable of launching live bodies into flight.

The force of the semblance can be seized upon and made use of. It is no accident that the development of perspective painting was associated with the rise of court society. The "aura" of it was seized upon and used to heighten the prestige-value of the monarchy at a time when it was evolving in certain parts of Europe toward absolutism. The aesthetic event-value was captured by that political formation and translated into political prestige-value. The semblance that took off from the framed canvas was reframed by the court institution, which gave it an abstract function integral to its own dynamic system.

Photography also lent the aura to reframings of value. The photographic semblance came at a time when production and consumption were being privatized. It was used to transfer the royal "aura" of painting to the private capitalist citizen as pillar of the new civil society. Photographic portraiture could make visible, no longer the *social* prestige-value that attached to the private bourgeois individual in its public role. This was just a brief way station, because the semblance was already migrating again, thanks in large part to the new traffic in images photography made possible, into the magic of the marketed commodity object (Benjamin 1999a, 2003). What is the ghostly force of Marx's "commodity fetishism" if not a semblance of life lived through consumer artifacts? There is still a kind of aura to it: a kind of *personal* capitalist prestige-value that rubs off on the purchasing privatized individual, down to the most banal details of its everyday life. The aura of the life banal. The art of cool. Or in a more mainstream vein, lifestyle marketing.

But there is always a residue of semblant potential left after any and all of its captures. Semblant potential is singularly, generically inexhaustible.

The residual force of the photographic semblance is what Roland Barthes called the "punctum," which he describes in terms of an uncanny sensation of the lived quality of a perished life surviving that life (Barthes 1988). The punctum for Barthes is an affective force that makes the photo breathe with a feeling of life, *a* life, in all the singularity of its having had no choice but to follow the generic life path toward death in its own unique and unreproducible way. It's not about the content of the life per se or about psychological associations that a memento of it might arouse in the observer, it's not really even about grief. It's about the affective commotion of a direct, immediate, uncanny thinking-feeling of the dynamic quality of a life no more. The punctum is the appearance through the photo of an affective afterlife. It is the strike of a life as a force, beyond an actual life, In other words, as abstracted from it, as a real but abstract force of life-likeness.

The point is that art is in inventive *continuity with* natural perception. Every art object works by tapping into a certain aspect of "natural" perception in order to reabstract it, so that some actual potentials that were there are suspended while others that tended not to appear before, or even had never appeared before, are brought out. The new potentials can be captured and reframed, and even given functions, political, social, personal, or economic. They can also escape capture—in fact there is always a residue that does—in which case they appear as political, social, personal, or economic *resistance* to whatever external finalities and functional reframings hold sway (even death). The point here is that none of this is about a tricking of perception. It's about a continuing *expression* of its evolving potentials. Art isn't about "illusion." That's not what "semblance" means (although Langer herself uses the terms interchangeably). Art is about constructing arti*facts*—crafted *facts* of experience. The fact of the matter is that experiential potentials are brought to evolutionary expression.

Perspective painting makes the spatial 3D quality of experience into a purely visual matter of fact. In aesthetic philosophy, in Alois Riegl and Wilhelm Worringer, the word "haptic" doesn't mean touch. It refers to touch as it appears virtually in vision—touch as it can only be *seen*. Any practice of abstraction operates on all the senses at the same time, virtualizing some in order to heighten others with the abstract force of what then doesn't actually appear. Experience is a continuum. All its dimensions are always all there, only differently abstracted, in different

actual-virtual configurations, expressing different distributions of potentials. The actual-virtual configuration itself always appears, in the form of an experiential quality or "likeness"—objectness for "natural perception," an objective spaciness without actual objects for perspective painting, a certain animation without actual life for decorative motif, and after actual life for photography, at least of a certain kind at a certain stage of its cultural history.

**V2**  If a semblance can be given a function, doesn't that contradict its "autonomy"? What you've just said about the political function of perspective painting, for example, seems to corroborate the critiques of vision I mentioned.

**BM**  I'm not at all denying that perceptual artifacts lend themselves to regimes of power, or envelop in themselves power potentials as well as powers of resistance. What I'm saying is that they can do this *because* of their autonomy, as an effect of it. I mentioned before that a semblance in itself is a kind of "living-in" of potential, in the sense of holding life potential in immanence—wholly immanent to the semblance's appearance. How can a framed picture presenting a fragment of a scene hold a wholeness of potential in it? By including what doesn't actually appear, but that is necessarily involved in the thinking-feeling of what does. A semblance is a *form of inclusion* of what exceeds the artifact's actuality. That's Leibniz's monadic principle. Leibniz's monads are not "closed" in the sense that they are limited. They're closed because they're saturated, because they hold within themselves their own infinity. There's just no room for any more. They have their own "moreness," in how they potentially continue, how they self-distance, stretch themselves further than they presently go. A monad is the semblance of a *world*. It is the worldly way in which, in Whitehead's words, each thing "essentially involves its own connection to the universe of other things . . . an infinitude of alternative potentialities" (Whitehead 1968, 66). The monadism of a semblance is the way a thing includes its outside in itself. The semblance is a *little absolute* of "immediately given relation," as James puts it (James 1996b, 280). The great absolute is the Hegelian totality of self-sameness that "includes its own other" (1996b, 271) in its all-encompassing self-identity. In contrast, the little absolute includes its own other in such a way that its identity "telescopes and diffuses into other reals" (1996b, 272). It includes its own others

dispositionally, "doubling monadology with a nomadology" (Deleuze 1993, 137, translation modified). The little absolute is not so much closed as it is virtually in-folding and out-folding. This makes it a fragmentary totality, because it folds from its own singular perspective, and the "others" that it includes reciprocally include it, equally telescoped and diffused into *their* singular worldy perspectives. The telescopings and diffusings don't overlap perfectly. They don't fit harmoniously together. They are incommensurably mutually including. Each semblance is a world-fragment including all the others from its own perspective. This makes the universe they reciprocally compose a co-construct organized according to what Guattari calls a principle of "transmonadism" (Guattari, 1995, 112-116). Benjamin, in his own transmonadic vocabulary, says that the semblance is a "smallest totality" (Benjamin 1996c, 225). An artwork, understood in terms of its semblance, is a whole relational world, in the transmonadic sense of being a "little absolute" dispositionally expressing "an infinitude of alternative potentialities."

There is always a specific device or mechanism that is integral to the structuring of the artwork that operates the transmonadic inclusion and makes the artifact world-like in its own unique way. In Barthes's account of photography, the mechanism is the punctum and its way of including in the portrait the dynamic wholeness of a life-world including its own afterlife. In perspective painting, it's the vanishing point.

The vanishing point is how the scene's continuing into its own distance appears. What is *in* the distance doesn't appear. The vanishing point is not more content. It is where the content of the scene fades out into the distance. The distance *itself* appears, through the fading. But the fading-out doesn't even have to be painted in. It can be included in the painting without actually being painted, through the way the painting projects the eye into an abstract distance. The distance doesn't have to be painted, because it can be lived, by the eyes. This is achieved in perspective technique by a compositional principle that follows rules of geometric projection. The composition of the painting is guided by a geometry of parallel lines projecting infinitely toward the vanishing point, in whose virtual distance they appear to converge. This produces a virtual visual movement, not unlike the movement I described in decorative motif. Except in this case, the movement doesn't appear for itself, it appears for the geometric order that produced it. It doesn't take off in its own right, it falls back into

its abstract cause. What we see is not so much the movement. Through the virtual visual movement, we see the scene with a feeling of the regularity of its geometry. We can't see the artwork's content without thinking-feeling its spatial *order*. Without producing it for our own experience of the scene. Perspective painting *spatializes* the visual movement it creates in order to produce a perceived order. The harmony and regularity of this perceived spatial order continues infinitely into the distance at the virtual center of the vanishing point. But it also radiates. It circles back from the virtual center, around to the outside of the frame. The scene is centered on the infinity of its spatial order, and is also fringed by it. It is immersed in it. The artwork is actually bounded by the frame, but its scene is virtually unlimited. It's the semblance of a world, bounded *and* unlimited. The semblance is also in a sense closed, but not spatially. It closes the world's constitutive variety on principle: the principle of a single, infinite order of harmony and regularity.[3]

The only sense in which a semblance is an "illusion" is when, as in this case, the "immediately given relation" it expresses finds principled closure in an unlimited harmony of order—in spite of the partiality and incommensurability betokened by its individual framing. Benjamin (1996b, 283) calls a semblance that contrives to make a universal harmonic order effectively appear a "beautiful semblance." A beautiful semblance is one purporting to offer a transparent window onto a great absolute. A beautiful semblance "quivers" with the tension of this pretention to greatnesss. The tension is such that the moment its harmony is "disrupted" or "interrupted," it "shatters" into fragments. It then shows itself to have been all along but a "smallest totality"—like each of its infinitely included other-worlds whose status as real alternate potentialities has been effectively "veiled" by the apparent harmony of its virtually unlimited order (Benjamin 1996c, 224–225; Benjamin 2002, 137).

Pragmatically, the individual framing of the painting allows it, and its virtually unlimited order, to be inserted inside another frame. The painting is hung on the wall of the royal court. As a world-fragment in-spite-of-itself, it has no *actual* connection to this other world of the court. After all, its geometric order of harmonious connection is virtual, a beautiful semblance. But its insertion into the larger frame of the royal court makes its principle of universal order appear within that frame as well. Not uncoincidentally, the absolute monarchy aspires on its own behalf to just this

principle of an infinitely radiating harmonious order, as regular and uni-
versal as geometry. Like painting, like realm. The all-seeing eye of the
absolute monarch is the vanishing point of the kingdom. It is the abstract
(god-like) cause of the ordered space of the realm, infinite by rights. The
king's body is the preeminent body whose virtual movements constitute
the macro-order of the glorious whole of the realm. The space of the paint-
ing and the space of the realm are analogs of each other. They don't
connect in any direct way. They don't actually connect. There is an
unbridgeable reality-gap between them. They are actually incommensu-
rable. One is a painting, the other a realm. They have different qualitative
natures, operate at different scales, have different contents and compo-
nents, and are put together differently. Actually, they are in a *relation of
nonrelation*. Yet they produce, each in its own way, a semblance of the same
order. Where they do overlap is at their virtual centers—their vanishing
points coincide. The vanishing point only has an abstract or formal exis-
tence, because what it contains never appears. It's the form in which what
doesn't actually appear appears. Except it isn't even actually a form, it's a
form of abstraction, an abstract fading away, the appearing of a disappear-
ing into the distance that folds the distance in, most harmoniously. The
painting and the court enact the same form of abstraction, across their
differences in scale, content, and components. They are different revolving
around the same virtual center, which is immanent to both of them, the
vanishing point where they each live themselves in. They coincide purely
abstractly, at the very point at which they are immanent *to themselves*.

Remember that the vanishing point makes the perspectival artwork self-
embracing as a whole. This makes it the semblance of a harmonious world,
even though the scene it contains is actually partial. It is a self-embracing
harmonious whole because the spatial ordering doesn't fade out with the
actually perceptible contents. Quite the reverse, the fading-out of the
content makes the order come back around, to complete a circuit. The
spatial order wraps back around to surround the fringes of the frame, giving
a definite present a boundary to the infinity it holds. This offsets the infin-
ity of the world of the painting from its immediate surroundings. As a
result, it enjoys a self-embracing autonomy from what's actually around
it. The same goes for the kingdom: it is an infinitely self-embracing order
that is nevertheless offset from other kingdoms around it, and from other
political formations (even if they share the same actual territory, as with

the budding bourgeoisie that was already beginning to bubble up, in what Marx called the "pores" of soon-to-be ancien régime—in the gaps created by its self-distancing).

The frame that the royal court gives itself is sovereignty. Since sovereignty's order is in principle unlimited, the monarchy is always trying to actually live-up to the principle it virtually lives-in. It tries to expand its boundaries to actually include as much space as possible, to translate virtual expansiveness into actual expansion. Translated into expansionism, into an actual political dynamic, the sovereign framing turns imperialist. If the expansion is interrupted, so that sovereignty is forced to fall back within a particular territorial frame, then the god-like pretension to universal order turns totalitarian. A whole political ecology that will come to play itself out historically in a range of actually existing State formations turns out to have been virtually included in the immediately given relation-of-nonrelation absolutely centering each successive framing.

Perspective painting includes in its frame the same potential as gets played out in the absolutist empire. Nevertheless, there is nothing in the painting that makes a destiny of empire or totalitarianism. The very same dynamic can, and later did, scale down to the scale of the human body, which then appeared as what has been critiqued in political philosophy as the "legislating subject." This is the individual as sovereign of himself, king in the castle of his own body—and pillar of bourgeois democracy, as a kind of democratic absolutism. We see continuations of this in the concept of "sacred" human rights and "inalienable" personal freedom. All of this was recognized in a way by the critique of "ocularcentrism," which was particularly strong in the 1980s, when sovereign-individual freedoms started to be chipped away at by an emergent neoconservatism, centrally concerned with a latter-day State sovereignty of its own singular brand (Massumi 2009). Every monadic framing contains many destinies, transmonadically, if only in spite of itself.

I said awhile back that it is no accident that perspective painting emerged at the time the absolute monarchy was taking shape. Well, it *was* an accident, an historical accident, even though in another way they were made for each other. You can't say that one actually caused the other. Each has its own formation. They may have been in symbiosis for awhile and mutually reinforced each other, but that was the result of an encounter. It wasn't a destiny. There is no reason why it *should* have happened. It could

very well not have happened, even with all the necessary conditions in place, even with the potential readily available. That it happened was an event, an encounter, an accident. That's precisely what makes it historical. But it was an accident that was *sustained*. Their entering into cooperation was an accident *and* an achievement. Hard work and much technique went into sustaining the encounter, into holding them together: a system of court patronage of artists, an educating of court society and the larger society, a cultivating of taste, an adaptation of architecture to house the artworks implicated in the encounter (the Louvre being the case in point), new institutions (to give another example from France, the Academy). They were not so much connected to each other as they entered into the same zone of operative proximity capable of holding them together analogically, and of giving that holding-together a function. They "quivered" together in the same transmonadic field.

The reason they were made for each other is that sharing the same principle of order put them intensely into "resonance," as Deleuze and Guattari would put it. They connected abstractly, in analog offset, at the virtual center where their immanence to themselves appeared. The virtual center is like a black hole. It sucks everything in, but still emanates a certain energy. For example, the vanishing point in painting takes the whole scene in. But across the variations in painted content, it can also leak something back out. Not a thing, but an abstract quality.

Landscape painting, repeated and varied, gave the perspectival spatial order an *ethos*. It gave the purely geometric ordering of perspective space an *inhabited* quality. The semblance came to be virtual home to a people. An inhabited quality is just what a realm wants, if it is going to try to unite its people and not only try to expand its territory. It's an attractive quality for a kingdom, for reasons all its own. The imperial monarchy was predisposed to take that same quality into itself, to make it its own, to interpret it, in the sense of producing its own effective analog of it, in its own political world. As was totalitarianism, differently. And bourgeois democracy, differently again. There was no necessary causal connection in any usual sense of the word between perspective painting and the imperial monarchy. There was more an affective impetus—an autonomous "want" in the kingdom—that happened to echo with a qualitative spin-off effect of painting practice. The want was not an expression of a lack, but rather of the empire's striving or tending to sustain and expand its world-saturation.

It was an expression of its dynamic fullness with itself. It's what Spinoza would call "conatus." The formations communicated with each other through the abstract coupling of an affect with an effect, which because of its abstract qualitative nature could not be touched by any actually present cause. Simondon calls the kind of analog contagion between different but resonating formations of which this an example *transduction* in order to distinguish it from linear causality, with its ban on action at a distance and its presumption of actual, local, part-to-part connection (Simondon 2005, 31–33, 107–110 and passim).

Formations communicate only *immanently*, at the points where they live themselves in, or at their self-embracing fringes. They only virtually relate. All relation is virtual. Earlier, when I was talking about how vision related to the other senses, I ended up having to say that vision is virtual. It is only because relation is virtual that there is any freedom or creativity in the world. If formations were in actual causal connection, how they effectively connect would be completely determined. They might *interact*, but they would not creatively relate. There would be no gap in the chain of connection for anything new to emerge from and pass contagiously across. There'd be no margin of creative indeterminacy. No wriggle room. Or to borrow Whitehead's expression, there'd be no "elbow room" in the world (Whitehead 1967a, 195). The idea that all connection and communication is immanent, that there is no actual relation, is at the heart of Whitehead's philosophy. He calls it the "contemporary independence of actual occasions" (Whitehead 1967a, 195–199). He says that all formations cohabiting the present are completely autonomous in relation to each other. They are absolute in that sense. Pure monadic appearances (1967a, 177). Semblances. World-fragments. Drops of experience. Little absolutes. Each begins at a nonconscious, micro-experiential level. At this incipient level, the coming experience is *affectively* potentialized to unfold. It unfolds, singularly, in its "sheer individuality" (1967a, 177), from an immanent affective relation to other occasions. Drops of experience overlap in affect. An example he gives is anger (1967a, 183–184).

How, he asks, does an angry person know he's angry the next moment, even if it's just a half-second later? He isn't reflecting, he doesn't conclude that he's angry. He just is, still. He finds himself still *in* his anger. The anger is the in-ness of that moment, as it was the in-ness of the preceding

moment, and the two moments connect and communicate by overlapping in it. The affective tonality of anger is not the content of the moments. It's their shared in-ness, their mutual immanence. The angry content is the actual angry words and gestures that repeat and vary from one moment to the next. The anger was the qualitative vanishing point of the last moment, the angriness it trailed out in, and in which the next moment naturally found itself, with no perceptible transition. It's like an experiential dissolve. There's no determinate transition in a dissolve, just a continuous fading-out overlapping with a continuous fading-in. The point at which the changeover occurs is imperceptible by nature. It is purely abstract. But it must have happened. We know it did, because even if it wasn't perceived, it was unmistakably felt. Known-felt, thought-felt. It's a virtual affective event. The thought-felt continuity of the anger is the virtual event of an unperceived background continuity leading from one moment (or occasion) to the next. The anger doesn't determine what happens one-to-one, specific cause to linear effect. This "affective tone" (Whitehead 1967a, 176) is not a cause in that sense. It's a carry-over. What it does is carry-across the qualitative nature of what happens. It gives an abstract, purely qualitative background continuity to the two moments. The actual words spoken may skip. To the extent that they're angry words, it's almost assured that they will, they won't logically connect from one moment to the next. That's in the nature of angry words. The angry gestures will also be staccato. That's also their nature. It's their defining quality. What is actually said and done from one moment to the next is discontinuous by nature. But something continues, thought-felt across the gaps. In Whitehead's words, it's a "nonsensuous perception," a virtual perception of "the immediate past as surviving to be again lived through in the present" (Whitehead 1967a, 182). Every situation, whatever its lived tonality, is sundered by these nonsensuously lived micro-intervals filled only qualitatively and abstractly by affect. Like the vanishing point, they wrap back around to surround. What Whitehead calls affective tonality is something we find ourselves in, rather than finding in ourselves. An embracing atmosphere that is also at the very heart of what happens because it qualifies the overall feel. Affective tonality is what we normally call a "mood" (Whitehead 1967a, 246). As Gilbert Ryle says, moods are the weather patterns of our experience. They're not actual contents of it (Ryle

1949, 83, 96, 99). The contents are precipitation. A rain of words and gestures in the micro-climate that is life at this moment, coming in drops.

The discontinuity inevitably gets smoothed over. The attending-to affordance that I talked about earlier is one way it gets smoothed over. Use-oriented or behavioral focus on the flow of action translates the immanent overlap of experiences into an external relay from one action to the next. It translates the qualitative continuity of affect at the incipient micro-experiential level onto the conscious macro-level of objective interaction. Immanent relation is overlaid by the appearance of an actual connection. This occurs on an instrumental level forgetful of the nonsensuous perception at the heart of all experience. The virtual continuity *in* the gaps is arced over by what purports to be an actual continuity *across* the gaps. The monadic discontinuity between drops of experience is bridged over by a sense of interactivity that functionally passes over it, which is to say, passes it over.

*Narrative* is another powerful device by which the actual discontinuity between drops of experience is passed over. Interactivity involves a functional macro-continuity. Narrative produces a verbal meta-continuity. The angry words will be explained, justified, rationalized, excused, given cause and made understandable, smoothed over. It's fictional. And it's palliative. It takes the edge off. It glosses things over after the fact. It's "meta" in the etymological sense of "after." It's retrospective, operating on the level of conscious revision. This can be going on on a parallel track in the moment, like a revisory verbal echo of the perceptual déjà vu of the semblance. Narrative linguistically doubles experience's perceptual doubling of itself, and can do this with the same immediacy. A self-storied semblance. The self-storying reframes the event for ready insertion in the larger operative envelope of socially regulated discourse. This glossing makes sense of the semblance.

Of course, this isn't the only way in which language can function in art. It has many nonnarrative modalities—the phatic and the performative to mention just two—that operate in the immediacy of experience and can be taken up with art. These modalities may underlie sensemaking, as the phatic does. Or they undermine it. They may suspend it in order to cleave it asunder—"make language itself stutter," as Deleuze was fond of saying (Deleuze 1997, 15, 107–114). Or like the performative, they may operate within language in an asignifying manner, to make things happen

on other, nonlinguistic levels. These modalities may fuse together or relay each other.

Without going further into the language question, the important point for the moment is that Whitehead writes actual interaction out of "reality," which he identifies with the "real potentiality" from which an experience emerges (Whitehead 1967a, 179). He's saying that in the final analysis, when you get into what really (virtually, immanently) happens, when you're thinking-feeling what is really (abstractly, nonsensuously) lived, there is no such thing as interaction. It has no reality, because there is no actual connection between things.

This requires adjusting the whole vocabulary we use to talk about "interactivity." We have to translate that concept into relational terms, as I was trying to do at the beginning of this conversation, so that when we say "interaction" we're saying "immanent relation," with all the adjustments that come along with that in the way we think about what things actually are, what their action really is, and how they communicate. For one thing, we shouldn't say "interaction" without thinking-feeling discontinuity. We will have to give the gaps between things, and from one moment to the next, their vital, virtual due. It is in those gaps that the reality of the situation is to be found. If we gloss over them, we are missing the thinking-feeling of what really happens.[4] We have to take a distance on the rhetoric of connectivity that has been so dominant in the areas of new media and new technology. We will have to treat connectivity as a narrative, a metafictional revisionism. To call something fictional is not to say that it is useless or unreal in the sense of being purely an illusion. "In one sense," Whitehead writes, "everything is 'real,' according to its own category of being . . . 'to be something' is to be discoverable as a factor in the analysis of some actuality" (1967a, 197). The macro-continuity of interactivity shored up by the rhetoric of connectivity is indeed "discoverable as a factor in the analysis" new media actualities. It is a functionally effective fiction. One of the things its functioning does is to pass over the full spectrum of potential in the situations it organizes. It is not unreal in the sense that it does nothing. It just does otherwise than appears. The point is that connectivity and interactivity appear differently against the background of their virtual, Whiteheadian reality of immanent, affective continuity. (I should mention that Whitehead would not say "virtual." He use the terms "pure potentiality" where Deleuze would say "virtual" and "real

potentiality" for the virtual as it makes ingress into an actual occasion. For more on the way Deleuze charts his own vocabulary of virtuality, potential, and possibility into Whitehead's—which is too complex to do justice to here—see 1993, 79–80.)[5]

At any rate, there's an ethics and a politics of creativity contained in Whitehead's notion of contemporary independence that I think are important to explore. They lead in very different directions from the ethical and political orientations we've inherited from that other notion of autonomy native to our time, the idea of sovereign-individual freedom. That kind of autonomy seems to be presupposed not only by liberalism, but by many of the "radical" politics that interactive art often aligns itself with. The main project of the aesthetic politics I'm talking about would be to rethink autonomy in qualitatively relational terms. It would be an affective politics, more about seeding exploratory weather patterns than cultivating their determinate contents, the particular ideas or behaviors that will be performed.

**V2** Can you make this a bit more concrete as regards interactive art? We're still essentially in painting and in the visual. Can you give an example from interactive art?

**BM** OK, but give me a minute to work myself out of the vanishing point, which has taken over a bit. As I was saying, classical figurative painting employing perspective technique renders the abstract movement of perception as a spatial order governed by a universal principle ensuring harmony between perspectives. What shows-through the dynamic of this perceptual event is a spatial order that is as harmonious as it is unlimited. Its intimations of harmony seem to promise stability (although in the historical playing out of its principle in political ecology, what it delivers is far from it). The vitality affect of the perceptual event taking place is settling, pacifying, "civilizing." This is why it feels more "concrete" or "realistic" than later painting that claims for itself the explicit label of "abstract" art. In art, concrete and realistic mean appearing with the feeling of a stable perceptual order that lends itself to analogue capture by larger frames of social or political orders that promote stability as a conservative value, even though they are incapable of delivering on it, given the reality of the transmonadic "quiver" at the heart of every formation. Given the virtual agitation tensing the "chaosmic umbilicus" of its affective core

(Guattari 1995, 112). Given the Benjaminian disruptions and interruptions this lived-in tension, this lived intensity, immanently invites from outside, in the way it includes within itself its own-others that inhabit it as infinite alternative potentialites. The point is, we should be wary of calls for a return to the "concrete."

Decorative motif, for its part, is in no way radical. But it also has less potential for order-bound capture. That's why decorative art is considered fluff. It doesn't have that kind of potential because its motifs don't extensively spatialize, they don't spin off an extensive order that continues beyond the fringe, wraps back around, and strongly resonates with a political ecology of potential. It restricts itself to producing a movement-effect that is pretty much content to be how it is, where it is. Its effect is anodyne because the vitality affect it produces takes off from patterns of line and curve that in their actual form are figurative of determinate things likes leaves and branches and flowers. There is still a gentle uncanniness to the effect, which consists in an animation of the inanimate support on which the motif moves. But flowers coming to a semblance of life on the lace of a tea cozy are not the most disruptive or potentiating of things.

Abstract art, on the other hand, was and continues to be just the kind of disruption that figurative art was always afraid of, in its quivering heart of hearts. Abstract art is dissonant, dissensual, incommensurable. It's eternally popular to hate it. Even those who like it seem only to disagree about it. We interpret it in combatively disparate ways that never seem to find a common ground of judgment. No semblance of a universal principle of harmonious order here. The works punchily affirm the fragmentary nature of their worlding. They are interruptive in their own right, and proud of it.

Paradoxically, abstract art is disruptive in a way that, from the point of view of the quality of perceptual event that gets mobilized, places it in a kinship with the decorative art it often belittles. It also produces out and out movement-effect—and even takes that further. It is not disruptive, interruptive, dissonant because it brings threatening things to a semblance of life instead of anodyne ones. It is because it draws its experiential power from suppressing the figurative element as much as possible. It makes felt a dynamic, a vitality affect, that has no object. It's not an animation *of* anything. It's a pure animateness, a vitality affect that comes from no thing and nowhere in particular.

For example, in color field painting, the movement is dispersed across the surface. It is an irreducibly global effect that detaches from the surface, appearing to float above or across the canvas, like its ghostly double. You're not seeing the work if you're not seeing this lively immaterial double of it. It has this effect as an expression of its immanent relationality. What is being activated are certain relational dynamics of color—effects of simultaneous contrast and color complementarity, for example. These are relational dynamics immanent to vision, and productive of it. They are the normally unperceived activity constitutive of vision itself. What is being brought out is a perceptual energy that goes unseen even as it makes seeing happen. This is art going back to the conditions of emergence of object-perception, and bringing those conditions to visible expression. It's the production of a semblance of seeing itself, as it happens—a perception of perception in the making. This brings out the self-referential dimension of perception that I talked about earlier. It lives-vision-in in a totally different way than perspective painting does, without the projective aspect. Rather than projecting perception into an order of different dimensions from those of vision (the three infinitely extending dimensions of geometric space), and rather than projecting these dimensions into an analogical symbiosis with other orders (such a sovereignty), it brings out the dimensions proper to vision as such—dimensions that *only* live in vision. Touch can also do lines. Empire can also be expansive and extend its order all around. Color is something only vision can do. It brings these properly visual dimensions out as it lives them in. It brings them out and makes them float, in their own optical take-off effect. There's a tension between a sinking into the dynamic center of vision, from which it emerges, and a floating off from the surface of emergence. The painting visibly quivers. The effect can be a powerful visual feeling, a feeling of seeing sight caught in its own intensive act. The thinking-feeling of vision as it happens. This appearing for itself of an immanent activity, intensely going nowhere, is dizzying.[6] Abstract art dizzies vision, not unlike the way Deleuze says modern literature stutters language. It dizzies vision by returning it to its movement-potential while refusing to give that potential an actual outlet feeding it into other existing formations. It strives *not* to participate in political ecology in any conventional, harmoniously symbiotic way. Of course, this in itself is a political act of a certain kind. The slogan "art for art's sake" should be understood in this light, as an affirmation of the

autonomy of art in the sense discussed it earlier: not beholden to external finalities, bootstrapping itself on its own in-dwelt tendencies.

People often talk about the movement-feeling produced in art as "haptic" feeling (Marks 2002). I don't agree. It's overgeneralizing. It's not paying sufficient attention to the composition of the experience. The suppression of the object-like in practices of abstraction like color field painting also suppresses the uptake of tactility into vision. The other sense that virtually appears in dynamic visual form is kinesthesia, the feeling of movement.[7] Abstract art recomposes the senses. It composes perception with a different experiential palette than either perspective painting or decorative art, which, as I said earlier, takes up a certain tactility in its movement-effect. Here, there is a purely optical kinesthesia that can only be seen, and only that. Athough on the other hand, texture alone is enough to retain a touch of objectness. As we also saw earlier, where one modality of perception is present, so are all the rest . . . it's a question of modes of composition and degrees of virtuality. The question has to be reexamined in each case to evaluate the nature of the recomposition. We should be careful not to generalize, but rather always reevaluate, attuned to the singularity of the work. It is all too easy to settle on a quick half answer, like saying that the haptic is about touch taking priority over vision. The haptic is about touch as *only* vision can make it appear, just like color field painting is about doing kinesthesia as only vision can. Texture is an example of haptic vision: you immediately *see* how it feels.

The perceptual self-referentiality of abstract painting as a thinking-feeling of vision-as-it-happens makes it, in itself, proudly useless. So what kind of aesthetic politics can come out of it? Is there any way that it can come out of itself, in resonance with other relational dynamics?

I think of the work of Robert Irwin as showing a way. His work has always been concerned with staging what he himself calls the perception of perception. In the early period, he practiced abstract art that created subtle, whole-field movement from arrays of dots (Weschler 1982, 85–97). As in all his work, the effect takes time to set in, but when it does it is absolutely scintillating. It's less an out and out activity of vision than it is an *activation* of it. It's like vision vibrates with its own potential. Irwin then moved into a more sculptural practice involving disks mounted on walls but lit in a way that their three-dimensionality disappears into a semblance of surface that retains a barely perceptible but extremely powerful, inwardly

activated feeling of depth (Weschler 1982, 98–109). More a depth-likeness than a depth per se. He was making the third spatial dimension rise to the surface and insist on its visuality, in a kind of becoming-painting of sculpture.

He then moved into installation. He moved off the wall into 3D space itself, but also out of the gallery, into architectural or even urban spaces (Weschler 1982, 110–114, 147–154, 168–175, 182–203). People normally call this kind of art "spatial" because of that. They think of it as more "concrete," more "real," than abstract painting and other gallery practices. It's not at all more concrete. It's actually another practice of high abstraction. It's not more real, it's differently real. That's why it's powerful as art. I have reservations about calling Irwin's installation work spatial art. He moved into inhabited space in order to make it become other, as he had done with sculpture. It was what Deleuze would call a "counteractualization" of spaces of inhabitation.

What Irwin made inhabited space become is a living *event*. He carefully, minutely, obsessively prepares the conditions of perception so that an activation event takes off from them. The whole space is doubled by a perceptual activation or vibration effect, like the one he achieved with the dot paintings and disk works. But this time, it's immersive. It's not immersive in a 3D way. It's like a diaphanous surface that's everywhere and nowhere at the same time, a dimensionless semblance of lived space. Dimensionless but somehow totally space-filling, saturating every atom. The effect is slow to come, a lot of people don't have the patience to let it come. When you do let it come, it takes over your whole being. You have an immersive thinking-feeling of what it's *like* to be alive in inhabited space, and only what *that's* like. It's a perception of the perception of lived space. And you're all in that perception, every thought, every movement, every shadow, every sound, each of them modulating the others, in immediate vibrational relation, in resonance. The resonance is all-embracing. Relationally self-framing. In a way that is only for the moment, uniquely taking off from and floating in that space. It's monadic. A world of perception unto itself. A self-embracing micro-climate of experience.

This is not interactive art. There is no interaction. You have to *stop* acting for the perceptual event to happen. It then wells up of its own volition. It takes you. You're in it. It's not in you. You live it in, rather than living it out. You don't go anywhere with it. It stays where it happened,

as its own event. It's an intensive experience, rather than an extension of it. This is an example of relational art that suspends all interaction.

When I said that what interactive art can do is take a situation as its "object," that it could live up to its potential by then cleaving the interactions it situated asunder, I meant something like this, but done with and through interactions. Not suspending them altogether, but opening micro-intervals in them, so that there is a rhythm of departure and return between nonsensuous perception of affective continuity on the one hand, and on the other hand actually emergent drops of narrativizable experience precipitating determinate words and instrumentalizable experience precipitating gestures. When I say this, I'm not endorsing Nicolas Bourriaud's way of talking about relational art. From my perspective, his "relational" remains too wed to notions of interaction understood in terms of mediated intersubjective exchange. I'm talking about *im*mediation, immediately lived relation (chapter 4).

I'm not trying to set up Irwin as a model either. I'm saying that his installation work moves to a non-interactive relational limit of art experience, and that interactive art can take that movement up in itself. I'm saying that Irwin's installation work is at an experiential limit or pole that can itself be put into resonance with another pole, at which experience has taken a certain distance on itself. The first pole is the living-in of relation, the second its living-out. Relation out-lived is subordinated to recognized makings-sense, the conduct of outwardly meaningful acts, action-reaction, instrumentation, function. Or if not so baldly to instrumentation, then still to mediation. And if not prosaically to function, then to intersubjective exchange mediated by instrumentation. The poles, however, can be *played off each other*, or play with each other, so that the work produces a lived quality all its own, doubles itself aesthetically in a semblance of itself, and at the same time actually does or tells something specific. The poles are not necessarily mutually exclusive. In fact, they always actually come together to some degree. Even in the most intensely lived-in art practice, there is a minimum of recognition, making-sense, instrumentation, and function necessary to enable the work to take off. A modicum of living-out is necessary for the work to occur.

Thought of in this way, art practice is a technique of composing potentials of existence, inventing experiential styles, coaxing new forms of life to emerge across polar differentials. Art is inventive, literally creative of

vitality affect. I said earlier it was a technique of existence, and I do mean "technique." To achieve any affective-effective composition requires the same kind of care, minute attention to detail, and obsessive experimentation in how the situation is set up or framed as Irwin is famous for. In Irwin's case, the framing is nonobjective. It's more a performance envelope than an objective frame. A dynamic or operative frame.

The poles of relation lived-in and lived-out cut across every experiential distinction we can make. Take the senses. Each sense constitutes a pole of experience in its own right. We can separate them out, recognizing when we are having a predominant experience of seeing rather than touching, for example, and conducting meaningful functions accordingly. We can also consciously reconnect them across their separation, as when we look at a tool and think about the best way of taking into our hand for our use. This is the sense-equivalent of interaction. It is sense-experience at the pole, or limit, at which it is lived-out interactively. Toward the beginning I talked about what in perception studies is called cross-modal transfer. The problem for using that concept as it figures in perception studies for understanding art practices as techniques of existence is that the distinction between sense interaction and sensed relation is not made. The way in which the senses are lived-in is not taken into account. I used the word "fusion" to talk about the event of sense-relation. I said an object was a cross-modal fusion. The idea was that potential touches and kinesthesias normally (habitually) built into the situation inhabit the event of vision. Feeling between these modes, we really, immediately see unseen aspects of the object's presence in that situation. The point I did not bring out into relief enough is that in the immediacy of that *between* of different senses, the experience is not *in* one sense mode *or* another. It is not, strictly speaking, cross-modal. It is *amodal*. The relational pole of sense experience is amodal (Massumi 2002, 169–171). Lived abstraction, lived in-most, is an immediacy of amodal living.

As art plays between the poles of interaction and relation, so do the senses. Experience is always approaching one of its limits. It is always on the way to separating them out so they can be usefully cross-connected, or fusing them together in amodal immediacy to each other. As experience approaches either limit, it automatically toggles to the other. It is all good and well for the senses to function. But if they want to *potentialize*, they have to fuse. Every time experience separates itself out, depolarizes itself,

it has to repolarize, in order to recharge itself with potential. There is a necessary return to the fusional pole doubling every separate-sense experience, and every cross-modal connection. This eternal return of experiential fusion habitually passes unnoticed. It is nonconscious. Art, practiced as Irwin practices it, as a technique of existence dedicated to the perception of perception, can nevertheless make it felt, in effect. Or make it "seen." It make felt the play between the relational limits of experience. By doing this, it can learn techniques for recharging itself. The reason for integrating the kinds of distinctions I've been making here into our thinking about art and into the making of art is to renew and intensify its potential.

The toggling back to the fusional-relational pole is most intensely felt a when the separating-out of the sense modes is taken to an extreme. This is when a sense is made to do *only* what it can do. At that limit of what it can do, its relational conditions of emergence appear, as if experience returned through a wormhole to the other end of its universe in no time at all. Fusion effects spark, but so much in no-time-at-all that the vitality affect, the most outstanding lived quality of the experiential event, is in another sense mode, lived-out the other side of the wormhole. Incidentally, it is in the wormhole that James's "pure experience" resides.

This is what I was talking about with kinesthesic and haptic vision: how they are pure *optical* appearances of other-sense qualities of life. What's potentially instructive for art is more how the senses inhabit each other, even at the acme of their separation, than any putative domination of one by the other. The senses are always also taking each other up, coming into and out of each other in one way or another, worming their way around (Massumi 2002, 144–176). They never function alone. What we call the ocularcentric "domination" of vision over the other senses is in fact a highly functionalized and systematized cross-modal connection between vision and touch. Look forth and grasp, and have toolful dominion over the earth . . . the real issue is not so much the supposed domination of vision, it's the excessive instrumentalization of its interaction with tactility. "Ocularcentrism" is a certain interacto-centrism, technoscientifically enhanced.

The senses only ever function together, fusionally, in differential contrast and coming-together. Although it is fair to call each sense a contrasting pole, it goes further to think in terms of contrasting wormhole poles of amodal fusion. At the extreme of every sense's separating-out, it reaches

an immanent limit where it flips into an immediate relation with other-sense experience. At the limit, the sense-poles of experience are in constant virtual contact. They are always already in resonance, aquiver together at an analogical distance from each other that makes a destiny of their co-variation as part of the same ecology of experience. The same thing applies for stable spatial ordering and disruptive eventness. Intensity of experience and extension of it. Perception and action. Object perception and sem-blance. Objective perception and perception of perception. Self-referencing and function. Immanent relation (of nonrelation) and extrinsic relation (connective interaction). Actual (sensuous) form and nonsensuous (amodal) perception. Vision and narrative revision. Site-specificity and disposition. Monadology and nomadology. These are not dualities. They are polarities, dynamic orientations in an abstract qualitative map of potential experi-ence. The map is always multi-polar. All of these contrasting modes virtu-ally map each other, ripple into each other, canceling each other out or combining and amplifying, cresting and troughing, for calm and for tur-bulence, for continuing and turning back in, for immanence and out-living. Any way it goes, we always live at a unique crossroads of them. Each moment is carried by the current of a singular-generic fusion of all of them, mutually foregrounded or backgrounded, active to varying inten-sity in the formative stir of the field of emergence of experience.

What I'm saying is that when an art practice carefully sets itself up, lays down the constraints that enable its own signature operation, it is selec-tively activating these poles, to varying degrees, and to different stand-out effect. In the vocabulary of the next chapter, when it composes itself in this way, art is "diagramming" livable relation. Each setup, each situational framing, will orient what happens more toward one end or the other of given polarities. It might, for example, bring narrativity out more than the affective in-whichness, or try to do both equally, superimposing them on each other or oscillating between them. Or it might favor instrumental interactivity more than making the relationalities conditioning it appear. It may fuse vision with tactility, or with kinesthesia, or spin one of them off from vision at vision's own immanent limit. Or it might be forcefully disruptive, and make felt jolting disjunctions between sense modes, for example between sound and sight. It might spatialize more than eventuate. It might tend to root in the site-specific, or fan out into a distributed

network. The possibilities are as infinite as existence. Art is a literal com-
posing of existential potentials. Life design.

The crux is in the technical laying down of operative parameters. In the
design of the performance envelope, or the enabling operative contraints
(Manning and Massumi, forthcoming b). If "anything goes," it's not art.
Because if anything can go, it does—the aesthetic effect just goes away,
dissipates. There is no dynamic form. Not even a semblance of a semblance
appears. This was a problem facing installation art, which struggled with
the temptation to pile everything in. If you do that, what you end up
with is . . . a pile, a mess. It's a problem again with interactive art, because
with digital technology you can connect anything to anything else. When
you leave the connective potential too open, you end up with the digital
equivalent of a mess. On the other hand, when you close it down too
much, you make it a game.

Deleuze used to say that life is an art of dosages. And the art of dosing
life with creative potential is one of creative subtraction (Deleuze and
Guattari 1987, 6, 21, 98–99). That goes for art as a whole, which as we've
seen is not separate from life even when it carefully appears to be. You
have to strategically subtract to activate an autonomous limit or fuse for
a situation. And you have to selectively fuse to sunder.

**V2**   Still no example.

**BM**   OK. One thing that's happening more and more in interactive art is
a fusing of vision with movement. This is operating at the same nexus
between visual dynamics and kinesthesia as Irwin's relational art does, but
in a very different way because there is in fact interaction. An example I
saw a couple of years ago was at a work-in-progress session at Sha Xin Wei's
Topological Media Lab, which works on responsive environment design.
One of the projects was by Michael Montanaro and Harry Smoak. The
concept was simple. There were two dancers going through a choreo-
graphed routine on stage in front of a large screen. A motion-sensing
camera analyzed their movement. When the movement reached a certain
qualitative threshold—a certain speed and density of gesture—a video
window opened up on the screen. But it wasn't at all like a Windows
window, thankfully. It was like a visual bubble that grew from nothing and
expanded. It was like vision was flowering out of the screen, expressing a
quality of movement, its speed and density, purely visually, in a sight that

Michael Montanaro, Harry Smoak, and Topological Media Lab, *Artaudian Lights*. Calligraphic video, structured light, experiment at movement, and responsive architecture workshop, TML, Montreal, Canada, 2006.

doubled the actual movement. It was a semblance of movement transducing it onto a different register of experience and into a differently dimensioned space, a surface. The translation was analogue, as all transduction is according to Simondon, even though technically it was digitally achieved, because what was expressed on the screen was a quality of the movement. A quality of the movement was made visible with and through the actual, digitally projected image of it. The screen also made otherwise perceptible another quality of movement—its rhythm. When the speed and density subsided, the vision bubble started to break apart at the edges, emanating micro-bubbles of vision, then collapsed into itself. You got a strong sense of thinking-feeling qualities of movement, and not just seeing bodies in movement and their images. This sensation doubled the technical connection between the bodies in movement and the movement on screen with a more encompassing semblance, a lived quality of the interaction underway, a semblance of the global situation. This is what I meant when I said

that the ins and outs of the interaction can fold back in *together* to produce a semblance of the whole interaction. Toni Dove's interactive project, *Spectropia*, works at this same perceptual nexus, between body-movement and its transduction on screen, but with the added dimension of cinematic narrative. She uses the narrative element, among other things, to translate the interaction into a participatory production of cinematic point of view and even cinematic time. It's all done with a conscious engagement with the "uncanniness" of the interaction—a very ambitious and exciting project in what interactive cinema can be.

**V2** In the dance example, the interaction is staged. There's the traditional theatrical separation between the performers and the audience. The interaction is only between the performers and the technology.

**BM** That's what the audience said. The project was strongly challenged because of that. People said it was politically bankrupt because it had no "real" interaction, and it embraced the stage space without attempting to network out of it. I think that criticism misses the point. It's that reductive idea about framing I mentioned awhile back—that the frame is reducible to the actual spatial parameters, and anything that appears within that frame has no relation to anything outside. It's the idea again of "elitist" art trying to be "autonomous" in the most obvious sense of the term. Why not accept for a moment the constraints that the artist has carefully built in, and see what you can feel with them? It may turn out to be autonomous in the way I redefined it—in a relation-of-nonrelation with other formations that might analogically "want" it and be able to capture and reframe it, so that it expands or contracts to fit other spaces and takes off from other conditions, where its effect could well be political. While it is true that the audience was not in on the interaction, they *were* in on the relation. You couldn't not see the relation between movement and vision being recomposed before your eyes. You felt the dancers making an actual sight of their bodies' imperceptible movement talents. Kinesthesia was not only fused with movement, it was like vision itself was emerging from it. Body vision. Kinesthesia was making vision appear in the bubble, and the bubble was making bodily qualities of movement appear—a double capture of vision by movement and movement by vision, in a unique composition. Why can't that experiential double capture of separate dimensions of experience lend itself to a double capture between the theatrical space

housing it and other spaces of interaction? Think of the way vision and movement are coupled so banally in the urban environment, subordinated to the maximum to functional circulation. What if this new composition of kinesthesia and vision were recomposed within an urban performance envelope? What might that do? Who or what might want that?

I don't know. The artist doesn't know. The audience didn't want to think about it. But that doesn't mean that the potential for a transduction of that kind wasn't effectively produced. Xin Wei, responding to the audience's critiques, said something I'm in complete agreement with. He said that the point of the Topological Media Lab was to do *speculative* work with technology. That doesn't mean that we're supposed to speculate on what the technology might potentially do or who or what might want it or even what it does. It means that *the work itself* technically speculates. Its dynamic form *is* speculative by nature. It's a speculative *event*. To speculate is to turn in on yourself. You turn in, in order to connect immanently with what is absolutely outside—both in the sense of belonging to other formations monadically separated from your present world, and in the sense of what may come but is unforeseeable. Xin Wei was suggesting that technically staged situations, understood as aesthetic events of recomposition, can also do that. When they do, what is happening is an exploratory collective thinking, a collective thought-event of the outside.

When Lozano-Hemmer talks about relational "architecture," he doesn't mean architecture in the narrow disciplinary sense (although of course architecture may itself be practiced relationally). It's similar to what I'm talking about here: the technical staging of aesthetic events that speculate on life, emanating a lived quality that might resonate elsewhere, to unpredictable affect and effect. Stagings that might lend themselves to analogical encounter and contagion. That might get involved in inventive accidents of history. It's about architectures of the social and political unforeseen that enact a relation-of-nonrelation with an absolute outside, in a way that is carefully, technically limited *and* unbounded.

Demands made on art to display its actual political content, or to observe a certain actual form that is deemed more political, are demands to curtail this kind of speculation, and the aesthetic politics it performs. They are demands to curtail aesthetic potential. There is nothing in principle wrong with that. As I said, life's an art of dosages, and there can be very good reasons to dope artistic potential with explicit political content.

It's just when that becomes a general injunction against certain kinds of experimentation that it becomes a concern to me, and I find myself vigorously dissenting.

**V2** This has been a long conversation, and you haven't used the word "media" once, except maybe in the stock phrase "new media." It's a word that's all over the place in interactive art. Why have you shied away from this concept?

**BM** Because I don't think it is one. I mean, I think the concept of media is in crisis. It's in tatters. That's because the digital isn't a medium, but it's currently dominating the media field. Digital technology is an expanding network of connective and fusional potentials. You can take an input in any sense modality, and translate or transduce it into any other, say sound into image. You can take any existing genre of artistic practice and fuse it with any other, say animation with cinema. Digital technology has no specificity as a medium in its own right. That is why commentators like Lev Manovich call it a "meta-medium" (2005). But that doesn't get you very far. From there, the best you can do is catalogue the kinds of connections that are possible and chart their permutations. It leads to an encyclopedic approach. At best, it gives you a combinatory flowchart, what Manovich calls a remix map. It entirely shelves the question of art and artfulness. It doesn't give you any vocabulary to think the properly aesthetic dimension, what makes digital art "art."

The basic problem is that the concept of media was never well-formed. Theorists have argued endlessly about what defines a medium. Is a medium defined by the material support, say celluloid for cinema? If so, is digital cinema then not cinema? Is a medium defined by the sense modality the product presents itself in—sound for music, vision for cinema? That alternative misses the absolutely fundamental fact of experience that the senses can take each other up. Michel Chion (1994) made that point about cinema. He showed that it is not visual. It operates through what he calls audiovision, a singular-generic fusion-effect of sound and image that emerges when they operate in resonance with one another. Neither sound nor image, audiovision is a kind of effective cross-resonance between their respective potentials. The cinematic image, according to him, is a singular kind of relational effect that *takes off* from both vision and audio but is irreducible to either. It comes of how they come together. It's a thirdness,

a supplement or boosting that needs them both to happen, but isn't one or the other, even though we say we "watch" a film. It has an experiential quality all its own. It's not a simple mix. A fusion is more than a mix. We "watch" a film amodally, seeing *through* the cinematic fusion-effect. We are watching at the immanent limit of vision, seeing sight reel into wormhole, only to bootstrap itself out for another scene. Chion's analyses of audiovision has the merit of emphasizing the fusional aspect of cinematic experience.

*Mixing* as a concept just doesn't go very far either. It has the same limitations as the concept of meta-medium. It's just a general name for the mapping operations that meta-media theory attributes to digital technology. Both concepts repose on the concept of connectivity. The "mapping" is a charting of interconnectivity—what I talked about earlier as local part-to-part connection. Extrinsic rather than immanent relation. These concepts don't sufficiently problematize interactivity.

Beyond that, there's the whole problem of the unexamined assumptions about perception that go into the very notion of "mediation." Perception as I have been trying to talk about it, as Whitehead's philosophy says, and as embodied cognition also says, is always direct and *imm*ediate. It's always its own self-embracing event, one with its own occurrence.

Chion is pointing us in the right direction when he analyzes cinema as staging a certain kind of experiential fusion-event. For an aesthetic politics, I don't think you can use a typology based on the media as they've been traditionally defined, and then mix and shake. There is philosophical work to be done, concepts to compose, and this has to be done with as much technique, even artfulness, as any other craft. The concepts needed must differentiate between lived qualities of experience as it happens. It must be capable of accounting for different kinds of technically achieved fusion and resonance events.

All arts are *occurrent arts*. That's another phrase from Susanne Langer (1953, 121). All arts are occurrent arts because any and every perception, artifactual or "natural," is just that, an experiential event. It's an event both in the sense that it is a happening, and in the sense that when it happens something new transpires. There is eventfulness in art, just as there is artfulness in nature. And there is creativity across the board. Because every event is utterly singular, a one-off, even though with and through its

one-offness a "likeness" is necessarily thought-felt to a whole population of other events with which it forms an endless series of repeated variations. Langer has probably gone further than any other aesthetic philosopher toward analyzing art-forms not as "media" but according to the type of experiential event they effect.

You have to rethink what the typology is based on, but also what a typology can be logically. It doesn't have to be a classification system, in the sense of subsuming particulars under an abstract, general idea. It can be based on a differentiating singular-generic thought-feelings. That is to say, it can try to take into account the kind of abstraction that effectively *makes* a perception what it will have been—the really lived abstraction of that singular thinking-feeling. This is a generative typology, of dynamic forms of perception's speculative appearing to itself and in itself. It is an immanent typology or a typology of immanence. It amounts to the same thing. The kind of logic called for is what Simondon called *allagmatic*, an operative logic of the analog expressing "the internal resonance of a system of individuation" (Simondon 2005, 48, 61). This is a diagrammatic logic. It is a logic of individuation, because this kind of typology will have to keep generating variations on itself, as the experience is always being restaged as an event and in the event, recomposed from within. New dynamic forms are always immanently emerging. Art is part and parcel of that process. Its practice speculatively advances its own generative typology. It practically contributes to its own thinking.

Thinking art is not about imposing a general overlay on its practice. The last thing it should be about is forcing art to fit into another discipline's categories, and holding it to them. It's about putting art and philosophy, theory and practice, on the same creative plane, in the same ripple pool. Art and philosophy, theory and practice, can themselves resonate and effectively fuse. Thinking-feeling art philosophically can intensify art's speculative edge. It's totally unnecessary to put theory and practice at odds with each other.

**V2** One last question. A lot of your vocabulary might strike people as a new romanticism—all the talk of lived qualities and life-feeling, not to mention oceanic experience, a term you actually used without cringing. What would you say to someone who accused you of doing little more than reviving romanticism for the interactive age?

**BM**   There are worse things to be accused of, I guess. Any time you try to talk about what happens in the world in qualitative terms, you're bound to be accused of waxing romantic. Personally, I don't think of it as a romanticism. Remember that the ocean came in drops, and there is as much separation between drops as there is pooling. And the pooling can just as well turn out to be a puddle. Sense of aliveness in a mud-puddle is not terribly exalting. I'm not advocating a romanticism of connection. That's actually what I've been arguing against. Neither is it about an exaltation of relation. I try to emphasize that the notion of the virtual requires that all relation actually be seen as a relation-of-nonrelation. Connection and relation, such as they are, are not always exhilarating. They can be terrifying. Or boring. Or restricting. It gets you nowhere to romanticize them. But it is important to give them their due, as much politically as philosophically and artistically, and without imposing a value judgment on them from outside or at a general level. Giving continuity and relation their due also involves doing the same for discontinuity, because they are necessarily implicated in each other. Something that is continuous with itself is so precisely because it detaches its activity from the outside it absolutely lives-in. Also, events continuously unfold, but across their unfolding they inevitably "perish," as Whitehead would say. Continuity and discontinuity are in reciprocal presupposition. The problem is always to evaluate, case by case, in what way they implicate each other: *how* they are.

If I am guilty of romanticizing anything, it would be *intensity*. By intensity I mean the immanent affirmation of a process, in its own terms. This is not a stated affirmation. It's an activity. It's when a process tends to the limit of what only it can do, and in that act resonantly embraces its own range of variation. It's not mystical to call that self-affirming "life." If you like Latin, you can join Spinoza and call it conatus. You can call it many names. The important thing once again is that in each instance you ask and answer "how." Then it becomes a technical question of *ontogenesis*, or of the self-production of being in becoming.

Even if you do call it life, that doesn't necessarily land you in a vitalism, because there is no need to posit a life-substance or life-force "behind" appearances. All you need posit is the appearance of a tendency. A tendency, as it appears, is always, only, and entirely in process. But tendency is already a complex notion, because it implies a certain self-referentiality.

Tendency is a performed self-referencing to other states, past and potential. As such, it is a way in which an event in some sense, not necessarily consciously—in fact most often and in large part nonconsciously—*feels* itself, catches itself in the relational act. And in some sense, not yet separable from this feeling, nonsensuously *thinks* itself, in that very same act. This is what Whitehead calls "prehension" and what Deleuze calls "contemplation." Both authors apply these concepts to *all* events, whether they occur on organic or inorganic strata. I suspect that this is where many people would part ways. To accompany this kind of thinking, you have to be open to the possibility of rethinking the world as literally *made of* feelings, of prehensive events. The philosophy of the event, in Whitehead's words, is an immanent "critique of pure feeling" (Whitehead 1978, 113). The feeling is "pure" because it needs no subject—or object for that matter—outside the dynamic form of the event's own monadic occurrence. You have to be willing to see the world in a semblance. That *could* be mystical. But then again, it could be a question of technique.

Given that the question of technique is at the core of the approach I've been outlining, I like to think of it as a *speculative pragmatism*, understood as a species of empiricism closely akin to William James's *radical empiricism*. This way of formulating might be more companionable to more people. As James defined it, there are five guidelines of radical empiricism. The first it shares with classical empiricism:

1. Everything that is, is in perception (read, if you will: in prehension). Radical empiricism begins to part company with classical empiricism with the next guideline:

2. Take everything as it comes. You cannot pick and choose according to a priori principles or pre-given evaluative criteria. Since things come in lumps as well as singly, this means that:

3. Relations must be accounted as being as real as the terms related. In other words, relations have a mode of reality distinct from that of the discrete objects that appear as terms in relation. The mode of reality of relation is immanent, lived intensely in under conditions of mutual inclusion (worldly activation). The separable terms that come to be in relation come in a mode of extrinsic connection, governed by the law of the excluded middle. They are extensively lived-out (functional interaction). The living-in and the living-out are contrasting poles, and coincident

phases, of the same ontogenetic process. The sense of "relation" and of "real" change significantly depending on which ontogenetic level the focus is on. It follows from this, in light of the first guideline, that:

4. Relations are not only real, they are really perceived, and directly so. Relations not only have their own mode of reality, but each has its own immediate mode of appearance. The final guideline says that the vast majority of what is, in perception, actually isn't:

5. "Ninety-nine times out of a hundred," James writes, the terms and relations that appear "are not actually but only virtually there" (1996a, 69, 71–72). They are present beyond the frame, on the "chromatic fringes" (73) and at the processual vanishing point, or "terminus," in James's vocabulary, where each event turns in on its own unfolding toward its tendential end. "Mainly, we live on speculative investments" (88). The empirical world is ninety-nine percent lived speculation, a surfing "on the front edge of a wave-crest" of "tendency" (69). In order to avoid a romanticism of connection, James drums it in that guideline number two, take everything as it comes, means that you have to take continuity and discontinuity as *they* come. The beach-falls with the wave-cresting. You have to give each its due. By which time this has continued quite long enough.

—cut—

# 3    The Diagram as Technique of Existence: Ovum of the Universe Segmented

I

"We judge colors by the company they keep" (Lamb and Bourriau 1995, 149). Colors are convivial. "A" color "is an alteration of a complete spectrum" (Westphal 1987, 84). However lonely in appearance, a color is in the company of its kin—all its potential variations. The spectrum is the invisible background against which "a" color stands out. It is the ever-present virtual whole of each color apart.[1]

II

"I was in a totally white room. As I held the prism before my eyes, I expected, keeping Newtonian theory in mind, that the entire white wall would be fragmented into different colors, since the light returning to the eye would be seen shattered in just so many colored lights. But I was quite amazed that the white wall showing through the prism remained as white as before. Only where there was something dark did a more or less distinct color show. . . . It required little thought to recognize that *an edge was necessary to bring about color.* I immediately spoke out to myself, through instinct, that Newtonian theory was erroneous. . . . Everything unfolded itself before me bit by bit. I had placed a white sheet of glass upon a black background, looking at it through the prism from a given distance, thus representing the known spectrum and completing Newton's main experiment with the camera obscura. But a black sheet of glass atop a light, white ground also made a colored, and to a certain degree a gorgeous specter. Thus when light dissolves itself in just so many colors, then *darkness must also be viewed as dissolved in color*" (Goethe 1972, 35; emphasis added).

The spectrum is convivial. It is always in the company of darkness. The range of achromatic variation forms a larger encompassing whole against the background of which the spectrum appears. "Color and illumination constitute . . . an indissoluble unity. . . . One illumination with its colors emerges from the other, and merges back into it; they are both indicators and bearers of each other" (Katz 1935, 294).

Bearers of each other, triggered into being by an edge. The convivial edge of emergence: one line indicating all, presenting the continuity of variation that is the shadowy background of existence. And at the same time effecting separation: the spectral distinction of what actually appears. Merging; emerging. Virtual; actual. One line.

III

"There must be a continuity of changeable qualities. Of the continuity of intrinsic qualities of feeling we can now form but a feeble conception. The development of the human mind has practically extinguished all feelings, except a few sporadic kinds, sound, colors, smells, warmths, etc., which now appear to be disconnected and disparate. In the case of colors, there is a tridimensional spread of feelings [hue, saturation, brightness]. Originally, all feelings may have been connected in the same way, and the presumption is that the number of dimensions was endless. For development essentially involves a limitation of possibilities. But given a number of dimensions of feeling, all possible varieties are obtainable by varying the intensities of the different elements. Accordingly, time logically supposes a continuous range of intensity in feeling. It follows, then, from the definition of continuity, that *when any particular kind of feeling is present, an infinitesimal continuation of all feelings differing infinitesimally from that is present*" (Peirce 1992a, 323–324).

The enveloping of color and illumination in one another extends through the senses, each one bearing and indicating all. Mutually enfolding. A many-dimensioned virtual whole of feeling is enfolded in every actual appearance in any given sense mode. Synesthesia. A color, smell, or touch is an emergent limitation of the synesthetic fold: its differentiation. *A* color, smell, or touch extinguishes the whole in its difference. And in the same stroke presents it: as the totality of its own potential variations. All the befores and afters it might be, instantaneously. The distinctness of

each present perception is accompanied by a vague infinity of self-continuity. An integral synchrony of befores and afters. Unbeen, beable. Time-like, logically prior to linear time. In the limits of the present. Wholly, virtually, vaguely. Differentiallly. Edging into existence.

## IV

"Let the clean blackboard be a sort of Diagram of the original vague potentiality, or at any rate of some early stage of its determination. . . . This blackboard is a continuum of two dimensions, while that which it stands for is a continuum of some indefinite multitude of dimensions. . . . I draw a chalk line on the board. This discontinuity is one of those brute acts by which alone the original vagueness could have made a step toward definiteness. There is a certain element of continuity in this line. Where did the continuity come from? It is nothing but the original continuity of the black board which makes everything upon it continuous. What I have really drawn there is an oval line. For this white chalk-mark is not a *line*, it is a plane figure in Euclid's sense—a *surface*, and the only line that is there is the line which forms the *limit* between the black surface and the white surface. This discontinuity can only be produced upon that blackboard by the reaction between two continuous surfaces into which it is separated, the white surface and the black surface. The white is a Firstness—a springing up of something new. But the boundary between the black and white is neither black, nor white, nor neither, nor both. It is the pairedness of the two. It is for the white the active Secondness of the black; for black the active Secondness of the white" (Peirce 1992b, 261–262).

Something new: First. And with it, simultaneously and indissociably, a Secondness: a visible separation of surfaces. The separation is across an insubstantial boundary, itself imperceptible. Pure edge. Neither black nor white. Not neither not both. A virtual line.

An insubstantial boundary does not effectively enclose. Quite to the contrary, it "actively" connects that which it separates. The virtual line is the *activity of relation* of the black and the white: a reciprocal coming-Second. It embodies the *event* of that pairedness. The pure edge invisibly presents the immediacy of spatially and chromatically differentiated surfaces to each other. That immediacy is also an immediacy of forms. The

virtual line is the event of the oval and the plane coming-together: their belonging to each other. As proto-figures to each other's oscillating ground.

"Like the ovum of the universe segmented" (Peirce 1992b, 262).

A perceptible difference has emerged from vague potential. The continuity of the virtual whole of be-ability has fed forward onto the plane of actual being-different. As been, the whole presents itself twice. Once: in the concrete surface continuity of black and of white. Again: in the pure abstractness of the invisible line separating and connecting the surfaces.

Surfaced, continuity is on either side of a divide. It bifurcates into a perceptual contrast between co-present and disjunct elements. A "co-presence of disjunct elements": the definition of space. The "integral synchrony" of mutually enfolded before-afters has been supplemented by something planely spatialized. A spatiality is emerging from its own potential time-likeness. It has unfolded as an after, its before almost left behind. Continuity is no longer entirely in self-continuity. It is divided, supplementarily, into a double difference-from: direct contrast, spatial and temporal.

The co-surfacing of the oval and the plane does not entirely detach from the continuum of potential. The insubstantial boundary separating and connecting them retains the vagueness of the virtual whole: neither this nor that. Neither black nor white, neither plane nor oval. Rather, the pure activity of their relating. Reciprocally, in their spatial separation. Recursively, in a kind of instantaneous oscillation joining the disjunct in mutual Seconding. Actively, reciprocally, recursively. Eventfully: the boundary preserves an edge of timelikeness. The virtual line is the virtual whole as it edges, imperceptibly, into the actual. Timelike continuity is drawn out of itself, cutting into the actual, where it appears as pure edging: discontinuity in person. Unenclosing, the line is not a boundary in the usual sense. It is spatializing (its timelike cutting-in constitutes the simultaneity of the surfacing disjunction). But it is not in itself spatial. The virtual line is less an outline than a *limit*. It is the processual limit between the virtual and the actual, as one verges actively on the other. The "brute act" of the actual and the virtual relating. Drawing each other, to the verge of formal definition. Contrastive difference is *proto-figural*: emergently ordered, insubstantially bounded.

The defining limit of the proto-figural is doubly an *openness*. On the level of actual being, it is the active reciprocity of differentiated forms to

each other. Between that level and its be-ability, it is the openness of forms to their belonging-together, infinitely, continuously, indefinitely in potential.

The double openness is of relating.

"The line *is* the relation" (James 1950, 149).

V

Now multiply lines on the board, each succeeding mark intersecting the last at a set angle. A black oval now stands out against distinctly against the white edging of the lines. Make the lines black ink and the background white paper. The effect is the same: a *figure* is distinctly visible. The proliferation of line -ovals has emerged from its own repetition into a super-oval.

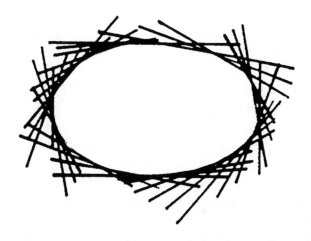

The unity of the figure strikes the eye immediately, even though it is composed. It is a gestalt. Its figurative unity stands out from the multiplicity of its constituent marks. The edge has taken on a visible thickness. The line has propagated into an outline.

The imperceptibility of each mark's virtual edge no longer presents itself, disappearing into the thick of boundaried vision. Separating more than it connects, the intervening boundary brings a palpable stillness to the figure it encloses. The immediate reciprocity of black and white has settled into a *mediation* of two surfaces that divided from each other but

qualitatively the same—white-inside separated from white-outside. The
"activity" or eventfulness of the contrast is lost, along with its immediacy.
What directly strikes the eye is no longer an invisible, yet vaguely palpable,
oscillation evocative of infinite potential. Rather, it is the stillness of a
figure, standing out.

The stillness of the figure's inside is echoed, muted, in the white outside
*against* which it stands, mediated by the boundary. Mutual Secondness of
black-Firstness and white-Firstness is replaced by boundaried offset of
white against white. The boundary sets same against same. The only dif-
ference between white and white is the relative emphasis of foreground
over background. What comes with the edge is no longer a singularly
direct, qualitative difference in perception. It is a relative emphasis of
qualitative homogeneity.

The direct "pairedness" of pure, open contrast is replaced by an *opposi-
tion* between mediated sames. The opposition is an effect of the figure's
perceptual closure, its boundaried enclosure. The white outside is limited
to a neutral backgrounding for the inside's standing out. The figure's stand-
ing out is passively delimited by that standing back. Outside, inside are
offset against each other as different regions defined by the boundary: they
are spatialized. Figure, ground, and their across-the-boundary relation are
spatialized. They are set in place relative to each other. The edgy activity
of relation no longer presents itself as it did before. Where once was a
singularly direct Seconding across the absolute limit of a time-like edge of
no dimension, there is now a spatial relativity of figure to ground across
the inky blackness of a filled-in boundary.

The emergent activity of *relation* has given place to the stable *relativity*
of disjunct gestalt result. The oval's standing out stands still in space, as if
it had stepped out of time. The stillness of figure seems to stand in space
for a species of eternity: a particular instance of a Platonic form. The *sin-
gularity* of an edging into existence has yielded to the appearance of a
particular instance of a *general* type.

The ovum of the universe, as been. Hatched eternal.

Look closely, and you will still almost-see the invisible edge of each
constituent mark. Use your imagination. Each mark is imperceptibly
bounded by a virtual line. Thus the marks never effectively intersect. There
are cracks between them. Since they do not intersect, they never actually
form a boundary. Their iteration fractally multiplies the cracks,

intensifying edginess. The unity of the figure is actually composed of a cross-proliferation of virtual cracks. The unity is abstract, superadded as a perceptual bridge across the cracking. The super-oval resulting from the bridging in-fill is not so much seen as *overseen*. Look closely, and you will see the bridging, you will undersee the seething cracks. Activity, under-still. As the figure crumbles into the cracks it straddles, the background rearises from its mute subordination. Whites and blacks rebecome reciprocating proto-figures to each other's oscillating ground, or grounding oscillation, their active contrast afloat in a deepening virtual abyss. Hatched eternity dissolves back into a vaguely timelike coming together of qualitative dif- ferings-from, immediately grounded in a co-flotation of Seconding: recip- rocally self-standing.

The fuller the unity of the figure, the better actualized the figure, the more multiply and intensely the virtual edges in upon it. The more pas- sively the figure stands out in its unity, the more actively its multiplying constituents reciprocally self-stand. The undermining insistence of the virtual is a complementary and inverse movement to the actualization of the figure. The virtual is gestalted out of the picture by the same iterative process that fractals it in ever more deeply. Double articulation between levels: of emergent proto-figural activity and its resulting figurative annulment.

Double vision. Looking more or less closely, focusing more or less atten- tively, the eye oscillates between the annulment of the process and its activity. Flicker. Between fully-hatched stability and continuing, cracked emergence. Flicker. Between the made and the making. Flicker. Between seeing the figurative stability and seeing the imperceptible float of figural potential. Flicker. The eye tires of the flicker. It habituates to bridge-level stability. The eye is the organ of habitual oversight.

The figure is an habitual inattention to the imperceptible in vision.

## VI

We have returned to double vision when we can say that "it is nonsense to talk of form perception" (Gibson 1986, 178)—all the while acknowledg- ing that the "nonsense" is directly and effectively seen. Or when we say that "the figure-ground phenomenon does not apply to the world" (Gibson 1986, 66)—even as we hang pictures on our walls. Or when we say "there

is no special kind of perception called depth perception" (Gibson 1986, 148) because space itself "has nothing to do with perception" in the act of edging in (Gibson 1986, 3)—as we measure where the new sofa might go. Or when we say that "we perceive not time but processes" of emergence (Gibson 1986, 12)—impatiently checking our watch.

When we say these things, we are saying that form, figure/ground, Euclidean space, and linear time are not foundations or containers of perception. Experience cannot be derived from them; it is they that emerge with experience. Experience cannot be contained by them; they are among its contents. They are derivations of a more open process: superadditions of habit. Creatures of habit, not grounds of perception (which, as we have almost-seen, is actively self-standing).

This does not imply that we can turn completely away from the level of formal stability. We can never, of course, literally see the imperceptible "ground" of potential over which the figure actually hangs. But then we cannot literally see the figure either. We see our fill. Vision is never literal, always figurative, in an outstandingly direct, overfull way. Acknowledging that does not concede potential and the virtual. For if we cannot see the imperceptible, we can sometimes see the flicker of the figure as it emerges from it. We can undersee the proto-figural abyssing the figure. Seeing the figure's self-standing by underseeing it is as close as we come to glimpsing potential. We almost-see it, edgily side-perceive it, approaching the actual limit of vision.

## VII

How could we ever literally see a unitary form or figure when the light striking our eye is splintered into countless separate points by the rods and cones populating the retina? Gloss over the gaps. How could we literally see a continuous surface-surround of space when our very own nose sunders our field of vision in two—not to mention the holes poked in both halves by the blindspot of each eye? Bridge it over. How could we see depth when our retinas are two-dimensional to begin with, even before what they register is poked, sundered, and splintered? Superadd it. We see unity of form in excess of our eyes.

What literally strikes our eye is *edging*. Not only color, but space, time, figure/ground, and formal stability, in their reciprocal difference and on

their respective levels, all of these emerge from the edge of illumination. For the simple reason that light scatters. Its scatter carries interference patterns, gaps, and gradients of intensity: lines of proto-figural differentiation. This "ambient light array" is what literally strikes the eye. (Gibson 1986, 65–92). A chaos of vision. For not only does the array continually change, but a body is always moving: a complex coupling of two continual variations. Even more: the flicker almost-seen in emergent form is prefigured by jitter. "Saccade": the constant, involuntary micro-jerking of the eyeballs in their sockets. If the jerking stops, vision blanks out. Vision arises from the addition of random jitter to a complex coupling of two continual variations. How do unity of form, stability of spatial relation, constancy of color and brightness, and linearity of time derive from these impossibly complex, chaotic conditions? We already know the answer: by superadding to the seen.

The continual variation draws the proto-figural lines of the ambient array across the gaps between the rods and cones, across the nose hole, and across the blindspots. The discontinuities are giddily bridged by a continuity of movement. The bridging does not yield a unified figure or stability of ground. It yields a complex of moving lines of light *continuing across* invisible abysses of darkness. Proto-bridges of continuity, self-standing, over a void of vision.

To get an emergent figure, you need to add senses other than vision. In particular, touch and proprioception, the registering of the displacements of body parts relative to each other. Say a varying complex of light-lines comes to the eye with a change in proprioception. Intersensory conjunction: the first complex of moving light-lines segues into another. With the new complex comes a feeling from an outstretched hand: intersensory conjunction. Say the two intersensory conjunctions repeat. Next, their repetition is anticipated. Habit. The anticipation is recursive, since it arises retrospectively from an iteration of already repeated line crossings and conjunctions. Habit is the actual experience of a before-after, in a continuity of present conjunction. Of course there are also smell and hearing. A panoply of before-afters merge into and emerge out of each other, bearers one of the other, folded together by habit. The folding together fuses an infinite continuum of potential crossings and conjunctions, befores and afters, into the singularity of an event of perception. A vague, unbounded virtual whole self-presents without actually appearing: abstract "ovum" of

an experiential universe emergent. "When any particular kind of feeling is present, an infinitesimal continuation of all feelings differing infinitesimally from that is present." "Development essentially involves a limitation" of that abstractly felt potential.

Say that on the level that limitatively develops, the two conjunctions just described will be experienced as seeing an edge (complex of light-lines), moving around it (proprioception), and touching something behind that was occluded but is now visible (new complex of light-lines). The new complex of light-lines is a second occlusion: there are still other things behind the thing behind. Focus on what the habituating eyes register: an edge, then an edge. After the habit has set in, the second edge will come with the first edge, in anticipation, before the movement around. It will *also* come after the movement. Double articulation: before-after. Of course, the second edge will come after the first differently than it preceded itself: with a touch and a proprioception. The before-after that is seen with the first edging is a simultaneous disjunction of surfaces: a germ of space, a barely-there of navigable depth to move into. The anticipated coming-after differently is a germ of linear time. The self-difference of the second edge —the difference it encompasses between its coming after something else and its preceding itself—is the germ of its identity as an object: its predictability, its sameness across its variations, its reaccessibility time after time, its dependable just-thereness.

Experiments have verified that a "surface . . . being uncovered [is] seen to pre-exist before being revealed" (Gibson 1986, 190). The *identity* of the object is seen. Again with different emphasis: the identity of the object is *seen*. Identity is a recursive (before-after) unity added by habit to the sight of a simultaneous disjunctive difference. Identified, the edging associated with the object thickens into a stable contour. What now appears through the edging is not a simple boundary but a 3D contour. The light arrays habitually conjoined with the inside of the contour detach from the ambient array, and come to be seen as the object's color. The color makes the object stand out, a visible 3D figure gestalting its way into the brightness of being against a muted background onto which it casts its shadow. Form and depth co-emergent. The ovum of the universe segmented: into contrasting objects separated together. Together: adjacent in space. Separate: succeeding each other in time. "Of the continuity of feeling we can now form but a feeble conception." That "feeble conception" is the

identity of the object in space, persisting stepwise across time. Identity is the emergent activity of relation gone plodding.

The continuity intensely continues apace with the plodding. When identity is seen, what is being seen is an anticipated next touch conjoined with an anticipated next proprioception conjoined with an anticipated second vision. The eye is functioning synesthetically to see the unseeable. To *oversee* touch, proprioception, and its own present, skipping over the here-now of its own formative activity, fed forward in anticipation of there-afters. An anticipated touch, proprioception, or vision is a *potential* touch, proprioception, or vision. The overseen is unseen potential. The unity of identity, the simplicity, of the resulting object has been limitatively extracted from the complex chaos. That chaos continues to be seen, feebly: underseen in the form of identity. The chaos must continue for the object to have something to reemerge from, as anticipated. Double vision: figurative or objective order out of iteration; and a continuing chaos of light ever-dawning. Vision abstractly oversees order by synesthetically superadding habit's abstractions to the singular immediacy of its ever-renewing chaos.

The objective extraction of identity arises out of movement. Vision's synesthetic result stands on an oscillating kinesthetic "ground." Perceived stability and order emerge from perceptual chaos. Vision is the process of that passage: from the giddiness of light-struck eyes to the practical grip of abstract oversight. From the invisible abyss of the proto-figural to relative objective clarity.

Each time eye jitter draws an edge with the world's continual variation, a whole universe of potential abstractly appears to vision in the form of a particular object among others, inhabiting the same order in space and time. The edge effects a synesthetic-kinesthetic emergence layering levels (objective foreground /background, potential next, virtual continuity) and an ordering of identities (in an emergent space-time of experience).

## VIII

Let's go back to the drawing board. Draw a line, this time on a piece of paper. The line draws forth the emergent edge again. The line repeats the edgy event of appearing relating. "The line *is* the relating; see it and you see relation; feel it and you feel the relation" (James 1950, 149). You have

cracked opened a whole universe of proto-figural relation. You have invoked the virtual. You have called the potential it enfolds toward existence. Nothing substantial has come of it. The potential is as yet *only* felt, synesthetically-kinesthetically in vision renewing. But only-felt is almost something. And already a great deal virtually: an infinitesimal continuing of all feeling. Any more, and it would come to less. The virtual would actualize, limitatively.

Go for more (and less). Draw more lines, until a geometric figure defines itself. You have figuratively closed the virtual world by selecting one from its infinity of felt potentials. You have limitatively actualized the virtual.

There is nothing to be done. Except to draw another line. Return to the edge, see and feel the relation. Enclose its active potential again in another figure.

At each repetition, you draw forth an infinite continuum of experiential potential, then selectively deactivate it. You invoke active powers of existence, and move to enfeeble them. Renew, annul. Existential flicker.

The annulment of powers of existence is all the more enfeebling when more than one figure are laid side by side on a single page. The disjunctive germ-space of pure contrast, flickering with the timelikeness of each mark's virtual edge, disappears. The page is now a neutralized space of comparison. Difference is no longer active. Active contrast has been passified into an opposition: a planely separated either/or. Either the figures are the same, or they are not. Either they share an identity, or they do not. Sameness, or mutual exclusion.

An opposition is not a duality in the Peircean sense. Duality is the self-standing positivity of still-active contrast, pure unmediated "pairedness": the Secondness of a mutual Firstness springing forth from the formative chaos of vision. Either/or applies to the already-sprung: completed figures. It applies to the completed with an automatic view to a value judgment: either/or, for better or for worse. Before an assessment of value can be made, the question of whether the figures share an identity, whether they are the same or whether they are mutually exclusive, must be answered. Better or worse makes no sense applied to the same. Their identities must be assessed. The only way to assess them is to compare them to each other while comparing both against standards of identity . . . and the standard makes three.

Comparison involves a Thirdness. A mediating third term is abstract in much the way a Platonic form is: ideally still, glossing over the chaos and the jitter. Except that it takes the gloss to a higher level. It raises the mediation of figures off their shared surface to a space of judgment hovering above. The standard hovers unseen in a thought-space above the surface of perception. It is a height of generality. It is a general paragon. It is ideal. As an ideal, it is not so much overseen as it is overseeing. It oversees the correctness of the assessment.

The space of comparison is a normative space of ideal Thirdness rising above. What goes up, can come down. Instead of an oval, draw a cube. Project it onto a ground-level chaos. A razed plot of urban land, say. Think of its form as an abstract sieve to filter the chaos. Then concretize the form. Build a building according to its standard. The standard of comparison has now returned to earth, as a constructive model. It has gone actively to ground. A plot-size of selected abstract potential has been poured in concrete. Now it is a concrete ground for moving through and around. What ambient arrays, what edgings in, what potential crossings and connections, what glossings over, what identities and orderings will emerge from the movement it standardizes? An architect has modeled a building. The building itself now takes the baton, and models a plot-sized slice of life.

## IX

"The greatest point of art consists in the introduction of suitable *abstractions*. By this I mean such a transformation of our diagrams that characters of one diagram may appear in another as things" (Peirce 1997, 226).

The empty blackboard was a diagram of the "original vague potentiality" at "some early stage of its determination." The pure edge of the lone line, the one that was actually an ovoid proto-figure, was a diagram of that original vague potentiality's continuum of variation at another phase of its determination. The super-oval that was composed out of a number of such lines was a diagram of a Platonic form, the formative vagueness now glossed over in a fully determined figure, the activity of formation appearing stilled. The reaccessibility of the object that revisited these phases in volume, intersensorily, was also a diagram: that of a self-identical form in 3D space through time. Any ideal standard of comparison that might be

applied to a figure or an objective form to overlay a value judgment on it is also a diagram. Used as a model, it projects a figure's Platonic form, and an objective identity normatively conforming to it, into a new construction. In so doing, it selectively transfers to the thing under construction certain "characters" that have forwarded through the process. The "characters" are less the proto-figure, figure, or objective form as such than the potentials that carry across them. It is these potentials that are selectively lifted out of the continuum of variation, filter through the phases, and go to ground as the concretization of a model.

Blank slate—singular proto-figure—stable figure—object identity—ideal standard—general model. All of these are diagrams in their own right, each in its own way. Each step in the process by which potentials lift into existence, filter through, and plot into a new construction, is also a diagram according to Peirce's just cited. In the most extended sense of the word, the entire process is its own occurrent diagram.

The resulting new construction is an added existence. Pragmatically speaking, its diagram is the toolbox of techniques—from seeing to overseeing, from habitual inattention to attentive habit, from comparison to judgment, from judging to plotting, from projecting to constructing—that went into shepherding a select set of potentials into the concreteness of the construction's added existence. The diagram in this sense is a constructivist *technique of existence*. It is a technique of bringing to new existence. A technique of becoming. Becoming-concrete. Becoming, determined. If, as Peirce's definition says, diagramming is abstraction—an extraction of potential—then the very process of *becoming determinately concrete is a process of abstraction* (Whitehead 1967b, 51–55, 157–179; 1978, 7–8).

This is where the questions *begin*. What, after all, is a "suitable" abstraction? If the abstraction process produces an interlocking of proto-figure, figure, form of identity, standard, model, and construction is a process of becoming, then the question becomes: which becoming? Why? To suit whom or what? If becoming involves passing through phases selective of potentials, the question is: which phases, for what potentials? If the passage toward the final determination of the construct is limitative, the question is: is that the end of the story?

It isn't, because there is still the question of *how* limitative, and in what way. Perhaps all processes of abstraction for becoming-concrete are not

equal. Perhaps there are abstractive techniques of existence that curtail the role of Platonic forms and skip the standardizing judgment phase. Perhaps there are *nonstandard* constructivisms (Migayrou 2004).

A nonstandard constructivism would no longer be a modeling. It would not select one set of potentials in conformity with a projected identity. It might, for example, select several sets of potentials that do not habitually share the same space or before-after each other in an easily anticipated way. This would *overdetermine* the construction. Overdetermination makes the construct problematic. Left at that, a nonstandard diagramming technique is *de*constructive. A deconstructive architecture combines what are normally defined as "mutually exclusive or opposing spatial strategies" into a single architectural element (Eisenman 1994, 21). For example, a corridor that at first approach seems to end incongruously in a wall. The potentials for passage and for enclosure are overdetermined. These moments of incongruity and overdetermination punctuate the architecture with interruptors ("inversions," subversions). The aim is to momentarily subvert the normative course of architectural practice and inhabitation, in order to make a self-referential statement about architecture's "interior." To the extent that it aims to construct a statement, deconstructive practice remains "authorial" (Eisenman 1999, passim).

A different nonstandard abstractive technique of existence might plot into a construction triggers for on-the-fly selections of potential that give pause, not primarily to interrupt and make a statement, but to invite and enable an effective variation on continuing. These would be variously determined, circumstantially, at particular junctures, in the course of the movements that come to pass through the building. In other words, the seeing/unseeing, potentially touching, always proprioceping, tirelessly kinesthesing, constantly jittered, self-emphasizing, dynamic forms of embodiment that finally enter in—the architectural "clients" and "stakeholders"—are invited to *continue the diagramming process* to suit themselves. They are invited to inhabit as embodied coauthors of the architectural process, prolonged. Triggers are built in that jolt the emergent proto-figural level to reappear, in abstract oscillation with other levels. The continuum of potential is now un-unseen, without becoming objectively visible. Instead: intersensorily felt to flicker with the objective forms. Rather than one or the other, continuum of potential or objective vision, it would be the stroboscopic flicker between them that would momentarily

foreground itself at the trigger-juncture. Built in at strategic points would be an eventful, flickering vagueness of resurgent abstraction doubling vision. The process will have constructively brought back out the continuum of abstract potential. The presence of the full continuum of potential allows the experience to toggle between sets of potential. This is neither inversion nor subversion. It is intensification.

Whatever figures, formal identities, and even ideal standards and general models that may also be built in alongside the trigger-juncture are submitted to the flicker of intensity. They do not dominate. They do not definitively foreground themselves. "Indicators and bearers of each other," they collaborate in the toggling. They are no longer limitations, as they are in standard, normative architecture. They are no longer constraining. They are the enabling constraints of a renewed selection. The selective renewal is of the kind that composes an "alteration of a complete spectrum" of lived experience. It brings back to life its virtual color and shadow, in all their intersensory textures. It recharges the activity of relating from which all experience emerges. Becomings continue, in a prolonged chromatics of variation. Ovum of the universe edgily re-segmented.

Not deconstruction: continued construction. Reconstruction, on the fly. Not interruption: recharging, resaturation with potential. For deconstructive strategies, architecture is a "scene of writing" (Eisenman 1999, 26–35). For reconstructive strategies, it is a platform for diagrammatic reemergence. Deconstructive strategies pointedly interrupt the event of architecture. Reconstructive strategies fluidly continue it.

None of this makes any sense if space is considered to be the medium of architecture. Seen reconstructively, "spatial strategies" *create* the space of inhabiting experience. This inhabiting *event* is the medium of architecture. The architectural space of inhabiting-experience is always the *result* of the diagrammatic process of architectural abstraction becoming-concrete, as a prolonged event. What architecture recomposes in new variations are not pre-given spatial elements. What it recomposes is the *experience* of inhabitation itself. Architecture is a diagrammatic art of lived abstraction: lived-in abstraction, in a quite literal sense. For nonstandard reconstructive architecture, the inhabiting experience is also the continuing product: the medium made eventfully renewable, beyond the final plotting of the design.

Skipping the standardized judgment phase means that new forms of Thirdness must be invented. Only an intervention of Thirdness

can regulate becoming in any way, whether normatively for stability, or self-renewably for the existential flicker of reappearing potential. Because that's what Thirdness is: regulated passage from one phase to another. Essentially, that means "habit-taking" (Peirce 1992a, 277). But it also means "law." Law in its "original" sense is nothing other than the regularity of habit acquired in the chaotic course of emergent experience (276). In a derivative sense, law is an imposition of habit from on high, through the mediating influence of a comparative standard or normative model. It is the challenge of any architectural process that wishes to live up to its vocation for living-in diagrammatic abstraction to invent techniques of coming to architectural existence that *do not model* in the traditional sense. That reinvent pliable "laws" of architectural design in the "original" sense, where the emergence of regularity "mingles" with a "lawless" element of "pure spontaneity." In a flicker with chance. Law then returns to the "pure chance" and vague "indeterminacy" it "developed out of" from the First (276). So that it repeats the act of emergence. Evolutionary law fueled by chance. Architecture reinventing itself, as it reinvents new techniques for mingling chaos and regularity toward the determination of new architectural form.

What a design practice of this kind does is *meta-model*, in the way Félix Guattari speaks of it (in a very different sense of "meta-" than in Manovich's "meta-media," discussed in chapter 2 above; Guattari 1995, 22, 33, 127–128; Genosko and Murphie 2008). "Meta-" is to be understood here in its etymological sense of "among." It refers not to the on-high of the ideal, but on the contrary to the spontaneous remingling of acquired regularities of practice with the emergence-level chance and indeterminacy from which they evolved. The practice itself is not of course chaotic. A commingling of habit or law with spontaneity is at most *quasi-chaotic* (James 1996a, 63–65). Meta-modeling is a practice that strategically returns its process to the quasi-chaotic field of its own emergence, in order to regenerate itself as it generates new figures, forms, and constructs, for itself and others. So that both the discipline, and its clients and stakeholders, live-in a fullness of potential, as part of a continuing process. Commingling: activity of relating. Techniques of existence are techniques of relation.

Since what is relationally modulated with remingling technique is potential, meta-modeling can be considered *the* procedure of the speculative pragmatism suggested by the radical empirical perspective.

# 4 Arts of Experience, Politics of Expression: In Four Movements

## FIRST MOVEMENT: TO DANCE A STORM

### Nonsensuous Similarity

"We must assume," writes Walter Benjamin, "that in the remote past the processes considered imitable included those in the sky." People danced a storm. Benjamin is quick to add that the similarity that made it possible for the human body to imitate cloud and rain is different from what we normally think of today as a resemblance. It could only have been a "*nonsensuous*" similarity because nothing actually given to our senses corresponds to what our bodies and the heavens have imitably in common. Benjamin goes on to suggest that not only can this nonsensuous similarity be acted out, it can be *archived*, "most completely" in language. But not just in language. For nonsensuous similarity is what "establishes the ties" between the written word and the spoken word, and between them both and what is "meant"—meaning what is sensible (preceding quotes from Benjamin 1999b, 721–722). It is in the ins-and-outs of language. Tied to the senses but lacking sense content, it can nevertheless be "*directly perceived*"—but "only *in feeling*" (Benjamin 1996a, 208). Direct and senseless in feeling, in and out of speech and writing, it evades both "intuition and reason" (Ibid.). What is this paradoxical "semblance in which nothing appears" (Benjamin 1996c, 223)? Simply: "relationship" (Benjamin 1996a, 208).

What is he talking about?

## Felt Perception

A good place to begin to find an answer is movement. The perception of
the simplest movement responds in many ways to Benjamin's criteria for
nonsensuous similarity. Movement has the uncanny ability, in the words
of experimental phenomenologist Albert Michotte, "to survive the removal
of its object" (Michotte 1963, 138). For example, Michotte might show you
a screen with a dot and a circle. The dot starts moving toward the circle.
Then just before the dot is about to hit the circle, it disappears. That is
what, objectively speaking, you will see. But that is not what you will *feel*
you saw. You report "that the dot disappears while its *movement* continues
right up to the circle, and then is lost 'behind' it" (Michotte 1963, 138).
There would be no sensory input corresponding to that movement. The
dot didn't actually continue its path. It disappeared. Yet you would effec-
tively perceive its movement continuing. This wouldn't be a hallucination.
A hallucination is seeing something that actually isn't there. This is actu-
ally not-seeing something—yet directly experiencing it in vision all the
same. This is a category all its own: a felt extension of vision beyond where
it stops and 'behind' where it stays; a *perceptual feeling*, without the actual
perception. Sight *furthered*, following its own momentum. To the point
that it is *only* felt: not *in* perception, but *as* a perception.

Movement, Michotte sums up, is "a phenomenon sui generis" that may
"detach itself from [the] objects" of sight (Michotte 1963, 137).

## Nonlocal Linkage

This kind of effect is not limited to special controlled conditions. When-
ever movement is perceived, we are presented with a *"double existence"*: a
physical registering of sensory input and a perceptual feeling of continuing
movement (Michotte 1963, 222).

Think of a case as ordinary as one billiard ball hitting another and
launching it forward. The sensory input impinging on the retina registers
two forms, each with its own trajectory. One moves toward the other and
stops. The other then starts and moves away. That is what we see. But what
we feel perceptually is the movement of the first ball *continuing* with the
second. We perceptually feel the *link* between the two visible trajectories,
as the movement "detaches" itself from one object and transfers to another

(Michotte 1963, 14–15). We are directly experiencing momentum, to which nothing visible corresponds as such.

We are presented with a double existence whenever we perceive a movement involving a change of state. With the dot, the change was a disappearance. With the balls, it was causal, an impact effecting a launch. It could be any number of other things, as well: for example, a "tunneling" (one object 'seen' to pass behind another and come out the other side); an "entraining" (one object approaching another and dragging or carrying it off); an "ampliation" (a relay or spread of movement); an attraction, repulsion, or resistance; or, suggestively, an "animation" (a self-propulsion). The variations are endless. But what they all have in common is that accompanying a plurality of forms or a combination of sensory inputs there is a felt-perception of something unitary: a continuing *across* that seamlessly links the separate elements or inputs as belonging to the same change.

A continuing-across is by nature a *nonlocal* linkage, since all of the separate elements participate in it simultaneously from their individual positions. It is a "well-known fact" that these seamless linkages "do not show any observable resemblance" to the objective combinations involved (Michotte 1963, 225). How could they? The linkage is what the objects share *through* their combination: implication in the same *event*. The felt perception of continuing movement is *qualitative* because it directly grasps the changing nature of the shared event 'behind,' 'across,' or 'through' its objective ingredients and their observable combinations. It is, simply: relationship. Directly perceptually-felt; "nonsensuously" perceived.[1]

Now say you walk out of the pool hall and instead of billiard balls you see a car approach another stopped at a traffic light and then collide into it, launching it a few feet forward. The objective ingredients are obviously different. As is the overall affective tenor (about which more later). The perceptual feeling of the continuing-across of movement, however, is unmistakeably similar.

The two continuings share what Daniel Stern calls an "*activation contour*": a continuous *rhythm* of seamlessly linked accelerations and decelerations, increases and decreases in intensity, starts and stops (Stern 1985, 57). The linkage that is the perceptually felt movement has "detached itself" not only from the balls in the first combination, but from that combination altogether. It has migrated from one objective combination to another, neither of which it resembles in any observable way. What the linkage

resembles in migration is only itself: its repeated rhythm. Internal to each of the objective combinations, the unitary, perceptually-felt movement qualifies the nature of the event as a launching. Jumping across the gap from one event to the next, it echoes *itself* in repetition. It resembles *itself* across the gaps. Taken separately, each instance of its repetition resembles not so much other events, as the echoing-itself. Behind, across, or through repetition, the perceptually-felt movement exemplifies itself as a *species* of movement-feeling. It is now a self-exemplifying *quality of movement* beholden to neither car nor ball, as indifferent to the cuestick as to the traffic light, inhabiting its own qualitative environment, in migratory independence from any given context. Pure self-qualifying movement: an autonomy of launching.

## Double Ordering

The ability of a manner of movement to achieve qualitative autonomy in repetition means that the double existence perceived in every change of state extends into a *double ordering* of the world. On the one hand, it is possible to follow the life-paths of objects as they move visibly from one combination to another, and from one event to another. This serial, objective ordering, hinged on the visible form of the object, is what Michotte calls a *"world-line"* (Michotte 1963, 16–17). World-lines *bring identity to difference*: the object's visible form is recognizably conserved across the series of events composing its historic route.

It happens all the time that we jump from one world-line to another, re-feeling an activation contour in its migratory independence as it reappears in different objective combinations, from balls to cars to any number of other things. It is possible to jump world-lines to "yoke extremely diverse events" in perceptual feeling (Stern 1985, 58). This yoking can operate across great distances in objective time and space. A nonsensuous linkage, through its resemblance to itself, can bring an extreme diversity of situations into proximity with each other according to the quality of movement—the activation contour or shape of change—they nonsensuously share. The nonsensuous similarity between distant events brings changes—differencings—qualitatively together. World-lines bring identity to difference. Nonsensuous similarity between world-lines *bring differencings together*. The yoking of events through nonsensuous similarity brings

differencings together, cutting across world-lines and the identities conserved along them. This transversal linkage between world-lines composes a *universe* of migratory nonlocal linkage exhibiting an autonomous order all its own: an order of manners of movement, of qualities of moving experience.[2] This qualitative order doubles the objective order of the world's historic routes, self-detached from it. Unbeholden to it, it is freed of objective constraints. This does not mean that it would be free from all constraint. The qualitative order of experience has at least one major constraint all its own: its "spontaneity."

Michotte insists that the felt-perceptions of movement-quality continuing behind, across, and through objective encounters, of balls or cars or anything else, are not learned. They arise spontaneously. They normally go "unrecognized," even if the objects involved are recognized. Or rather, largely *because* the objects are recognized. The nonsensuous appearance of the movement-quality as such, as a phenomenon sui generis, is backgrounded by the reappearance of the object's identity. Still, felt perceptions of movement quality are operative in all circumstances. If they weren't, there would be no continuing-across of movement. The continuity of movement that comes with nonsensuous perception would go unfelt, fragmented into the discrete forms of the plurality of objects in combination. There would be no direct causal perception, no direct perception of relation, no direct experience of change—only indirect logical association (Michotte 1963, 19–20). There would be no experience of *events* as such. Stern emphasizes that the activation contour, the nonlocal linkage constitutive of the event, is a direct causal perception that normally operates "outside of awareness" (Stern 1985, 52). Fundamentally, it is a nonconscious, operative "*trace*" (Michotte 1963, 19).

## Amodal Reality

Stern makes the point that these operative traces are *amodal*, meaning they are not in one sense mode or another. Nonsensuous, they can jump not just between situations but also between sense modes. If the activation contour that is the signature of the movement-quality is a rhythm of seamlessly linked accelerations and decelerations, increases and decreases in intensity, starts and stops, then the same activation contour experienced in the collision of two cars may also present itself, for example, in a coming together

of musical notes. The operative traces that are activation contours are in no way restricted to vision. They link events of vision to other-sense events.

"Amodal" is a more robust concept for this than the more usual "cross-modal transfer." The term cross-modal is used to refer to a "transfer" between different sense modes—forgetting that what comes and goes *between* them, what actively appears in their interstices as the perceptual feeling of their co-occurring, is itself, strictly speaking, in *no mode*. It is the direct perception of what happens between the senses, in no one mode. All and only in their relation. Purely nonsensuous. Abstract. What is felt abstractly is *thought*. The perceptual feeling of the amodal is the fundamentally nonconscious thinking-feeling of what happens between.

Now instead of thinking of the path of an object along a world-line, think of a body traveling its life-path from situation to situation, recognized object to recognized object, encounter to encounter. That life-path is a world-line intersecting with those of objects, but following its own orientation. At each encounter along the way, an activation contour nonsensuously self-detaches. At each step, operative traces declare their independence, making themselves amodally available for yoking diverse events, across distances in space and time, and across registers of experience. Each trace joins others, accumulating in a qualitative universe all their own.

Up until now in this account, there has been an implicit presupposition of an already constituted subject of experience observing objects as they encounter each other and enter into combination. In a word, there has been a supposition of a self. But selves *emerge*. We are not born into "the" world. We are thrown into world*ing*. Amodal experience, and the qualitative universe of nonsensuous similarity it composes, are active in the *constitution* of the self worlding. The qualitative order plays an active role in that constitution. It participates in emergence. It plays an *ontogenetic* role.

**Form of Life**

Stern discusses the ontogenetic role of amodal experience at a nonconscious level before there is a sense of self. "For instance, in trying to soothe an infant, the parent could say, 'There, there . . . ,' giving more stress and amplitude on the first part of the word and trailing off toward the end of

the word. Alternatively, the parent could silently stroke the baby's back or head with a stroke following the same activation contour as the 'There, there' sequence, applying more pressure at the onset of the stroke and lightening or trailing off toward the end. If the duration of the contoured stroke and the pauses between strokes were of the same absolute and relative durations as the vocalization-pause pattern, the infant would experience similar activation contours no matter which soothing technique was performed. The two soothings would feel the same (beyond their sensory specificity)" (Stern 1985, 58). This is the onset of a spontaneous *self-organizing of experience*. Instead of experiencing a spoken-word parent and a separate stroking-touch parent, the two parenting events yoke together, across their sensory, spatial, and temporal disparities, by virtue of the nonsensuous similiarity of their activation contour. There is one seamless soothing-parent. A new entity, the amodal parent-form, *emerges* as a function of the amodal activation contour, whose lived quality is *affective* (a soothing).

The affective nature of the new form of life that emerges prompts Stern to rename activation contours *vitality affects*. The world is not reducible to the recognized ability of objective form to conserve its sensuous identity in each of its serial appearings in different locations. On the contrary, that ability is the product of another power: that of "unrecognized," nonsensuous, affective, linkages that bring "extremely diverse" nonlocal differences together qualitatively. Affect brings form qualititatively to life.

Vitality affects give rise to *forms of life* that are fundamentally *shared*.[3] The soothing, like a launching, is a unitary continuing-across: from voice to ear, hand to back, hearing to touching. It is all and only in the linkage, which is the separate province of neither infant nor parent. The emergent parent-form is in fact an amodal coming to life of the *relation* between parent and child, through difference-yoking repetition.

## Differential Attunement

The simplicity of Stern's example masks the extent of the relational sharing. The infant is not a passive recipient of the parent's soothing. In a young child, every experience is a whole-body experience. The child's being vibrates with the parent's movements. Mouth gurgles, toes curl, eye blink

then close, arms flutter then still, in rhythm with the soothings. The child's movements have their own activation contour, across sense modalities of taste, vision, tactility, and proprioception.

The child's activation contour parallels that of the parent's, *in counterpoint*. The child does not imitate the parent. What the child does bears no resemblance to what the parent does. The child *accompanies* the parent, in an orchestration of movements *between* their bodies. The parent's movements have an activation contour. The child's have another. *And* the shared experience has an encompassing activation contour in the pattern of point-counterpoint passing between them. The overall activation contour takes up the difference between the parent's and the child's movements into its own complex unity of orchestration. This is what the two participants in the event share: *differential* involvement in the same event. A relational sharing of what comes between, from different angles of insertion into a single unfolding. A cross-embodied *attunement* of immediately linked activations orchestrating a nondecomposable in-between (Stern 1985, 138–142).

The cross-embodied attunements are affective attunements. They are affective in a broader sense than Stern's definition of vitality affect as activation contour. The activation contour carries a qualitative flavor that is more than a movement-quality as such. Soothing is a quality of life-experience that comes with the movements, but is not reducible to the dynamic form that is their vitality affect. The relational quality of soothing that comes with the overall activation contour is like an affective atmosphere suffusing and surrounding the vitality affects involved. It is an *affective tonality*. The vitality affect contributes a *singular* quality of liveness to this event. The affective tonality expresses the *kind* of liveness that is this event's: its *generic* quality. It marks its species. The vitality affect is the perceptual feeling of the region of being and becoming that the sharing under way exemplifies—a soothing versus a fright or frustration. Vitality affect plus affective tonality make every form–of–life singular-generic. The singularity refers to the "just so" of *this* event. The genericness is not to be confused with the objective identity brought to difference following an actual world-line. Rather, it refers to a diversity of events whose singular just-so's are directly, perceptually-felt to belong together, across any distance at which they might occur. It refers to the qualitative self-grouping of events felt to belong to the same region of the universe of nonsensuous

experience. The genericness of an event is with it from its first occurrence. It is the "like this" of the "just so": a fore-echo of return. When once was soothing, more may come. And that "moreness" is integral to the feeling of what happened.[4]

Affective tonality is an essential factor in making the event do what it does and be what it was (Whitehead 1967a, 176, 180, 215–216). For it is not inconceivable that the same activation contours that in this situation add up to a soothing might under other circumstances participate in another form of life, and come like a fright. The relational "form of life" of which it is a question in any given instance is vitality affect plus affective tonality: indissociably both. The form of life being lived is composed of their immediate, mutual inclusion in the event. The affective attunement is thus not just between the component activation contours point-counterpointing into a shared dynamic pattern. It is also the tuning into each other, for this event, of the two affective dimensions of vitality affect and affective tonality.

Affective attunement is *transindividual* (Simondon 2005, 251–253, 293–316). At this level, there is not yet an interaction between two selves. It is all in the occurrent between. The word "form"—either in the special sense of a form-of-life or in the more usual sense of an objective form—does not yet apply to the pointing or counterpointing considered each on its own side. It is only much later that the different angles of insertion into the parental relation will diverge from each other and come to be experienced by both parties as belonging to separate lives each with its own form. The spontaneous constraint of life's qualitative self-organization is that the autonomy of movement upon which it is predicated counterindicates the independence of the forms that originate from it. *It is the separation of forms that is learned*—not their dynamic relations.

The child will eventually learn to separate out what it actually hears, touches, and sees from what it perceptually feels amodally in the relational in-between of bodies. The aural, tactile, visual (not to mention proprioceptive) sense-inputs on each side will be yoked together, yielding two opposing locuses of linkage. The activation contours on either side, parent and child, will detach from their necessarily coming-together. They will begin to diverge, following different life-paths: world-lines. What reappears following each world-line will be recognized in different times and places, involved with various combinations of objects. The recognized

reappearances will solidify, across their variations, into two identities. Objective organization comes, and with it the child's sense of its own independence as a separate, locally self-moving object vis-à-vis another: an embodied self. The child separates into its own form-of-life, and its life no sooner takes on objective weight, appearing even to itself as one object-form among others. The spontaneous constraint of shared differentiation in nonlocal linkage is slowly overcome. The stronger this objective organization of the world becomes, the more deeply will the cross-embodied vitality affect that made it possible recede into the state of a trace. Its operations will continue unaware, with, behind, across, and through the world of objective forms populating life-paths.

Transindividual affective attunements will continue to resonate at every encounter along the way, with new attunements forming at every age. The nonsensuous perceptions with which they come will accompany all social learning and all knowing. But they will remain largely nonconscious.[5]

## Reenaction

The adult is not so different from the child. More than a hundred years before mirror neurons were discovered, James observed that every perception of a movement directly "awakens in some degree the actual movement" perceived (James 1950, 526). "Every possible feeling," James continues, "produces a movement, and that movement is a movement of the entire organism, and of each of its parts" (372). "A process set-up anywhere reverberates everywhere" (381). Whitehead similarly sites an instantaneous, all-absorbing "reenaction" as the initial phase of every occasion (Whitehead 1967a, 192–194; Whitehead 1978, 237–238, 245). In what we call thinking, the acting out of the movement is inhibited, resulting in what Bergson calls a "nascent action," or "virtual movement." The nascent action *is* the thought; thought is virtual movement (Bergson 1988, ch. 1). Point, virtual counterpoint. The difference between the infant and the adult is that the adult is capable of refraining from acting out its nascent actions. The accomplishment of the adult is to gurgle virtually to a soothing.

If we apply this to the examples of object perception used earlier, where there seemed to be an implicit presupposition of a passive subject observing a scene, it is now clear that the "spectator" was as directly involved as

the billiard balls or cars were. The spectator is just as absorbed in the col-
lision, on the level of his nascent actions. He is riveted into affective
attunement, in instantaneous reenaction. Action is only half the event:
action-reenaction; rhythm-reverberation; point, virtual counterpoint. Thus
everything that was just said of the parent-child relation applies to the
direct perception of change involving what we normally think of as con-
stituted objects entering into combination. What is happening is a new
occurrence of the primary coming-together in qualitative relation that,
ontogenetically speaking, is prior to any separation of self-identities fol-
lowing their individual world-lines. In every event of perception, there is
a differential co-involvement in the dynamic unity of one and the same
occurrence. The differential is between roles, or manners of direct involve-
ment in the event (active, reenactive; rhythmic, reverbatory). Every move-
ment has an activation contour, a rhythm of activity: vitality affect.
Affective tonality, for its part, comes with reenaction. It occurs between
the action and the reenaction, the rhythm and the reverberation, express-
ing their mutual inclusion in the same event. The affective tonality—the
excitement of dropping a billiard ball in a pocket, the fear of a car crash,
the soothe of a gesture—is no less a constitutive factor than the respective
events' activation contours. It comes flush with the instantaneous between
of their action-reenaction.

It is in fact the objective order of the world that first "detaches" itself
from the multidimensioned affective/qualitative-relational order of experi-
ence to which it owes its emergence. The detachment of the qualitative-
relational order and the objective order is mutual. This means that the
separable forms that objectively co-populate the world are themselves
traces. Objects are traces of their own detachment from the order of imme-
diately attuned, affectively inflected, direct perception that gave rise to
them. They continue nonconsciously to belong to that qualitative-rela-
tional order, and contribute to it, to the degree that they enter into new
combinations and the combinations change. Each new event retraces the
world's qualitative order, even as it advances by a step the world's objective
ordering. Each time we experience an event, we are nonconsciously return-
ing to our own and the world's emergence. We are in re-worlding. We are
reattuning, and reindividualizing. The ontogenesis of forms of life contin-
ues. New attunements are added to the diversity of events that can be
yoked across distances in space and time. With each event, we are

perceptually feeling the expansion of that universe of qualitative order, as we simultaneously advance along a world-line. Each recognizable body or object available for encounter stands for a potential next step down a world-line. Doubling that step, it stands for a coming expansion of the qualitative universe of directly felt relations through which separate forms of life emerge-together in occurrent affective attunement. From this perspective, a body or object is a *self-archiving of a universe of felt relation*. Separate forms are a tacit archive of shared and shareable experience.

## Open-Range Abstraction

Language gives voice to the archive. It makes it possible to move and share felt relations at any distance from the sensuous object-forms they yoke. Words are by nature nonlocally linked to their formal meaning, since they can be repeated anywhere and anytime. Words also yoke to other words, in a "chain of derivations . . . whereby the local relations" and their sense-perceived meanings may in the end be "entirely lost." At the limit, language can "suppress intermediate links" and operate *only* with nonlocal linkages (Whitehead 1985, 83). It was said earlier that it was possible to jump from one world-line to another. Language makes it possible to jump world-lines, or jump ahead on a world-line, skipping over objectively necessary intermediate steps. Language is the very technique of skipping intermediaries. Skipped "intermediaries" is also a concept James uses in connection with the affective/qualitative-relational order of felt abstraction with which language operates (James 1996a, 175; James 1978, 247–248).

What is the directly perceived "self-detachment" of a nonsensuous similarity from a set of objective conditions if not a *lived abstraction*? What is lived abstraction if not *thought*? Language, skipping intermediaries, takes up the thought-felt abstraction of nonsensuous experience into its own movement. This intensifies the autonomy of nonsensuous perception by incalculably increasing the range of its potential yoking between extremely diverse events. "The paths that run through conceptual experiences, that is, through 'thoughts' or 'ideas' that 'know' the things in which they terminate, are highly advantageous paths to follow. Not only do they yield inconceivably rapid transitions; but, owing to the 'universal' character which they frequently possess, and to their capacity for association with

each other in great systems, they outstrip the tardy consecutions of the things in themselves, and sweep us on towards our ultimate termini in a far more labor-saving way than following of trains of sensible perception ever could" (James 1996a, 64).

Thought, taken up in language, raises the affective autonomy of the qualitative-relational order constitutive of forms of life to a higher power. Language is a labor-saving machine for accelerating and intensifying life activity, thought-skipping the "tardy consecutions" of sensuous perceptions. Language is a thought-machine for adding nonsensuous degrees of freedom to activity. It is a machine for remixing world-lines, skipping us down the lines and cross-jumping us from one line to another. This remix ability enlarges the parameters for the reindividuation of forms of life, beginning from the nonsensuous traces of the affective/qualitative-relational realm and moving back into the sensuous realm of actual action among sense-perceived objects.

James, however, goes on to say that "ninety-nine times out of a hundred" our ideas are actually "unterminated perceptually." It is only as an exception that our thinking effectively reenters the objective order of things to reach a sensuous terminus. It continues on its own path, past the sensuous, making termini thought-felt only in order to keep on moving on. "To continue," he writes, "is the substitute for knowing" in the "completed" sensuous sense (James 1996a, 69). Thought keeps on skipping, with the all the rapidity language can muster. It keeps on living nonsensuous abstraction's moving on.

Whitehead remarked that in the highly abstractive movement of language, nonsensuous perceptions may detach so thoroughly from objects that the "sense-perceived meanings" are entirely lost. Crucial for the present account, the direct perception of their relations is *not* lost. Direct perception of relational qualities of movement and change continues with the movement of language. Affective attunement continues. The nonsensuous universe of life's qualities of relation goes on expanding. The living of life's abstraction goes on going on.

As taken up in language, the thinking-feeling that is nonsensuous perception is exonerated from having to move with the actual displacements of the ongoing event matrix that is the body, as it follows its path through the world. Now the thinking-feeling can follow the flow of words, freed from objective constraints. The infinitely rapidly permutating flow of

words removes all limits to nonlocal linkage: open-range abstraction. This is what is called "thinking." When we pause to think, this is what we're doing: continuing life abstractly. Intensely.

It is paramount to be clear about this: the *world* is never lost in thought. Neither is the world's order lost. What is taken up in language is precisely the qualitative-relational orderings of the objective world: the nonlocal linkages and affective attunements that are the perceptually-felt dynamic form of what happens. Language takes them up. As its moves, the qualitative-relational order of the world moves with it. World-lines permute.

It is always possible, it goes without saying, to go astray in words. Language infinitely augments our powers to delude ourselves. But what language does with respect to abstraction can in no way be reduced to delusion. It also enables truth.

### Foretracing

James defines "truth" as a linguistic procedure consisting in skipping intermediaries *in such a way that they can be reconstituted in actual movement*, given the conditions. This is what he means by "termination" (see chapter 1 on the terminus and the virtual in James). To truly say where a certain university campus building is, when it is not immediately present in local relation and lacks "sense-perceived meaning," is to enable oneself or another to *go* there and terminate the speaking-thinking of it in a sensuous perception satisfying the tending-toward. Truth doesn't represent things. It detaches from them—in order to go back among them. It is "ambulatory" (James 1978, 245–247). Language is the potential for an abstractly initiated movement to terminate in an anticipated sense-perception, no less than it is the potential to go astray in the world by dint of detachment from sense-perception.

What James calls the "meaning of truth"—the true meaning of words— is the pragmatic potential to begin a movement nonsensuously and terminate it in a sense-perception satisfying an anticipation. This is likely what Benjamin had in mind in the opening quotes of this chapter when he said that what is meant is the sensible. Taken out of context, Benjamin's statement might be taken to endorse the reductive view of language according to which its operation essentially boils down to a one-to-one correspondence between words and things. James's observation that the

correspondence is left at odd ends ninety-nine percent of the time seriously skews the putative symmetry between language and its sense validation, scrambling any unambiguous anchoring of language and thought in referential function. The relation of language to the sensible, even in the rare cases it does terminate, is not fundamentally referential, but demonstrative: *that* way; *there* we go; *this* is it. Words point-toward, in active tending, more than they pin down, in logically fixed designation (James 1996a, 55).

"Pure demonstration," however, "is impossible," Whitehead says (1964, 10). (Oddly, he also uses the challenge of finding a campus building as an example of a terminus—evidence perhaps of philosophers' legendary propensity to lose themselves in thought). Pure demonstration is impossible, according to Whitehead, because a demonstrative gesture always takes place against an inexhaustible background of shared presuppositions. Without a tacit truncation of what is meant, the tending-toward would get lost in a thicket of complicating detail. It is necessary to skip potential intermediaries all the more concertedly, in order to get anywhere with language. The impossibility of pure demonstration, Whitehead observes, means that demonstration is *always* essentially *speculative* (Whitehead 1964, 6). Language has more fundamentally to do with speculation than designation, or any form of one-to-one correspondence between words and things. There is always, implied in a linguistic gesture and the thinking it advances, the tacit complication of an ambulation—the potential unfolding of an event against a weltering background. "Thus the ultimate fact for sense-awareness is the event" (Whitehead 1964, 15). The ultimate fact—the truth—is the event and the welter of potential steps it navigates.

The speculative nature of language is underlined by James's remark that in the ambulatory meaning-and-truth process any actual movements advancing meaningfully along world-lines present themselves first virtually, in a pre-thinking-speaking of their terminus. Language projects world-lines in advance of themselves. It *foretraces*. Truthsaying is the language-assisted translation of virtually thought-felt foretracings into actually followed action-paths. If the action-path terminates in sense-perception as the tending-toward speculatively anticipated, it is because the unfolding event has succeeded in navigating the welter of the world. The event's unfolding has accomplished a preoriented selection of intermediary linkages advancing stepwise through sensuous experience, aided at every turn by a backgrounded universe of unspoken, barely thought presuppositions.

At each step, the event's unfolding doubles the complexity of its thought-ambulation with speculatively demonstrative sense-perceptions. Language can as effectively return us to the sensuous world as it can detach us from it in thoughts unterminated and interminable. In fact, the two operations are one: double existence. Two sides of the same speculative-pragmatic coin.

### The Making of Truths Foretold

The ambulatorily-challenged professor can and does get lost in thought and the meanders of language, as we all do at times. The pragmatic-truth potential of language is sometimes weltered-out by the backgrounded crowd of virtual paths and termini coming undemonstratively to the fore. When the event falls too heavily on the speculative side of the coin, we lose the ability to follow through a particular tending-toward to its sensible terminus in stepwise attunement to selectively demonstrative sense-perception. We are lost in too-open-range foretracing. We—our events' unfoldings—are absorbed in speculation. The selectively oriented segueing from virtual foretracing to sensibly sign-posted ambulation is in suspense. Tending-toward does not sensuously terminate. Rather than ambulating, it ambles on. This is imagination: suspended ambulation. In imagination, we are speculatively absorbed in a universe of nascent actions whose terminus-tending unfolding is inhibited. We are free-range navigating the nonsensuous side of the world's double ordering.

This ambling navigating of the nonsensuous side can end up in delusion. This occurs when it is forgotten that the event unfolding is a suspension of ambulation, and premature conclusions about sensuous termini are drawn in the absence of the stepwise conditions for their demonstrative fulfillment. It is not the free-range ambling on the nonsensuous side that is delusional. What is delusional is taking the ambling for a good-enough substitute for an effective ambulation, forgetting that pure demonstration is impossible. Delusion is not a disorder of the imagination, or of thought per se. It is a defective expression of the *positive power* of thought-as-imagination to free-range foretrace, with the meanderings of language. Delusion is in fact a disorder of the *language* factor involved. We are delusional when we forget that the operation of language is not essentially one of designation, that it is never purely demonstrative. We are delusional

when we forget that there is always, essentially, a speculative aspect to language. We are delusional when we forget the double existence of the world: the immediate abstraction ingredient to every experience, the skipping of intermediaries that is always eventfully afoot in one way or another listing our movements to one side or the other of the world's double ordering, or terminally attuning them to each other.

To be delusional is to forget that language and thought, as they virtually go together, are *creative*.[6] Relieved of the immediate imperative to terminate in the world sensuously, free to range as openly as words are wont to do, the thought-movements initiated by speculation in its imaginative usage are enabled to *invent* world-lines previously unheard-of and never before seen. These invented world-lines might, as part of some later adventure, turn out to be terminatable in sense-perception, proving themselves pragmatically true after all. In the meantime, they remain as virtual as the nascent actions they string together in thought, as free as a word.[7]

This signals a second-degree "meaning of truth": the pragmatic potential to invent ways of terminating movements that were initiated nonsensuously in action-paths yet to be seen, world-lines unheard-of. This is the *constructive* meaning of truth: the paths leading to a sensuous termination of the movement begun in thought and language must be brought about. They must be *made*. Their making means that the constructive truth is no less pragmatic than truth in the first, ambulatory, sense. It is speculatively pragmatic with the emphasis squarely on the speculative: intrepidly future-facing, far-rangingly foretracing.

## Powers of the False

Mobilizing intrepidly future-facing creative thought-powers of language, in a mode we might categorize as purely imaginative (literature) or purely speculative (philosophy), is a *political* act: constructive of alternate future paths for the world that extend its qualitative-relational universe of life and the forms of life that potentially co-compose through it. Language, seen from this perspective, harbors what Deleuze calls "powers of the false" (Deleuze 1989, 126–155, 274–175). He inflects "false" away from "erroneous," toward "not yet." Powers of the false as yet correspond to no truth, for the simple reason that they *produce* truths. This power is "false" also in the sense that a thinking-feeling, without the actual feeling, is the

semblance of an event. As indicated in the opening citations from Benjamin, semblance is another word for nonsensuous similarity.

Another way of approaching this is to say that through the activity of language, the directly felt qualities of experience present in bodies and objects in nonsensuous trace-form can cross over into each other with greatest of ease, incomparably increasing the world's potential for self-organizing. The activity of language involves a becoming-active of nonlocal perceptual linkages in their own nonsensuous right. The more active they are in their own right, the greater the number of directly felt-connections they can muster among themselves. This expands their aggregate relational potential. More events, more distantly related in actuality, come into each other's orbit. Their coming into each other's orbit can be repeated in words, and varied with verbal permutations. The ever-varied repetitions invent new permutations on abstract thinking-feeling.

This is entailed by the doctrine of reenaction discussed above: the sensible production of a word reenacts a nonsensuous attunement event. The reenaction is in nascent action. A nascent action is the reenaction of a *tendency* to action. Tendential reenaction recedes by degrees to the limit of the virtual: a tendency to reenact a tendency is itself a reenaction. As is a tendency to reeenact a tendency to reenact a tendency—ad infinitum. The virtual limit, never actually reached, is where the feeling side of the thinking-feeling of language tendentially fades out. The last traces of the sensible go mute, leaving pure unverbalized thought. Reenaction purified of any trace of sense modality: pure amodal reality. No longer beholden to the empirical order of the senses, thought, at the limit, throws off the shackles of reenaction. It becomes directly *enactive*—of virtual events. It becomes purely, virtually active, *producing* nonsensuous similarities: activation contours never felt, but already virtually reverberating; abstract dynamic forms of future-feeling; vitality affects awaiting encounter. Language cannot reach this directly future-feeling limit of thought. But in imagination, it can approach it. When it does, words resonate with virtual thought-events lying on the linguistic horizon. Language fore-echoes with amodal invention. It vibrates with nonsensuously inventive activity. It becomes-active in resonance with pure thought. It is this partnership with pure thought that makes language the "most complete archive" of "semblances in which nothing"—that is, pure thought, pure amodal reality—"appears."

The creative power of language resides in its capacity to echo in its own operation virtual events lying amodally on its horizon. The infinite

permutation ability built into the operation of language expands the world's repertoire of nonlocal linkage to a degree that sensuous forms could never achieve linearly following the world-lines of their actual encounters. The ambulatory potential that language also has to foretrace world-lines gives pure thought a pragmatic issue in the actual world that it does not have on its own. Being infinitely recessive, left to its own devices it moves farther and farther in the other direction, toward furthest horizons of amodal reality. Without language—or a *nonverbal* resonation machine for virtual events (of which, as we will see, there are many)—the archive of experience would be full of nothing appearing to the absolute limit, without so much as a semblance. Void of thought.

The inventive power of language depends on *techniques of existence*: techniques to channel the activity of pure thought toward an issue in the sensuous world, through which the world becomes. Speech is one such technique. Writing is another. The differences between them as techniques of existence are crucial to take into account, but are beyond the purview of this essay, which has a date with the weather to keep.

## Produced Resemblance

Nonsensuous similarity has nothing to do with an analogy based on resemblance. An invented virtual event has no model to contour itself to. It can, under certain ambulatory conditions, contour actual events to itself, although not in any one-to-one correspondence. If there is a resemblance, it is pragmatically produced, like a truth (Benjamin 1996a).

The principle that resemblance is produced applies to the linkage between two sensuous events as well. The sensuous experience of the word "storm" does not resemble what happens in the sky; any more than the sight of a dancing body resembles a downpour, or an undulation of hands a billowing of clouds. The dance and the storm are nonsensuously similar in that *between them* they co-compose a joint activation contour of differential attunement to the same event. As we have already seen, the affective attunement is amodal. It *is* their nonsensuous similarity. It *is* their analogy. The nonsensuous similarity is a being of analogy *occurring* in the in-between event of the two component events' coming abstractly together. It is invented by the technique of existence effecting that coming-together: in the events alluded to by Benjamin, that technique of existence is ritual.

The nonsensuous similarity produced by a bringing-abstractly-together of two component sensuous events results from the echoing of the events in each other, within or across sense modalities. This is possible because the movement-qualities of each component event are already in nonlocal linkage, just as the launching quality of colliding billiard balls or cars was. The dancing body and the storm are self-abstracting in the way Michotte describes: their movement-quality self-detaches from the sensuously regis-trable combination of objects involved. Thus all that is needed is a nonlo-cal linkage between nonlocal linkages: their mutual inclusion in a joint event. As we also saw earlier, what constitutes a mutual inclusion of this kind is the affective tonality enveloping the disparate movement-qualities, or vitality affects. It is the affective tonality that produces the resemblance between the events, by holding them together in itself. It makes the sin-gularity of the activation contours of the two distant events come generi-cally together in a ritual event. The job of the technique of existence of ritual is to set the conditions in place for an affective tonality to be pro-duced and, in appearing, to produce the singular-generic event of a dance and a storm ritually coming-together in nonsensous similarity.

The nonlocal linkage between nonlocal linkages that is at the heart of this operation was just analyzed in terms of thought and language. Ritual is a way of *performing* thought. It is a technique of existence for bringing forth virtual events through techniques involving bodily performance, in mutual inclusion with events of the other kinds. Events, for example, of the heavens, of a cosmological kind. Ritual resonates with virtual events, as the operation of language does. Ritual gestures forth virtual events from the horizon of thought. Language speaks or writes them. The techniques ritual employs to set the conditions for virtual events to appear involve language use of many kinds. But ritual's ability to mobilize affective tonal-ity in order to nonsensuously link nonsensuous linkages to each other hangs specifically on the performative use of language—language as *gesture*. Nonverbal gesture, however, can do the trick just as well, if the conditions for set for it.[8]

### Visionary Semblance

The fundamentally gestural nature of ritual means that the affective tonal-ity of the event attaches most directly to *proprioceptive* experience

(experience that is self-referencing, registering its own unfolding as its only content; as opposed to the exteroception of sensory experience registering impulses from the outside that are in principle outwardly referenceable to objects). The in-between of activation contours is directly kinesthetic. It consists in an immediate echoing of action in reenaction, in an in-between of movements. Action-reenaction is kinesthetic, and kinesthesia is proprioceptive. It references the relation of the phases of an unfolding movement to each other—its accelerations and decelerations, increases and decreases in intensity, starts and stops—as belonging to the same event. Proprioception is not one sense mode among others. It is the mode of experience of the amodal as such. The whole concept of the activation contour is that the "same" contour is to be found across modes, in the *rhythm* of seeing, or touching, or hearing. Rhythm is amodal. It is the abstract shape of the event as it happens, across whatever modes it happens with. It is the immediate thinking-feeling of nonlocal linkage. Rhythm is the amodal in person.

Now that we have seen the extent to which the "sameness" of movement-qualities is a creative production, we can appreciate that proprioception is natively inventive. It is the body's in-born technique for the production of nonsensuous similarity. The body's automatic abstraction method. It operates "spontaneously" under all "natural" conditions, as well as in the laboratory. If it didn't, it is worth repeating, there would be no experience of events. There would be no experience of change or relation. Proprioception is not only abstracting. It is self-abstracting: it is by nature recessive, always already slipping away behind the other sense modes to the nonconscious limit of experience, where sensuous experience rejoins the pure activity of thought (Massumi 2002, 58–61, 168, 179–188). All techniques of existence bringing forth virtual events work with proprioception and its privileged connection with thought.

According to Susanne Langer, ritual is a technique for bringing forth virtual events, nonsensuously yoking diverse events of the bodies and the heavens. Ritual produces a semblance of an event in which nothing proprioceptively appears—but is nevertheless seen. The ritual dancer "sees the world in which his body dances" (Langer 1953, 197). Ritual technique performs virtual events furthering vision beyond where it actually stops and behind where it continues, into other, cosmological, worlds that are really, virtually, nonsensuously felt to double the sensuous world. Ritual produces a perceptual feeling of seen cosmological spaces. Its gesturality is

visionary. It involves proprioception in the invention of a virtual event of vision, of a cosmologically spatializing kind. Ritual technique produces a cosmological semblance of a spatializing event of vision, perceptually felt at a point of indistinction with cosmological thinking.

### Semblance of a Truth (in Double)

This perceptual feeling in vision of spaces thought-seen beyond the sensuous ken of sight might be dismissed as a mere hallucination—were it not for the years of hard training, the practiced technique, and the meticulously prepared collective context necessary for the event of its performance. If this is hallucination, it is not "just" a hallucination. It is a collective availing of the creative powers of the false incumbent in all experience. It is less a hallucination in the pejorative sense than an *invoked relational reality*. That is what ritual does: it invokes into occurring a collectively shared nonsensuous experience of a cosmological kind. This is a speculative dance of the imagination: a cosmological *semblance of a truth*, abstractly lived, with all due amodal intensity.

An abstractly lived truth of this kind may in fact find ways to ambulate along actual world-lines, to terminate in sensuous experience that would not have been possible by any other route: a renewal or a healing; a war-avoiding or a peace-making; a renegotiating of relations of reciprocity and power. The virtual events of ritual are not without their pragmatic truth potential. They are not only shared, but have their own efficacy. The intensity of the affective tonality with which they envelop vitality affects may effectively carry truth-producing powers. The relational reality invoked may foretrace world-lines whose terminations positively come to pass. If, that is, the bodies attuned to each other and to the cosmological realm in which they are co-implicated by the ritual are so moved, nonsensuously. This production of ritual truth is accomplished as if by magic, through *suggestion*: the suggestive force of the shared nonsensuous experience. A semblance of a cosmological truth carries "magical" power to move bodies without objectively touching them, and to make things happen without explicitly ordering the steps to be followed, as long as the conditions have been set in place with the appropriate intensity of affective tonality, and with the necessary technical precision. That this process is suggestive makes its truth-producing no less real, no less effective, no less technical, no less pragmatic, no less terminally true.

## SECOND MOVEMENT: LIFE UNLIMITED

### Semblance of a Truth (in Depth)

Language may be the most complete archive of nonsensuous similarity, but the technique of ritual shows that it is eminently possible to activate and disseminate relation by predominately nonverbal means. It was said earlier that objective forms are the sensuous traces of essentially nonsensuous qualitative-relational experience. It follows that any differential attuning of sensuous forms to each other is a way of performing virtual events, permuting or inventing nonsensuous similarities, and producing speculatively pragmatic truths, or semblances that foretrace them. Sensuous forms may also constitute an "archive" of relational experience.

Susanne Langer treats forms as mundane as perspective painting in just this way. In a painting, "everything which is given at all is given to vision" (Langer 1953, 73). But we perceive more than we see. We see surface but perceptually feel depth. Thus there must be in the painting "visible substitutes for nonvisible ingredients in space experience": "things that are normally known by touch or [the proprioceptive sense of] movement" (ibid.). This couching of nonvisible trace experiences in visible form can only be achieved if the artist "departs" from "direct imitation" (ibid.). The artist must falsify vision in just the right way to produce an effective inclusion in the visible of what cannot be seen. In other words, she must paint not the visible resemblances her eyes see in sensuous form, but rather the nonsensuous similarity between vision and other-sense events that yoke together amodally in movements through space. If painted with enough artifice, their linkage will be activated even in the actual absence of the movements and spaces to which they belong. The painting archives amodal, nonlocal linkages that operate through vision but are not contained by it.

Because of the necessary falsification involved, Langer calls the semblance of space an "illusion." But she also emphasizes the extreme "artifice," the mastery of technique, necessary to "construct" the semblance. One philosopher's illusion is another's produced truth. Perhaps we can halve the difference and say in this case *truth-likeness*. Unless and until the art-constructive process prolongs or initiates tendencies toward new pathmaking activity in the world, becoming political in its own inimitable

aesthetic way, what it has produced remains a semblance of a truth concerning space and movement (see chapter 2).

The experience of space we feel when we view a painting, Langer emphasizes, is a real experience of space and the potential movements it affords. It's just that the space is virtual. Visible form has been used as a *local sign* (James 1950, 155–165) of nonlocal linkages. The function of the local sign is catalytic. A sensuous form has activated the formation of a "created . . . virtual form" (Langer 1953, 172, 173). The canvas, pigment, and frame that are actually seen are the local signs hosting the semblant event.

Perspective painting is like ritual in that it produces an experience in vision of a spatialized virtual event. The virtual space of perspective painting, in contrast to ritual space, is fundamentally this-worldly, projecting a geometric formalization of the empirical order. Think of landscape painting. Through the device of the vanishing point, the perspective order producing the perceptual feeling in vision of depth is posited to continue out through the painting. The painting projects, beyond its frame, an extensive continuum that virtually rejoins the actual spatial order of the unpainted world within which its frame is nested. Perspective painting in this way posits its virtual event-space as *as-good-as-actual*—while in no way hiding the rigorous artifice necessary to produce this effect (though the salience of the event's artificiality may later subside, through processes of habituation and conventionalization, if not through an ideological project of normalization).

A produced virtual event that mobilizes its power of the false to posit itself as as-good-as-actual is "representational." The semblance of truth produced by representational techniques is a *semblance of the empirically real*, according to a definition of the empirical that equates it with the objective order. The aim to equal the empirically real foregrounds the element of produced resemblance—while disavowing it. The brush strokes through which a landscape is nonsensuously seen do not objectively resemble a pasture, any more than the word "storm" objectively resembles what happens in the sky, or a dancing body a downpour. The resemblance—like all resemblances—is produced, by essentially dissimilar means. This is lost from view in representational art.

A representational technique of existence foregrounds the produced resemblance to particular effect in the kind of semblance it creates. It

foregrounds the resemblance in a way that suggests that it actually stands behind the painting producing it, authorizing it, and guaranteeing its truth-likeness. A perceptual feeling is produced that the seen resemblance is the founding principle of the semblance. This glosses over the differential nature of the attunement between senses, between the sensuous and the nonsensuous, and between spatiality and movement potential, upon which the semblance's appearance depends. The principle of resemblance privileges the sensuous forms, divorced from this background of differential attunement. The resemblance is felt to be entirely between sensuous forms. The virtually occurrent, nonsensuous qualitative-relational order is outshone by a resemblance whose production could not have occurred without it.

The nonsensuous qualitative-relational order is replaced by a *formal order*: the geometric order of perspective. The geometric order exhibits itself in the perceptual event performed by the painting. It is also used to formalize techniques for the construction of perspectival paintings. The geometric order comes before as technique, as well as being exhibited with it. Coming before and with, it appropriates the event of the painting to itself. The geometric order is felt. It is a lived abstraction. But it is felt-not to be an event. It is posited by the experience as an a priori: an eternally preexisting, abstract frame; a transcendent abstraction rather than an integrally lived abstraction. It is this transcendent abstraction that purports to be foundational, and its purporting to be foundational authorizes and guarantees the produced resemblance. This makes the resemblance appear not only necessary but "natural." The resemblance is made to be *reflective* of an eternal, necessary, natural order. That order arrogates the abstraction of the painting to itself. The lived abstraction of the qualitative-relational order of nonsensuous similarity, its ever-occurrent contingency and spontaneity, is lost in the reflected glare. The resemblance is now guaranteed to be between sensuous forms. The resemblance between natural forms is authorized to be a "natural" reflection of a necessary transcendent order. Since the eternal order of transcendent abstraction is posited as the principle behind the resemblance, the resemblance stands in its reflection as in principle unproduced. Perspective in representational painting produces a semblance of unproduced resemblance exhibiting itself as the natural order of sensuous objects: the objective order of sensuous forms.

The painting is experienced as formally "reflecting" the truth of an objective order within its frame: in its sensuous content. The frame of painting closes on the sensuous scene it contains, even as the scene reflects an abstract frame so transcendently wide open as to encompass the entirety of the objective world in its principle of order. This opening onto the world beyond the painting's frame—the "window" on the world and its a priori order the painting makes appear—is purely formal (Panofsky 1991, 27). It is abstract in a purely formalist sense. A *formal abstraction* is one which produces an opening onto the whole world through reflective closure.[9] The speculative-pragmatic truth that the painting is a semblance of *a* truth (participating in the world's worlding), and not a reflection of *the* truth (of the world's objective already-thereness), is windowed out of view. A representational semblance of a truth is one that denies that it is one. It produces a semblance of a not being a semblance. This is what is often called "realism" in art.

The nonsensuously lived order, analyzed in this essay as "doubling" the ordering of objects as a universe of qualitative relation furthering experience through inventive events of becoming, is real but nonrepresentational and *nonobjective*. It is moving, occurrent, affective, qualitative, relational, potentializing, becoming, spontaneous. It is self-abstracting from the objective order, in continual, moving, intensely perceptually felt excess over it. It is *more than* objectively real. It can never be contained within a frame. It is never reducible to the sensuous content of any framing of experience. It is not reflective of the objective order. It is self-detaching from it. It is the immediately lived reality of the objective order's spontaneity, in encounter and eventful transformation: its changeability. Its creativity. Its semblance as immediately lived abstraction, directly perceptually felt, unauthorized and without guarantee. Purely occurrent.

If perspective painting is illusionary, it is only in this sense: that the semblance it produces, produces a semblance of not being one.

## Departing from the Semblance of Depth

There are practices of painting and drawing that which disturb the semblance-of-not-being-a-semblance of realist art while retaining something of perspective and representational content. This is accomplished by making felt the fact noted by Langer that nonvisible reality can be made

to appear in vision, that nonsensuous similarity can be made to perform itself through sensuous form, only if the technique departs from what has come to be experienced as direct imitation. The departure, more or less subtle, is from techniques reenforcing the habitual, conventional, or normalized experience of the artifact's semblance-of-not-being-a-semblance. The departure from the representationally reigning techniques creates a crack in the window through which the artifact's powers of false show, in perceptual feeling.

Take portraiture. Paul Valéry, discussing Degas's portrait drawing practice, writes that "the peculiar alteration that an artist's manner of executing . . . makes the exact representation suffer" exerts a "power of transposition" altering the "manner of seeing" incumbent in the drawing. The drawing's manner of seeing "significantly extends itself to include: manner of being, being able, knowing, wanting" (Valéry 2003b, 206–207). In a word: it extends itself into a form-of-life. The "drawing is not the form," if by that is meant a visibly sensuous form (Valéry 2003b, 205). The form-of-life departs from the drawing in that sense of form.

When a human form is taken as a point of departure, the drawing is the appearing of a complex form of life: a multiplicity of vitality affects are mutually included in an event of vision, enveloped in the affective tonality of the sight of the drawing, and appearing virtually to "reconstitute *someone*" (Valéry 2003ba, 207). The more exact the representation, the more "detestable" the drawing (Valéry 2003cb, 81). The more intense the perceptual feeling of form-of-life, the more successful the drawing. And paradoxically, the more intense the perceptual feeling, the more *impersonal* the drawing becomes ("someone"). The reconstitution is not of a particular "someone," since the drawing has taken great pains to depart from any such focus on representing. The "peculiar alteration" the drawing suffers makes it commit a *"personal error"* (Valéry 2003ba, 207; emphasis in the original). It makes an art that is purportedly of the personal, creatively "err" in that apparent vocation. It makes a self-respecting semblance of it again.

In chapter 3, the drawing of a peculiar alteration which exerts a power of transposition that creatively extends a manner of seeing into a form-of-life, understood as a complex manner of being/being able/knowing/wanting appearing eventfully together in virtual mutual inclusion, was termed a *diagram* (Deleuze 2004b, 81–90). The diagram was considered a

technique of existence. Conversely, every technique of existence can be considered a diagram. Valéry treats Degas's drawing as a diagram. Deleuze corroborates Valéry's main point: "the suprasensible diagram is not to be confused with the audio-visual archive" (Deleuze 1988a, 84, translation modified). It "doubles" the order of sensuous forms and their history with a "becoming of forces" (manners of being/being capable/knowing/wanting) (Deleuze 1988a, 85; translation modified). Semblance and diagram-as-technique-of-existence go doubly, becoming together.

Every vitality affect is a relational form-of-life. Left to their own devices, they are partial: they self-detach from the objects-in-combination implicated in the event. The combination of objects is only a part of what is objectively present since the encounter occurs against a background of other combinations whose own dynamic form is not positively doubled by the nonsensuous trace created. The dynamic form of the encounter stands out from them, in semblance. The partiality of the semblance's standing out is self-selective: spontaneous, autonomous.

"Realistic" portrait drawings that fail to "err personally" bind a complex of vitality affects together into the semblance of a whole, in disrespect of their partiality and the autonomous self-selecting of their standing-out. The sensuous form from which the semblance of the whole detaches is the tip of a nonsensuous iceberg. An unseen depth of personality is perceptually felt "behind" the semblance. This suggested depth of personality replaces the actual background of the experiential event of the drawing. Once again, resemblance appears as a founding principle. This time, it is the resemblance of the partial view of the person presented by the drawing to the unseen whole: a self-resemblance. The autonomous partiality of vitality affect is subordinated to a suggested whole whose showing sensuous tip is seen as its dependent part. The part seen is nonsensuously owned. Its selectivity is wholly integrated.

The principle of resemblance in this case—the self-resemblance of the dependent part to the owning whole—is authorized and guaranteed by no objective order. There is indeed an order, and it is again felt to be transcendent. But now it is a subjective order. The portrait is a "window" on the soul. The perceptually felt content of the portrait is an inner landscape where the truth of the soul resides. The picture is of self-transcendence, the truth of personal soulfulness. The drawing purports to truly harbor content. The frame of the drawing contains an inner landscape of

unplumbable depth. Its sensuous closure opens onto a whole subjective world. The drawing is as-good-as subjectively real. The semblance that effectively appears once again purports not to be one. Rather than assuming its status of nonsensuous similarity tuned to real differentials, it subordinates itself to a subjective principle of self-identity. Instead of making felt its participation in a double existence between sensuous form and the nonsensuous universe of a qualitative-relational order whose elements are autonomous and contribute their spontaneity to it, the semblance settles for the redundancy of self-resemblance. Instead of living up to the power of the false, it settles for a "the" truth.

Returning representation fully to the status of the semblance, freed of its pretense to the truth, means peculiarly departing from the representation in such a way as to reimpart an impersonal force of vitality to what otherwise, "realistically" speaking, would appear to be personal. Valéry's "someone" is Deleuze's "fourth person singular" (Deleuze 1990, 141). Not some particular person but a form of life "in person"—directly perceptually felt in all its abstract intensity, qualitatively-relationally more-than objectively real. Not inner being: "extra-being" (Deleuze 1990, 7). The drawing has yielded from sensuous form an event of extra-being. Art of this kind is best called "figural," to distinguish it from the representational ("figurative") art from which it departs (Deleuze 2004b, 10–13, 31–38; Manning 2009b, 170–183).

Departing from representation means returning the semblance to the event of its native abstractness: the spontaneous, impersonal force of thinking-feeling that comes amodally to vision through the cracks in the artifact's sensuous form. The feeling of human depth that conventionally accompanies a rendering of a human figure of the kind that aspires to representational "exactitude" is brushed away. The "peculiar alteration" of line that returns the semblance to itself is unabashedly, wholly and only, technically, *on the surface* of the paper or canvas. The semblance speculatively-pragmatically detaches itself from *this* surface, peculiarly, singularly, directly for the abstract seeing. "Everything now returns to the surface," self-abstracting (Deleuze 1990, 7). The semblance makes no pretense of making another world appear, or of being authorized or guaranteed by a depth of order objectively underlying this world, or again of reflecting a subjective depth of personal experience. Returning to the surface, the better to detach from it, the event of the figural is ambivalent toward its

own sensuous content. It *de*-limits the surface, without giving it the semblance of depth that would make it a virtual space for the content to be abstractly contained in.

The alteration that returns drawing to semblance is, simply, a *line* (Valéry 2003c, 78). The peculiarity of the actually drawn sensuous line is doubled by a perceptually felt abstract line. Their in-between is constitutive of the semblance. Between them, they *gesture* to a *style* of being and becoming, in the fourth-person singular: a dynamic form-of-life "in person"; impersonal force of vitality detaching itself from someones in particular to affirm its own qualitative-relational consistency; "a" life (Deleuze 2007, 388–393; Manning, forthcoming b; on style, Valéry 2003c, 81). If the drawing is actually of someone, if it was made from a live model, it is more precise to say that the actual person from which the semblance has detached belongs to the impersonal force of vitality this event brings to surface expression, than it is to say that the semblance belongs to the actual person as his or her true resemblance. The likeness of the actual person is but the host of the semblance's qualitative-relational event: its local sign. Any person to which the drawing corresponds is more *possessed by it* than possessing of it. Figural drawing returns a quasi-magical power of gesture to representational art. It makes-felt *personification* as a force of life in itself, in excess of any given instant or instance of its actual taking sensuous form. It makes appear what Benjamin would call the "aura" of a person. Benjamin defines aura as "the unique apparition of a distance, however near it may be." In the vocabulary of this essay, Benjamin's "aura" is the singular and immediate perceptual feeling of a nonlocal linkage (Benjamin 2003, 255).

This, oddly, allies drawing to ritual. Ritual, as a technique of existence, reaches to the sky in order to bring to cosmological expression magical powers of gesture. Figural art as a diagrammatic technique of existence departs from representation to bring *stylistic* expression to quasi-magical powers of gesture. Rather than realistically evoking a transcendent feeling of a certain someone's depth of person, it peculiarly, stylistically invokes the directly perceptually-felt excess of a self-detaching surface-force of personification immanent to "someone." As with ritual, the creation of this effect requires rigorous technique performed under prepared and propitious conditions. The conditions for the drawing's success are also sociocultural: the suggestiveness of portraiture is no less an invoked relational

reality than the suggestion of ritual. It is not in all cultures at all times that the relational conditions are propitious. Valéry's account of figural drawing, published in the 1930s about art from the previous century, was already retrospective. Under the combined pressures of the rise of mechanical reproduction famously analyzed by Benjamin (2003) and abstract art's complete rupture with representation, the sociocultural conditions had already passed beyond a threshold.

The gestural kinship between figural art and ritual fell into abeyance. Which is to say: into potential. Which is to say: potentially drawn back out, intensely, reinventively, to surface again. Antonin Artaud's drawing of magical "spells" in his works on paper of the late 1940s does just that, making an effective neoarchaism of figural art.

To understand these drawings
   as a whole
     one has to
     1) leave the written page
           to enter into
    the real
        but
     2) leave the real
          to enter into
              the surreal
              the extra-real ...
              into which these drawings
                keep on
                plunging
            seeing as they come from here
          and seeing as they are in fact ...
    but the figuration
    on paper
    of an élan
    that took place
    and produced
    magnetically and
    magically its
    effects
      and seeing as these
      drawings are not the

Antonin Artaud, *Self-Portrait,* 1947, Musée National d'Art Moderne, Centre Georges Pompidou, Bequest of Paule Thévenin, 1993

representation
or the
figuration
      of an object
or a state of
mind or fear,
of a psychological
    element
    or event,
      they are purely
      and simply the
      reproduction on
      paper
      of a magical
         gesture

<div align="center">(Artaud 1948, 34–35)</div>

## The Unlimited Returns

Abstract art frees the line from representation, as radically as possible. In doing so, it frees vision from the task of having to depart from realistic content, as well as freeing it to forego personification. Its lines (and contrasts, and color fields) double the sensuous surface of the canvas or paper with a sense of movement perceptually felt in vision, but not continuing "behind" anything else or "beyond" where it goes. Pure activity of vision, stirring itself, but going absolutely nowhere other than with *this* visual event, stalling any possibility of a pointing-toward a something or particular someone beyond its own occurrence. Vision self-detaching into its own virtual event: *semblance of seeing*. Semblance of a truth of vision.

Abstract art returns vision kinesthetically to its own self-creative activity. Vision is remitted to the felt activity of its coming eventfully into itself: a proprioception *of* vision. Pure visual activity, at the absolute vanishing point where it enters a zone of indistinction with thought, from which its action is ever renascent. Pure thinking-seeing, perceptually felt. The abstract opening of vision onto thought is purely dynamic. It brooks no closure. Unspatialized, eschewing content; neither containing nor contained. "The unlimited returns" (Deleuze 1990, 7).[10]

Any technique of existence can be de-limited (as the figural does for drawing or painting), or unlimited (as abstraction does for all of the plastic

arts), in a virtual event returning its predominant sense mode or principal experiential factor to its own activity, at a point of indistinction with thought. The more unlimiting this event is—the more speculative its force—the more difficult it becomes to imagine an ambulatory conversion along invented world-lines from semblance of a truth to pragmatic truth. That translation, however, is always possible, given creative impulse of adequately open-range and powers of the false of an intensity commensurate to the purity of the virtual stirring. The more abstract and unlimited the event, the more dynamically it will stall on its own occurrence. Active cesura. Break. Brake. Translation awaits, in an inaugural stalling of eventful foretracing. The visual event expresses its coming into itself, already intensely tending, but as yet unextending toward others to come. Pure intensive expression, without person, object, or issue. Open expression, in just *this* event, and only of it.[11]

## Animateness

There is a move from modern dance to contemporary dance that parallels the change from figural drawing to abstract art. The transition is classically seen in the difference between Martha Graham and Merce Cunningham. Graham's modern dance made symbolic use of gesture. The movements of the body were deployed to evoke depths of personal feeling striking a universal chord. Dance, she wrote, "is the evocation of man's inner nature . . . the history and psyche of race brought into focus. . . . The reality of dance is its truth to our inner life. Therein lies its power to move and communicate experience." The role of dance is to evocatively communicate an extra-dance truth, construed as the universal truth of "man." Its "reality . . . can be brought into focus—that is, into the realm of human values—by simple, direct, objective means" (Graham 1998, 50, 53). Simple, direct, objective means: operating metaphorically.

Cunningham disables metaphor and cuts communication. He strips dance of "all representative and emotional elements that might drive movement . . . to focus on pure movement" (Gil 2002, 121). The focus on pure movement brings dance integrally back to the "kinesthetic sense," as taken up in vision: specifically at the vanishing point where proprioception enters into a zone of indistinction with thought. Dance kinesthetically "appeals through the eye to the mind" (Cunningham 1968, 90).

It can do this only if actions are "broken up" (Cunningham 1968, 91). This means disarticulating the objective interlinkages that form between actions following actual world-lines, binding them into recognizable pathways with pre-understood meaning. It also means "emptying" movement of any symbolic evocations or metaphorical associations that might build upon this pre-understanding (Gil 2002, 121–122). Cunningham's uncompromising de-Grahaming of dance excludes any "meaning" that is not "betrayed immediately by the action" (Cunningham 1968, 90). Dance thus actively recurs to the immediate thinking-feeling of bodily gesture. Withdrawn from any in-built relation to extra-dance reality, it recurs to its own event. To what it can do best, and better than any other technique of existence: give immediate meaning to bodily gesture, in and of itself. But what "meaning" can pure bodily movement have once it is "broken" and "emptied? Only a creative semblance of meaning—a speculative meaning of a singularly dancerly kind.

Valéry anticipates the Cunninghamian transition to contemporary dance. "Most of our voluntary movements," he writes, "have as their end an exterior action: it is a question of reaching a place or an object, or of modifying some perception or sensation at a determinate point. . . . Once the goal is reached, once the affair terminates, our movement, which was in a certain way *inscribed* in the relation of our body to the object and our intention, ceases. The movement's determination contains its extermination; it cannot be conceived or executed without the presence and collaboration of the idea of the event terminating it" (Valéry 2003a, 27). "There are other movements," he continues, "whose evolution no localized object excites or determines, can cause or conclude. No *thing* which, rejoined, brings resolution to these acts." Movements of this kind have "dissipation itself for its object." Such movements are "an end in themselves." Since this is an "end" without conclusion, all of this amounts to creating a perpetually "nascent state" as an end in itself (28). Lacking an immanent principle to terminate or finally determine its movements, the movements "must multiply" until some "'indifferent circumstance" intervenes from without to dissipate them: "*fatigue*, or *convention*." Even this intervention from without brings no conclusion. The movement returns to the end it carries in itself: its nascent state. Paradoxically, when dance movement takes dissipation for its only external object, it becomes self-moving, ever returning itself to a nascent state. It becomes self-reenergizing. This "modifies our feeling of

energy" (28). What it means to feel bodily energy changes: it is now imme-
diately thought-felt, in perpetual nascency, unmediated by any predeter-
mined idea of finality. This change, this gestural opening to an experience
of movement unlimited, is the semblance of meaning produced by dance
as pure movement, or what Gil calls "total movement" (Gil 2001).

When gesture is deprived in this way of its terminus, its pragmatic truth
potential is suspended. This makes it a purely speculative activity. Any
determinate relation to an objective order or a subjective realm of personal
intention that may be habitually or conventionally "inscribed" in it is ex-
inscribed. The movement relates only to its own self-energizing event. The
unlimited recurring of dance to its own event is just that: an eternal recur-
rence. When gesture's determination is no sooner its extermination,
making it as self-dissipating as it is self-energizing, movement enters a state
of perpetual turnover onto its own rebeginning. Gesture barely just made
folds over into gesture already in the making, in continuous variation.
Movement "doubles back on itself" (Gil 2002, 123). Each doubling back is
both an actual transition between actual movements and a *form of transi-
tion*. The form of transition belongs to no one movement. It comes between,
with its own qualitative-relational feel. It is a nonlocal linkage. Vitality
affect. The experience of the dance is of the nonlocal linkages, not the
individual movements taking separately or even in aggregate. The order of
the dance as such is the order of the nonlocal linkages' turning over into
each other, their relational qualities accumulating in a "Universe of Dance"
(Valéry 2003a, 31) spontaneously detaching from the actual surface of the
body, doubling its actual movements. This is the universe in which bodily
vitality affects are kinesthetically thought-felt to merge and diverge, repeat
and vary, fold in and out of each other in their own manner, sui generis,
exonerated from both the objective constraints of world-line formation
and subjective pre-understandings of their human symbolic significance
or metaphorical associations.

Asked to define the body, William Forsythe answers: "a body is that
which folds" (Forsythe 2008; Manning 2009a). A body is that which
doubles back on itself in a perpetual turnover of gestures, from which a
universe of bodily forms of transition self-detach, in live performance, to
compose a sui generis order that nonsensuously "diagrams" the body's
potential for infinitely renewed and varied movement. Performed event of
the body's vital self-abstraction.

Deleuze says of the diagram that it is "not a place, but rather a 'non-place': a place only of changes" (1988a, 85). The universe of dance in which the event of the body's self-abstraction nonsensuously occurs is not a "space."[12] It is a non-place, made only of forms of gestural change, bodily forms of transition, in a state of perpetual nascency. Each actual movement from which the dance self-detaches no sooner arises than it returns to the continually repeated variation from which it came. Each actual movement's orientation is to repeated change, doubled by an accompanying alteration in the self-detaching nonsensuous order of nonlocal linkages. These qualitative-relational "movements which are their own ends" have "no direction in space" (Valéry 2003a, 28). They self-abstract from the space of actual bodily movement. Not into another space of the body doubling its actual world with another (as was the case with ritual dance), but rather into "Time" (Valéry 2003a, 31). The space of contemporary dance is a temporal realm of "acts" (31) whose incessant dissipation and rearising makes nonsensuously felt energetic bodily change, in a perpetually nascent state "emptied" of both human meaning and pragmatic potential for termination.[13] Dance makes directly perceptually-felt time of the body expressing its potential for change.

The dance is the conversion of the body's movement in space into the Time of its alteration: its speculative translation into a universe of pure bodily becoming. The life of the body unlimited, in a pure experience of its becoming. Semblance of life. Embodied life: pure expression of the body's aliveness. Animateness as such.

The semblance of meaning produced by the dance is a direct, perceptually felt experience of the body's power of animate becoming. To dance is a technique of existence for performing a felt "consciousness of life": a direct "sense of vital power" experienced in a "play of 'felt energies'" (thought-felt-movement energies) that is as "different from any system of physical forces" (Langer 1953, 175) as space is from time. What is performed are "dance forces, virtual powers" (176). "The dancer's actual gestures are used to create a semblance of self-expression, and are thereby transformed into virtual spontaneous movement, or virtual gesture" (180). Semblance of self-expression: pure impersonal expression of bodily power, in nonsensuous excess over the body. "Superabundance of power" (Valéry 2003c, 31). Body unlimited. Abstract energy of embodied life unrestrained by content (Langer 1953, 174). The life amodal.

The dance as such is composed of nonlocal linkages: directly perceptually felt vitality affects. The danced vitality affects are singular. It is of the nature of performance that the "felt energies" of each performance are qualitatively different. The felt force of the performance varies night to night. The vitality affects' singularity, however, is enveloped in a generic performance envelope. Danced vitality affects are singularly enveloped in a generic affective tonality: that of dance itself as a domain of creative activity, or technique of existence. There is a generic thinking-feeling of dance's emptying of bodily movement that is incomparable, for example, to the thinking-feeling of figural drawing's de-limitation of personality. If there is any similarity between the two domains of activity, it is a nonsensuous similarity, thought-felt in the way a play of nonlocal linkages brings differencings together across varied repetitions.

## THIRD MOVEMENT: THE PARADOX OF CONTENT

### Of Force and Fusion

The technique of existence to which dance is traditionally considered most nonsensuously similar is music. Langer roundly criticizes the notion that dance dances music, or even rhythm (Langer 1953, 169–171), rather than purely "dancing the dance" as Cunningham insists (Gil 2002, 125). Cunningham's point is that for dance to take itself to the highest power, in order to express most purely the body's animate power, it must expunge itself of extra-dance elements (by "breaking up" movement). Any use that may be made of music, language, décor, visuals, lighting effects, must fuse into the dancing of the dance, taken up in it to become an element immanent to it—just as touch becomes an element immanent to sight in the everyday experience of perceptually feeling a texture through vision. Dance, like vision, or any other technique of existence, is a *relational field* that is as heterogeneous in its constitution as it is all to itself in its affective tonality and force of becoming (the powers of the false it marshals). There is a generic feel to seeing, even though every sight is singular, just as much as there is a generic feel to dance, even though every performance is different.[14]

Each technique of existence brings to singular-generic expression a relational field that is in principle infinite in its diversity. A technique of existence is defined less by the catalog of its elements, than by the

relational manner in which it eventfully effects a fusional mutual inclusion of a heterogeneity of factors in a signature species of semblance. It is defined by the manner of the event of lived abstraction it performs. As suggested in chapter 2, an evaluation of a technique's manner of event can replace the notion of the "medium."

The fusional practice of making extra-dance elements become immanent to the dance is best seen in the work of choreographers like William Forsythe, whose creative practice embraces a wide diversity of compositional elements. Cunningham, for his part, took great pains to maintain a radical disjunction between dance and music, insistently holding them in a relation of "nonrelation" (Gil 2002, 118). Relations-of-nonrelation, however, in no way exclude fusion. In fact, when the fusion does occur, it can be all the more striking. The audiovisual fusion in cinema discussed in chapter 2 in relation to the work of Michel Chion arises from a disjunction between sound and vision. To use the classic example, a cut may go directly from a swinging arm to a reeling body, skipping over the blow. The visuals of the blow are replaced by the sound of fist hitting jowl. Nevertheless, most spectators will report having *seen* the blow. The blow was really perceptually felt in vision, in what Chion calls a "synchretic" fusion of sound and sight occurring amodally across the disjunction between visual segments, and between them and the sound track. The effect is unitary (*a* blow). But the unity of effect is entirely owing to the experiential differential that is its compositional principle. The compositional technique employed was nondecomposably audiovisual. It occurred in the amodal between of hearing and seeing. It could not have occurred had sound and sight not come-together just so, in just this disjunctive way (timing is everything; technique is everything). Still, the resulting strike-effect is thought-felt in the affective tonality of vision (in a "withness" of the eyes; Whitehead 1978, 64).

Cunningham's insistence on the "autonomy" of the dance and the music cannot exclude this kind of synchretic fusion, only make it rarer by contriving it to occur only "by chance." Any fusion effects occurring will be thought-felt in the affective tonality of danced gesture, just as in the audiovisual example the synchresis was felt in the affective tonality of vision. The perceptual feeling of the cinematic strike is contrived in such a way that the disjunction is not experienced as such. The experiential differential is contrived to operate nonconsciously. The composition of the relational field of the fusion-effect's emergence disappears behind the

drama of its effect. If we apply this to Cunningham's technique of holding music and dance in extreme disjunction, it is not necessary to see it as a refusal of dance fusion and of the making-immanent to dance of music. Instead, it can be seen as a practice for bringing an awareness of the disjunctive operation of experiential fusion to the surface of dance, making consciously felt the fact that the compositional principle of this technique of existence, like all techniques of existence, is *always* differential.[15] There is always disjunction. No technique of existence can so purify its field as to make it homogeneous: simply non-relational. All techniques of existence operate through relations-of-nonrelation. Experiential fusion-effects. Mutual inclusion of a heterogeneity of factors becoming, singular-generically, forces of pure expression.

"Pure" does not mean homogeneous or simply nonrelational. "Pure" means: having the compositional power to mutually include; to bring differentials of experience together across their disjunction, to unitary experiential effect; to effectively convert heterogeneous outside factors into immanent forces of singular-generic expression.

It was the *force* of the blow that was audiovisually perceptually-felt in vision, as the cinematic event. The sound occurred with synchretized cinematic force. "Pure" dance likewise converts extra-dance factors into *dance forces*. This is done in different manners by different choreographic practices, in more or less rarefied ways, with or without this process becoming conscious in the usual sense (it is always thought-felt as the quality of the dance). Extra-dance factors become-dance, as dance becomes what it does, in a next eventful expression of how it makes itself felt for what it can do most purely.

"Pure" as applied to "expression" means: effectively fusional. It means: that the compositional "extra" of heterogeneous elements that technically enter-in is felt unitarily in the dynamic form of an immanent force issuing as an event, in experiential *excess* over both the sensuous forms involved and their sense modalities. Pure expression points to no content other than *this* event: its own event. Fusion is another word for nonlocal linkage. Effect is another word for nonsensuous similarity. Expression is another way of saying translation of world-lines into a changing qualitative-relational order doubling the objective order.

The observation that the necessarily differential principle of composition involved in every technique of existence—including the senses

themselves—can disappear in the drama of the effect produced adds an important tool to the project of rethinking the double ordering of the "archive" of experience as technique, as well as to the related project of rethinking the "media" according to the manner of experiential event catalyzed. The way in which the differentials of the field of relation technically co-compose to singular-generic effect, the way in which the constituent heterogeneity of the field is highlighted or erased, can be used as a criterion of evaluation, alongside the possibility of evaluating the speculative-pragmatic polarity of an expressive event.

## Animateness Afloat

Just as dance comes most intensely into its own by breaking up (breaking open) movement to become a pure expression of bodily power, music can break up sound, to become a pure rhythmic expression. The only way in which music can be said to be like dance is in the sense that it can effect, in its own relational field and in its own manner, the "same" process of emptying itself of symbolic meaning and metaphorical associations. Music "untouched by extramusical elements"—or to be more exact, music that fusionally mutually includes in and as its own pure event of expression all factors entering its relational field, so that upon entering that field they *become* musical forces—is termed "absolute music" (Ashby 2010, 6). Absolute music continually, varyingly, repeatedly dissipates sound and reenergizes it into a perpetual state of nascency, as contemporary dance does for bodily gesture. The significant difference is that music does not have to use the body as local sign. Its local signs are *incorporeal*: sound waves. Pure energy forms, directly perceptually-felt as rhythm in an amodal in-between of hearing and proprioception on a border zone with thought.

The thinking-feeling of dynamic sound-form effects an experience of vitality affect in lift-off from the body. The kinesthetic effect seems to float in a space of tireless movement where felt-energies of nonlocal linkage fold into and out of each other, merging and diverging in an endless play of variation. The bodies of the musicians playing the music occupy an adjacent space from which this universe of music departs, in experiential offset. Except, once again, this is not a space—all the less so for having set itself off in this way from the local sign of the body. All the more Timely. All the more impersonal. Not even "someone." No-one time. Not a

determinate time. Timeliness intensely alive with vitality affect. The conversion of the space of embodied experience into an intensive time of transformation is taken to a still higher power by music. Vitality affect floats in a sonorous universe, its qualitative-relational order of nonlocal linkage attaining unparalleled degrees of permutational freedom. Vitality affect afloat: animateness untethered. Semblance of pure aliveness in play.

## Aliveness Engines

"Aliveness": not the same as "live." Aliveness is the relational *quality* of life. It is a semblance: a nonsensuous similarity. Like all nonsensuous similarity, it self-detaches from the objective combinations of things that go into a live performance, doubling them with an order of lived abstraction. A priori, there is no reason to believe that a dance or music recording deanimates the expressive event. Since the aliveness of the performance detaches itself from the performance even as it happens, there is no reason it cannot survive a second remove. What is certain is that it cannot survive a second remove—or even a repeat live performance—unchanged.

This is because the conditions of production or reproduction of an event, in all their singularity *and* genericness, are just as active as "extra" ingredients in the expression as any other factors. Such contextual factors as the unique acoustics, and even the mood of the listener or the collective "feel" of the audience, are as fusionally ingredient to the quality of experience of a piece of music in a given iteration as is the plucking of strings. Given the kinesthetic-proprioceptive tenor of musical hearing, the iPod's launching of the experience of music into everyday movement can be expected to become powerfully immanent to how the technique of existence of music can make itself felt, and what expressively it can do. Technologies in the narrow sense—architectural acoustics, recording, computerization, miniaturization—do not denature techniques of existence. They propagate, disseminate, and vary their events. They impel techniques of existence into evolutions, and speciations. Understood from this angle, technologies are "machinic phylums" forming "technological lineages"—world-lines of technological movement (Deleuze and Guattari 1987, 404–415).

The formation of technological lineages is not extraneous to techniques of existence. It does not weaken or degrade their powers of expression. The vicissitudes of technology are immanent to the continuing self-

constitution of techniques of existence. Technological lineages distribute in chronological time and extensive space the natural movement of techniques of existence: expressive events' abstract intensity, coming to vary. Self-differing, as they always do, in any event. Technologies boost the natural dynamic of self-differing inherent to experiential dynamics. They prolong the spontaneous power incumbent in experiential events of self-detachment, toward continuing variation.

It is a commonplace of media theory to say that technologies prolong the senses. This is the least of it. The senses are in any event self-prolonging. They only ever work to detach from their objective (organic) functioning events of lived abstraction that take them places they cannot go (in thought, in language). The senses themselves are technologies of lived abstraction, doing hard fusional labor every microsecond of every day, between every living breath. Technologies are not "prostheses of the body." The senses are already that. Technologies are abstract-event multipliers and disseminators. They are prostheses of the life of abstraction. Aliveness engines.

The question then is not whether recorded music is better or worse in lived quality than live music, or whether a dance on video is no dance at all. Live music and recorded music are equally performative, if differently alive. The question is how they differ, according to the vital circumstances. How integrally are the contextual conditions fusionally enveloped in the event? To how unitary an effect? Synchreting from what generative differentials? With what variation of relational quality? How disjunctively? How "purely" (to what degree of effective abstraction)? With what regard to content? Arved Ashby (2010) is right to insist that "absolute music" and "mechanical reproduction" are not opponent concepts but must be commaed together: *Absolute Music, Mechanical Reproduction.* The same must be said for every technique of existence with respect to the expressive purity or "absoluteness" of its event and that event's evolutionary variation along the world-lines of technology.

## Conditions

Synchresis is one word for the spontaneous detachment of a fusion-effect from the differential coming-together of a heterogeneity of creative factors issuing into the occurrence of an expressive event. The fusion-effect is a

nonlocal linkage. A lived abstraction: an occurrent self-abstraction from the combination of objective ingredients from which it lifts off (the event's local signs). What the lived abstraction expresses is the event of its own appearance. It is one with its own abstractive manner of appearing. It *is* the abstraction of its appearance: a being of abstraction, in a becoming of the world.

But what of the bringing-into-combination of the diversity of creative factors considered in its own right? The elements have to come together just so, in just this disjunctive way, for the effect to lift off. The timing has to be right. The elements have to be brought into just the right proximity, in just the right way so that they detonate into a self-detaching experiential event. Technique is everything. In fact, the technicity of a technique of existence resides in how this is done: how the *conditions* for the event come together. The appearance of the effect is a spontaneous experiential combustion event. But the setting-in of the conditions is *prepared*. Meticulously prepared.

The preparation may be classifiable as "naturally" occurring (on physical, chemical, biological, geological, and meteorological strata, to name a few). But when they are "human" or "cultural" they are always also natural. There is no event of human experience without a body with senses to amodally combine. There are no bodily senses in flights of dynamic interplay without a ground to stand on. There are no technological extensions of the body's life of abstraction in the absence of creative differentials of the electromagnetic and metallurgical kind, among themselves and between their respective strata and others. The conditions for events of expression presuppose a nature-culture continuum from which the differential elements brought disjunctively into play are selectively drawn, to just this effect for each event.

If the lift-off of the experiential effect is a synchresis, the coming-into proximity in the manner propitious for this event is a *concrescence* (Whitehead 1978, 21, 22 and passim).[16] Synchresis and concrescence are not in opposition or contradiction. They are coincident aspects of the same dynamic: two *poles* of the *process* of experience, inseparably in each other's embrace. The sensuous and the nonsensuous, the abstract and the concrete, the objective world and the qualitative-relational universe, are two sides of the same event. The self-abstraction of an experience is co-occurrent with the concrescence of its ingredient elements. The

self-abstraction of experience is the speculative side, the concrescence the pragmatic side. A technique of existence attends meticulously to the second, in the flighty interests of the first's foretracing.

The concept of causality as it is usually employed is insufficient to account for the creative activity of techniques of existence. Causes are typically conceived to act locally, in part-to-part interaction. The speculative-pragmatic production of an experiential effect occurs through nonlocal linkage in the relational in-between of the parts involved. The effect is holistic. Not in the sense that it is a whole composed of its objective parts. A whole composed of parts is but a bigger part of a larger objective whole. An experiential effect is a whole apart: a self-detaching event having wholly and only its own dynamic unity. The event precisely expresses the *coming-together* of the parts, not the parts themselves or their structure.

An event of lived abstraction is strictly speaking *uncaused*. Its taking-effect is spontaneous: experiential self-combustion. It is uncaused, but highly conditioned: wholly dependent on the coming-together of its ingredient factors, just so. The conditioning always includes a pragmatics of chance. There is always the odd detail that might unexpectedly assert itself and destroy the effect. Or positively inflect it. A technique of existence must either embrace chance, converting the self-assertion of the odd detail into a positive factor in its taking-effect. Or it must steel itself against intrusions of chance. A technique of existence is always actively conditioning of its events. The conditioning crucially involves the setting into place of *enabling constraints* to filter and inflect chance contributions (Manning and Massumi, forthcoming b). The pragmatic side of the speculative-pragmatic process consists more in selecting for chance *inflections* than causing in the usual sense. Selecting chance inflections effects a *modulation,* rather than implementing a causation. The senses are the in-born modulatory technologies of the animal body. They do not reflect what is outside the organism. They inflect what takes off from it, carrying its animate life into the anorganic realm of lived abstraction, where all linkage is nonlocal and activity is in effect foretraced (on anorganic life, Deleuze and Guattari 1987, 499; Deleuze 2004b, 45–47).

Filter as a technique of existence may, chance always enters in, to one degree or another. There is always inflection. Modulation is the rule. The necessary incoming of chance toward the outcome of the experiential event gives newness to every event. It makes every occurrence the

appearance of a novelty. Every event a creative event. This is speculative-pragmatic *fact*, ever redefining itself, in process. Fact is definiteness. Novelty is inexplicable in terms of already-defined, objective or sensuous, forms. The definiteness of fact is due to a creative movement continuing behind, across, and through objective encounters.

The definiteness of fact is due to its forms; but the individual fact is a creature, and creativity is the ultimate behind all forms, inexplicable by forms. . . . The novel entity is at once the togetherness of the "many" which it finds, and also it is one among the disjunctive "many" which it leaves; it is a novel entity, disjunctively among the many entities which it synthesizes. . . . Thus the "production of novel togetherness" is the ultimate notion embodied in the term "concrescence." . . . "Creativity" is the universal of universals. . . . The "creative advance" is the application of this ultimate principle to each novel situation it originates. (Whitehead 1978, 20–21)

The term concrescence, however, falls short. Of itself, it "fails to suggest the creative novelty involved" in the world's movements (Whitehead 1967a, 236). It is for this reason that it is useful to have another word, such as synchresis, at the ready to specifically capture the aspect of the oneness of the togetherness creatively leaving the many: the synthetic, or fusional, pulse of process's bipolar coincidence with itself. Remembering that the "term 'one' does not stand for 'the integral number one'" but for the thinking-feeling "singularity" of an occasion occurring to itself (Whitehead 1978, 21; on fusion, Whitehead 1978, 233; 1967a, 211–214).

## The Eternal Return of Content

José Gil speaks of a "paradox" of the dancing body (Gil 2006). Quite simply, it is that dance has to continually return to the body in order to newly depart from it, to creative effect. Similarly, a universe of music only comes in offset from performing bodies. A nonsensuous linkage of any kind is a lived abstraction from a combination of sensuous forms. The objective order of actuality and the qualitative-relational universe of the virtual shadow each other at every step. They are fraternal twins, separately connected at birth by the umbilicus of creative advance. Dimensions of each other. Pulses of the same movements. Poles of the one process of the many comings-together to singular effect. Double ordering never ends. Double existence, always, in all ways.

The consequence of this is that the "purity" of a technique of existence's expression is a fragile achievement. In fact, the emptying of the event of expression of all content other than its own occurrence is a *limit* of process toward which the world's creative advance ever tends, never reaching. The doubling of every lived abstraction by a sensuous encounter means that there are always remainders of embodied animateness and objective order that are nonsensuously doubled—but not erased. Emptying is not erasing. It is taking-off-from. Breaking up is not sweeping away. It is breaking-away-from. The sensuous remainders are buds of content's regrowth: hints of symbolic meaning; provocations for metaphorical association. It is a very good thing they are there, for they are also local signposts for a reuptake of the event in pragmatic ambulation: buds also for an advancement of the objective order. Without the dogging of lived abstraction by sensuous remainder, the world would be lost in its own speculation. The perpetual nascency to which pure expression returns the event would fall on fallow time. It would churn infertile. It is the sensuous remainder of the event of expression that calls the self-detaching universe of lived abstraction back to the walkways of the world.

The buds of content are no less incessantly necessary than they are a constant challenge to any practice aspiring to take a technique of existence to the expressive limit of what it can do. They are constraints enabling of what a practice effectively does, approaching the limit of its expression. And approaching the expressive limit is what process never ceases to do. The limit of lived abstraction is the universal attractor of experience. It is no less than the ever-renascent *terminus of the world*: the perpetual point of departure for its renewal. Every technique of existence has an expressive appetite for pushing nonsensuous similarity as far as it can go, carrying it to its highest degree of abstractive intensity, making it as absolutely felt as it can experienceably be. Pushing the limit of lived abstraction is the universal "lure for feeling": *appetition* (Whitehead 1978, 184–185). Lure of extra-being. Lure for becoming.[17]

That is the necessity (of novelty). To understand the challenge, think of contemporary dance again. To dance the dance is to extract animate-*ness*—pure-movement qualities—from the actual movements of the body. But the body remains, shadowing the nonsensuous dance-form, in heavy contrast to its tendency to lift-off. One of the shadows the body casts is its physical frailty: its inevitable pull to the ground, counter to the push

to the limit. At the counter-limit : mortality. Any intense experience of the animateness of the body contains this contrasting pull in suggestive potential. Appetitive lift to abstraction / gravitational fall-back. It takes very little for the fall-back position to regain ground. Conventional language, with its stockpile of at-the-ready symbolic and metaphorical associations, easily provides the ballast. Content redux. How many reviews of contemporary dance have been written that ponderously a reveal a "theme" of death? Or sex and love, romantic ecstasy, and the wrench of jealousy? For the human body is as sexed as it is mortal.

Absolute music, for its part, courts the return of content by virtue of its very abstractive success. Its expressive detachment of animateness from the local sign of the sexed-mortal body yields what conventionally (stereotypically) speaking is avidly construed as soulfulness. How many music commentaries extol the grandioseness of its "spiritual" meaning? Wax lyrical on its revelation of human depth of soul? Pin its animateness-afloat for an evocation of the incorporeal life everlasting? Eagerly take its pure time of alteration for a glimpse of unchanging eternity?

For figural art, it is the narrative powers of language that lie in wait, content-ready. Imagine a story that the likeness seems to suggest—and the semblance recontains itself. Where once it struck impersonally as a force of personification, it now evokes a striking force of personality, its delimitation undone.

The turnoff onto the associative detours of conventionalized discourse through which content tends to return is already in bud in the direct experience of the expressive event. Crucially, there are already beginnings of a translation of the affective dimension of the event, as it happens, into emotion. As was discussed earlier, a multiplicity of singular vitality affects are enveloped in the affective tonality of the event. The affective tonality is the performance envelope of the event. It falls into a certain generic region of expression, depending on the technique of existence. The singularity of the vitality affects modulate the generic tonality of each event, giving it a singular-generic feel, but the modulation is contrived to stay within the parameters of the event-envelope. Positively, this means that the vitality affects resonate *in* the event, ensuring a certain intensity. At the same time, it prepares the way for their conversion of vitality affects into "categorical affects": identifiable, generally recognizable, narratively

(or otherwise) codable, symbolically evocative, metaphorically redolent human emotions.

Human emotion is the royal road to the recontainment of lived abstraction. It consists in the translation of the intensity of vitality affects' coming singularly together in the same event into recountable, codable, or formalizable content. It is precisely the overabundance of the vitality affects that opens the way for this. Their multiplicity is mutually included in an overall feel. Their singularities merge into a generic thinking-feeling of the event. At that level, their variety is only vaguely sensed. It is this indistinct perceptual feeling of a superabundance of lived intensity that is translated into emotion. From the angle of an overcoding or formalizing technique of existence conveyed by conventional language use, the *resonance* of the enveloped vitality affects comes across as an *ambiguity* of reference or meaning. The ambiguity then has to be processed. It can be reduced by interpretation to one "true" meaning. Or it can be relayed into concentric circles of symbolic or metaphorical plurivocity. From there it can spiral, centripetally into a dramatic center of signifiance, or centrifugally out of orbit into flights of more and more evocative fancy. Any of these procedures can be narrativized in one way or another, structurally coded according to one version or another of what constitutes a structure, or procedurally formalized to one degree or another.

Whichever path is taken, the point of conversion is the transformation of vitality affect into emotion. The conversion into emotion may be explicitly noted, thereby becoming the content itself. Or it may be transitioned-through on the road to content otherwise construed. The resonant tenor of the expressive event is doubled by what Barthes called a "supplementary message" to its sheer occurrence. The event passes from pure "uncoded" liveness (mechanically reproduced or not) to coded "message" (Barthes 1977, 19, cited in Ashby 2010, 234). It becomes communicable. The event ceases to be expressive on its own singular-generic account, to enter the general category of "communication"—a super-genre as envelopingly vague and indistinct as it is wont to take life's intensities to be. No general category understands the first thing about affect. They are always by nature emotion-ready, because they are always ready-made for content. They have an in-bred appetite for content. They maw for it. That's what they do. They are voracious techniques of containment. "Common sense" is

promiscuously dedicated to general categories. As is "good sense," in a more selective and disciplined way. "Opinion" invests general categories with a personalized emotional force of their own. Weapons of mass containment, all.

Cunningham describes, in the case of dance, the effects of the containment in emotion brought to the expressive event by coding in language, and (which amounts to much the same thing) overcoding on the model of language, of elements that would otherwise have the immediacy of forces constitutively immanent to the dance. The effect is deintensifying and indifferencing:

> the sense of human emotions that a
> dance can give is governed by fam-
> iliarity with the language, and the
> elements that act with the language;
> here those would be music, costume,
> together with the space in which the dance happens.

> joy, love, fear, anger, humor, all can be "made clear" by
> images familiar to the eyes.      and all are grand or meager
> depending on the eye of the beholder.

> what to some is splendid entertainment,
> to others merely tedium and fidgets;
> what to some seems barren, to others
> is the very essence of the heroic.

> and the art is not the better or the worse.

## FOURTH MOVEMENT: COMPOSING THE POLITICAL

### Aesthetico/Political

"And the art is not the better or the worse." The conventional "language" of dance, for Cunningham, has nothing to do with it *as art*. The aesthetic force of its event is elsewhere. But given the insistence of content to return, and its budding already on the level of the local signs from which the dance-as-dance lifts off, how can the "art" be effectively segregated from its conventional language? Does not the aesthetic question reside precisely in the tension between them?

The aesthetic force of an expressive event is its charge of lived abstraction: the manner of semblance it produces, and the intensities of

experience coming-together toward an issue in that semblance and playing renascently through it. The detachment of the semblance occurs in a relational field already overpopulated with techniques content-ready for its recontainment. Their inhabitation of the relational field within which an art is practiced makes that field a doubly *problematic field*. The aesthetic problem is always on the one hand *compositional*: how are the ingredient elements brought together in such a way as to become-immanent to the coming event as constitutive forces of its push toward pure expression? The compositional problem cannot be addressed without at the same time addressing the problem of relational co-habitation, which is *ecological*: which extra-elements will be admitted into the symbiosis of compositional co-immanence? Which will be treated as predators or competitors and be held at bay? How, and at what proximity or distance, to what follow-on effect? Will a degree of containment be accepted, or even encouraged with a view to managing it or channeling it? What will the posture be toward common sense? Good sense? Public opinion? Will gestures be made to certain codings or symbolic or metaphorical connections? If the latter, will they spiral in to a center of meaning or swing centrifugally out in associative abandon? If the former, of what kind? Narrativizing? Structurizing? Formalizing?

What brings these two sets of questions together as two sides of one complex aesthetic problem is that they both pivot on the question of immanence. What elements become immanent forces contributing to the event's appetite for pure expression, and how? What elements don't, and how again? It's the same how. It's the same question, seen from two sides. Any becoming-immanent to an event is toward the self-detaching of its semblance. Which leaves that which is detached-from out. This is a peculiarly altered "out." The elements that will be remaindered as extra must be outed-in—otherwise their buds of content will invade like weeds through cracks in the surface of the event. They must be actively ex-included. Whitehead calls this "negative prehension." A negative prehension is an exclusive *treatment* paradoxically "expressing a bond" (Whitehead 1978, 41).

One last "how": How can it not be obvious that the two sides of the problem, the taking-in and the out-treatment, taken integrally together, are *political?* Integrally, the doubly problematic field of art is aesthetico-political. And what event-expressive technique of existence, regardless of its avowed genre, is not an "art"?

## Composing Away

There are different strategies for dealing with the duplicity of the problematic field. Arved Ashby (2010) charts in detail how Gustav Mahler followed his tendency to "become a musical absolutist" (224) by out-treating the "quasi-linguistic meanings that arise from orderings of functional units" of musical composition (226). He worked concertedly "against the incursion of discourse, against words and obligatory meaning," against any "supplementary message" spinning off adventitiously from the music or grafting itself on it parasitically (234, 237). His project was to express as purely as possible a musical force of composition per se. His particular strategy was to out-treat extra-elements of the language species by embracing a different species of content-budding, this one inherent to the direct perception of music by virtue of the local signs it necessarily employs. Heard rhythm has a spontaneous tendency to transit amodally into virtual visual motion, thought-felt in nonsensuous similarity to it. There is a possibly innate amodal attunement between heard rhythm, visual rhythm, and kinesthesia-proprioception that makes it difficult *not* to see a rhythm perceptually felt in one of these modalities automatically in another. Few are those who can hear music without the virtual visual accompaniment of thought-felt movement patterns of color and light. Few are those who are not moved to reenact the hearing as it happens with virtual gestures. These nonsensuous similarities are just asking for translation into content, for example through conventional associations embedded in language (such as the association between a high tone and a rising gesture or visual movement, connoting hope, for example).

Mahler embraced the budding of visual thinking-feeling in music, while suppressing the "Romantic ideas of extramusical illustration" (234). His music would be intensely imagistic, but he would make it an "imagery without reference" (237). The technique he employed was to make the composition "so vivid and alive" that what it made felt would be "dramatic instantaneities" that would be "like" (a semblance of) the "performance of a real event" (224, 226). To manage content-formation, the semblance of event would have to be taken to the extreme. It would have to be overcharged, carrying an excess of dramatically instantaneous musical force. This was accomplished by de-limiting the imagistic element: ensuring that the music would be so vivid and alive that it would simultaneously carry

a number of image suggestions in its dynamic unfolding. This made the embrace of imagery "non-specific," and as a result of that "as stymieing as it is evocative" (232). The composition retains its properly musical force of expression, so powerfully enveloping the imagistic elements that the virtual visualization is converted into an immanent music-force without remainder. This becoming-immanent to the music of the imagery, according to Mahler, was so complete that it could take the place of actual vision. On a walk in the mountains, Mahler tells his companion: *"'No need to look—I have already composed all of that away' "* (222). What looking can do is now best heard in the music. Sightseeing dismissed with a blink of the ears. Mountains and mountains of sound.

This is an example of a compositional technique for out-treating sources for the adventitious or parasitic growth of content affecting music by taking in a bud of content of a favored kind. The selected bud is so tightly embraced, so excessively included, that it comes vividly alive *for* the technique of existence adopting it. It becomes-immanent to the expressive force of the event. The intensity of that inclusion edges out all rival content-readiness. This strategy is that of *composing-away*. Mahler invented a creative strategy for composing-away, and lived it out in an exclusive dedication to the potential intensities of one genre of expressive technique of existence, that of the symphonic music of his time.

In general, composing-away involves taking a particular technique of existence to its highest degree of abstractive intensity, making it as absolutely felt as it can experienceably be, given the conditions (individual, social, culture, economic, technological). There are always buds of content that sprout from within. Techniques for composing-away must negotiate these shoots in one manner or another. Mahler's technique of encouraging a certain modality of content growth, while simultaneously stymieing it by rendering it excessively non-specific, is a way of negotiating the problem of the eternal return of content by selectively embracing a certain order of content-readiness from the start, and then ensuring that it is not an extra-element but rather an element of an excess of immanence. When attempts are made to compose-away all trace of content-readiness from the get go, the growth returns at some point later in the process, often with a vengeance. The return may well take the form of an insurgency of another modality of experience bursting forth from within at the very moment the process of expression reaches its highest intensity and achieves the purest

appearance of nonsensuous similarity. Lived abstraction is always ontoge-
netically multiple—as a function of its purity, if not countercurrent to it.[18]

## Composing With

There are complementary approaches to composing away that set out to
compose with. Composing-with, as the name implies, involves combining
techniques of existence and their respective content-readinesses. The com-
bined techniques may or may not belong to a conventional "art" genre,
and the same goes for the outcome. Composing-with works across modali-
ties of experience, affirming their diversity as much in the process of
composition as in its issue. Techniques for composing-with—techniques
of existence for combining techniques of existence—are traditionally
referred to by such terms as mixed-media, multimedia, cross-platform,
interdisciplinary, and transdisciplinary, depending on the period, context,
and accent. The installation work of Robert Irwin is an especially instruc-
tive example because it comes to composing-with as an outgrowth of
an other-sense insurgency marking the *success* of a radical project of
composing-away.

## The Art of Nonobjecthood

Irwin recounts that his early artistic activity in the 1940s and 1950s in
representational portrait drawing left him unsatisfied, even though it won
him accolades and awards (Weschler 1982, 29–38). He felt as though he
were going through the motions. It lacked intensity. He felt the need to
purify his art of the "taken-for-granted": "pictorial or articulate reading of
images on any principled grounds (81)." He would "suspend such conven-
tions as much as possible" (81), purifying the work of "representation" and
"imagist associations" (61). The artwork "wouldn't be 'about' anything"
(65). It would have no content, it would be pared down to its own "act"
(81). "Everything that didn't" actively "contribute" would be "filtered out"
(63). Nothing would be left that did not become to a contributory force
immanent to the effecting of the act. The artwork would be full of "move-
ment," but it would no longer be "extensive" (69). Intensity would be
restored to the work when *it* made the motions—when it was composed

in such a way that it immanently energized its own act. It would then be a "nonobject" (81): purely its own self-occurring event.

Suspending conventions, filtering out articulate readings, discovering what actively contributes to the self-occurring of an event of experiential intensity, this is nothing if not painstaking. The artist's spontaneity is in not enough (hence Irwin's irritation with abstract expressionism, 41–51). It's all about technique. To make a pure act of art, it is necessary to "control every physical aspect of the work's circumstances" (77). This is because the *spontaneity must be transferred to the artwork*. Complete control of the objective conditions is necessary so that the artwork becomes *the subject of its own pure act*. This accords with Whitehead's vocabulary, in which the dynamic form of an event is called its "subjective form." Whitehead speaks of an occasion's subjective form as the "how" of feeling, its "quality of feeling": the way in which the event absolutely requires that its objective conditions be just so—but refuses to be limited to them or reduced to them. The feeling-quality is "how" the event "clothes itself in its self-definition," over and above its objective conditions (Whitehead 1978, 85–86). How it wraps itself in its own experiential quality, to take flight from its objective conditions. The event's act of self-occurring definition is as much a product of its appetitive "aim at further integration" (fusion) in a nonsensuous intensity of effect (culminating attainment of nonobjecthood) as it is about technique (19).[19]

Irwin set about the task of getting the conditions just right for his work to take flight in its own purely occurrent subjective form. Twenty years of "investigations" followed, during which time "the outside world progressively receded" (70). Composing-away. Irwin carried his work through a "succession of reductions" leading "all the way to a ground zero" (81). Ground zero was a detonation site. Or more precisely, the supplanting of the visual space of the painting with a self-combusting visual energy that bursts from the frame. "A good painting has a gathering, an interactive build-up in it" so that the effect just "jumps off the goddam wall at you. They just, *bam!*" (60). A "pure energy" is released through vision by the way in which the few remaining included elements reciprocally "act on each other" so as to exponentially "multiply" their individual abilities to the explosive point that they self-release into a single, dynamic, fusion-effect.

The fusion-effect detonates across a *distance*. It occurs to the differential between the sensuous and objective elements. It is the effective issue of a "real tension" (60). For example, Irwin first experimented with the reduction of the figuration to its most basic element: one or two lines against a colored background. He noticed by trial and error that an imperceptible change in the position of the line "changed the entire field" (71), as did any slightest change in color tone. This is because whenever a line is present, it activates a tendency in vision. Of its own accord, the line starts to detach from the background, in search of a figure to become. If the line is placed just so, it activates the figurative appetite of vision. It has already become more than a line, but is not yet a figure. If care is taken that no figure is evoked or in any way suggested by this minimal composition, vision is caught in a state of nascency of its tendency to figuration. It has been brought into a movement, but is pointing toward nothing outside itself. One of its capacities has been activated, but it has nowhere other than this capacitating event. It vibrates in its own capacity, shivering with an energy that has no object—an abstract energy. The disjunction between ground and figure is not filled with an energy of vision offering nothing to see. A perceptually felt movement occurring through an activation of vision, corresponding to no particular object of sight. A thought-felt kinesthetic-proprioceptive vision-effect. The horizontality of the line also activates a movement tendency of the colored background. A tension appears in the colored background, due to the tendency for vision to experience a horizontal line as a horizon line in a way that gives differential weight to the color below and above. The space below exerts a gravitational pull on vision that is perceptually felt as an inertia. Even the slightest suggestion of a lightness of color tone above will attract vision upward, accompanied by a sense that vision itself has been freed of a weight and has the lightness to rise. The overall effect produced by the painting is the encompassing fusion-effect of these two differential tensions.

Each tension is a vitality affect *of* vision. Their mutual envelopment in an overall unity of effect yields an affective tonality *of* vision—its singular-generic feel, in this event. "Of vision" means: immanent to it; coming directly with its activation, in the immediacy of its arising. Any change in the position of the line will toggle the tension between visual tensions, modulating the overall effect. The artwork has become a veritable machine of vision: a technique of existence for its production and permutation.

After enough line paintings were experimentally produced to give an intuitive sense of the range of permutation enabled by this particular technique, it was time to move on. Paintings composed of an even more minimal visual element took their place: after the line, the point. The dot paintings experimented with the differential tensions between the center and the periphery, and between two hues (green and red; 88–89).

## Perception of Perception

The produced effect is a "floating feeling" (81). Your eye "ends up suspended in midair, midspace, or midstride" (76). This abstraction-effect is "not abstractable" itself (76). It resides in its own occurrence. It cannot be applied to something else, or taken elsewhere. It is right where it is, "mid"-life. It is its own "unmediated presence" (87). Nothing more—or less—than a peculiar manner of vision suspended intensely in its own activity. Vision's "self-possession divulging itself" (104) in a playing-out of a tension between its genetic elements. Divulging itself as "a quality, an energy" perceptually felt to self-move, "emerging" from the surface of the painting only to "dissolve itself . . . in a kind of entropic dissipation" (91) The rise and fall of quivering vision caught in a state of self-agitating nascency.

"Some time will pass" (91). It takes time for the effect to build up and self-combust. The fusion-effect detaches from the surface of the canvas into a no place of the floating in-between. The effect is nonlocal. It is nowhere in particular. It is a whole-field effect. Where it effectively comes from is not strictly speaking a space either, but an elemental relational field. The objective space of seeing has been self-possessed by vision, and in the process converted into an abstract time of the thinking-feeling *of* vision. Semblance of sight.

The thinking-feeling of vision's self-possession is on one level a playing out of a differential relation (of nonrelation) between ingredient elements becoming immanent to its event. Simultaneously, on another level, it is a way of vision relating to its own occurrence: a self-relating of vision. This is a duplex event. A double experience. Experience of a double ordering. The sensuous order of local signs is seen to cede to a thinking-feeling of nonsensuous linkage in an overall fusion-effect. Vitality affects of vision are seen to emerge-together away from their surface, and dissolve into each other. The affective tonality in which they are enveloped, and in which

the singular quality of the event consists, concerns *only this* abstract move-
ment—which is the very movement of abstraction. The perception is not
of something in particular. It is a perception of perception (92). It is a
thinking-feeling of what experientially it means to perceive. A direct,
immediate consciousness of the world's ever-ongoing self-abstraction,
intensely exemplified. A kinesthetic-proprioceptive glimpse of the qualita-
tive-relational universe of its experiential becoming.

This self-relating of vision is self-referential, even reflective, in a special
sense. It is not a reflection in vision, of the world. Nor a reflection on
vision, in consciousness. Rather, it is a conscious reflection, in the event
of vision, of the pure act by which it always amodally departs from itself,
in a reaching-toward the point of its feeling-quality's relational indistinc-
tion with thought. All in the "fourth-person" singular. Of an event under-
stood as a pure elemental act we say, "it." *It* happens. *It* rains. *It* snows.
. . . *It* thinking-feels.

It is only at this culminating point where vision self-references its event
in a pure act of its own thinking-feeling, that the segue can occur from
this adventure in composing-away to composings-with venturing further
afield. Irwin's composing-away of extra-elements suspended seeing in
incipient figure-ground effect, incipient horizon effect, incipient vertical
gravitational effect. Buds of space. The pure energy released from the
visual surface could not be otherwise than kinesthetic-proprioceptive.
Quivering vision is not far, amodally-nonlocally speaking, from itchy feet.
Buds of ambulation. Irwin's painstaking investigations succeeded in
making immanent to vision a nascency of space and the extensive move-
ments that had been among the prime targets of its project of purification.
Inadvertent and unavoidable inclusions were caught in the pure act, in
the way prehistoric bugs are found as inclusions in amber. Things that
have been purified out of the world and suspended in time uncannily
returning.

**Reinvolvement**

Irwin realized that as a result of his "reduction" of vision to its relational
field of immanence, the work had paradoxically started to "take in" space
and extensive movement, but only just, as a function of its being just
minimally so. He further realized that this "taking in" was but a bug's

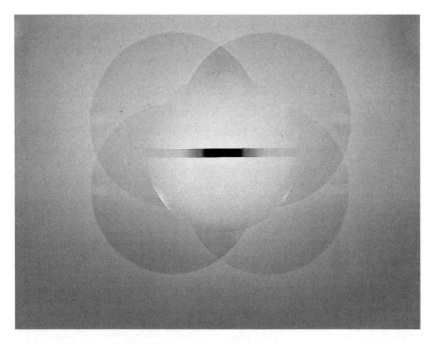

Robert Irwin, *Disc*, 1968–1969, Hirshhorn Museum

breath away from a "becoming involved" again with the actual space of the environment around the painting (99). His nonobject art was now ready to move out. It had enfolded into its own event, and now it was ready for its event to unfold and go walkabout. This is not as difficult in principle as it might seem. After all, the effect that detonates when the differentials of the elemental relational field fusionally "take" is nonlocal. It shouldn't be such a stretch to spread its nonlocality, so that its "taking" takes-in further differentials.

So Irwin now started adding. More elements, for an expanding relational field. He got rid of the canvas and frame, and attached discs directly to the wall. Objectness was back. Even the line became materialized in some disc experiments as an actual material band across the disc. He also added lighting: angles of illumination intersecting across the disc just so. The effect was the same energizing of vision as before. But now the art nonobject was perceptually felt to be detaching itself from the wall into the surrounding space. You couldn't tell if the disc was "real" or a semblance of an object. It didn't occupy a specific space, but still came across

as space-filling in some uncanny way. This resulted from a tension between tensions. The tension between intersecting degrees of illumination (light and shadow), and the tension between the actual relief of a 3D object and the flat background surface of the wall it stood out from, became enveloped in an overall tension. The tension between tensions had the effect of reinvolving vision's self-possession in a semblance of space. The net effect was a semblance of space wrapped into a semblance of seeing, in perceptual-eventful mutual inclusion. Semblance of seeing making room in itself, for buds of space to make their growth perceptually-felt. All of this was achieved through a composing-with: a compositional technique operating avowedly between elements belonging to different "media," and even reinviting 3D objects back into the fold.

### Ecological Immediation

From there, Irwin decided to take the work off the wall and move it into the room. He started doing environmental designs that created perceptually-felt fusion-effects compositionally taking-in the entire room. One example will suffice to show how this leads back to an ambulatory reinvolvement of artworking in the world.

A nearly transparent white scrim that goes all the way from floor to ceiling is offset from one of the walls of the room. The lighting is such that when you first enter the room, you don't notice anything at all. You think you see an empty room. But what you begin to perceptually feel through your vision as you walk around the room is a visceral sensation that something is amiss. The effect takes some time to set in. It nags at you. You think you feel a little disoriented, a tad dizzy perhaps. You feel something niggling, like a stirring on the periphery of vision itching for you to turn your attention to it. But attend as you might, you find nothing to look at. Then it happens. Bam! The scrim suddenly jumps into sight. It's less that you looked at it, than it jumped out at you. It suddenly appeared out of nowhere: out of the self-activity of vision.

Vision had been quivering at its own limit, under conditions it had difficulty taking-in. Walking around the room enabled it to come out into itself. That happened because the scrim's offset from the wall behind it was just on the threshold of perception. It was not distinct enough to see, but not so wholly imperceptible that it had no effect. This produced a niggling

depth-effect that was not consciously seen at first, but was already non-consciously activated. All it needed to come into effect was the actual kinesthetic-proprioceptive experience of walking around the room. The fusion-effect of the artwork resulted from a nonconscious collaboration between vision and the sense of movement. Your walking around the room was not just an incidental. It had been pre-composed into the coming event as an active force for its taking-effect. The viewer's walking around the gallery was included in the work as a constitutive element of it. It was made to become immanent to the work, as a contributor to the relational field. Extensive movement had been taken-in. As the tensions between elements involved were taking their time to play out, the determinate seeing of the scrim was rising toward the threshold of conscious awareness. The work is not the scrim. It is not the room. It is the perception of the perception-of-perception's complex becoming consciously determinate, in an amodal collaboration between seeing and extensive movement.

The perception of perception occurring is not the subjective viewpoint of the gallery visitor. The experience *takes:* it takes its own time; it takes elements into itself; and it takes in the catalytic sense of an effect setting in, or the combustive sense of a slow detonation. The experience belongs not to any one element, but to their coming-together in just this way. It comes of a *"nexus"* (Weschler 1982, 64). The human element of the gallery visitor is, to be sure, a privileged link in the nexus. But from the point of view of the technique of existence taking expression, the human element is less the center than the conduit for the expressive event's culmination. It is there for *feeling the nexus* (Whitehead 1978, 230), to give *it* determinate subjective form. The experiential effect occurs to the visitor, as it occurs to itself as its own event, through the conduit of the visitor. The effect wells up from below the threshold of human awareness. It comes to pass the threshold in *its* way, following its own rhythm, when it is ready to set in. *It*—the event-nexus—expresses its own coming-together, as it passes through its human-channeled bringing-itself-into-perceptual-focus. This makes the experience integrally ecological.

That the event is ecological does not mean that it is "natural" as opposed to cultural. It takes in elements classifiable as natural (the physiology of the human body, the physics of light and materials) in a way that effectively fuses them with cultural elements. The coming-together draws on a nature-culture continuum. What are normally considered elements

of cultural mediation enter as directly into the ecological nexus as any other element. In becoming-immanent to the event of expression, they become immediate contributory forces. They are *immediated*. It is no contradiction to say that the experiential effect is directly and immediately felt following its own immanent rhythm, and to note the degree to which cultural convention and codings contribute to its eventuating. It is only because the viewer is familiar with the conventional layout of a room and with the architectural codes of gallery buildings that this process is able to occur. Both the initial throwing-off of perception upon entry into the room, and the final determination of the singularity of the room, depend on this familiarity. The experiential event's playing-out plays on the very conventions, articulate readings, and ingrained habits that the experimentation with painting had so concertedly filtered out.

## Semblance of a Truth (the Bleed)

The immediation of the cultural, drawn into a continuum with the natural toward a nexus-expressing event, makes it possible to begin adding elements back in without losing the directness of intensity of experience that Irwin was after from the start. His tendency toward subtraction could now reverse itself while continuing the same movement toward increasing intensity. The work could go into hallways and staircases, then exit buildings, lodging itself in the spaces between them, as well as into gardens and groves. Fusion-effectiveness unlimited. Irwin had de-limited his own practice. Its intensity bled outward in ever-expanding circles, like an inkspot on absorbant paper, or an oil spot on pavement. Its technique of existence absorbed itself into its surroundings, irridescing across their surface.

Even before the artwork moves out into the world, it already carries an ambulatory effect. When you leave one of the scrim installations, an aftereffect follows you. You feel yourself thinking-feeling differently as you exit the gallery and walk down the street. The feeling of perceiving perception's occurring to itself stays with you. There is something a little odd about the perspective of the street. You are aware of thinking-feeling the depths of the city as you walk and look. The constitutive collaboration between vision and proprioception is still reflecting itself in an ongoing of its event. There is an odd feeling, like a very faint déjà vu, that you are double-experiencing the world. You are consciously experienced the semblancing

of experience—its double order; your double existence—that normally remains in the nonconscious background of everyday life. Perception feels itself renewed. Because your experience is tarrying in its nascency. This is powerfully suggestive, but nonspecifically. This *should* make a difference. *Could* make a difference. But *how? Which* difference? Could/should: *speculative.* How/which?: *pragmatic.* Walking down the street has rebecome speculatively pragmatic, in a way that is immediately thought-felt. The artwork has already made a difference. An incipient difference, in the dynamic form of a semblance of an ecological truth. What is left is to see how or if it will continue to play out, taking-in other elements, playing-on other familiarities, conventions, articulate readings, immediating its way out and down world-lines yet to be invented.

## Politicality

The way Mahler composed music is singularly-generically different from the way that Irwin composes with vision. The differences between their practices, qualitatively-relationally speaking, have little to do with the mere fact of working in classifiably different media in which different sense modalities are foregrounded. Mahler works with sound. That goes without saying. The real question is, what *else*?[20] What else enters into hearing through his work? We are getting somewhere in our understanding of the manner of expressive event at issue at the point that the orchestral sight of a mountain is heard. Irwin spent decades painting, purely painting, painting and nothing but. Yes, but … what else?[21] We are beginning to get a grasp on the techniques of existence he was investigating when the pigment bled into the streets and the process that had been purely painting went for a walk.

The evaluation of a practice of expression must grapple with the "how" of its process. It must grapple with understanding the "which" of the differences *occurring* through the phases of the process as it transformationally unfolds. The issue is the hows and whiches of creative *change.* The how is not reducible to the functioning of whatever technology is involved. The technology is a contributory element to the comings-together affected by a technique of existence whose appetite always takes-in many an extra of multiple kinds. It is only because the technique of existence is an art of life that the technology it involves can be an aliveness engine. The "which"

is not reducible to a difference in content. Its question concerns vitality affects more primordially than contents, and affective tonalities more suggestively than categories.

Processually speaking, Mahler fell on the same side as Irwin in their shared project of purifying their art of content. They differed in their strategies for how to deal with the eternal tendency of content to return, and how to maintain the experiential intensity of the events of expression to be composed.

Mahler composed-away for an absoluteness of music. He effected a singular becoming-sound of extra-musical elements. However, he did this in a way that was not apt to lead outside musical activity as he and his time generically knew it. Leakage into the surroundings of the music hall was included-out, even as the surroundings were grandiosely taken-in. The becoming of orchestral music he invented was designed to be *self-returning*. He peculiarly altered the vitality affects of musical activity, but retained its affective tonality as music. He figures prominently in the annals of music history.

Irwin's process of composing-away extra-elements in painting phased out into the surroundings. It continued into composings-with. His peculiar alterations in the vitality affects of painting launched themselves into an evolution that led them to become integrally other. The affective tonality of the undertaking was constantly under investigation at the same time as the techniques for modulating vitality affects (means of creatively imbuing the artwork with occurrent perceptual "energies"). His process extended itself through phase shifts. It was continually moved to dephase itself, morphing to a next phase. Irwin's place in art history will likely be long contested (painter? sculptor? installation artist? light artist? spatial artist? gardener?).

Mahler's technique of existence insistently rephased on a becoming more intensely and absolutely itself. Irwin's dephased toward becoming more expansively other, without ever compromising on the purity of its own aim for intensity. Mahler invented a new mode of musical perception, keeping it tightly wound around itself, and without highlighting the perception of that perception. Irwin invented new modes of perception in expanding circles while foregrounding the perception-of-perception at every step, making the pure act of expression expansively self-referential rather than tightly self-returning. Mahler embraced the speculative

production of a universe of music. Irwin's speculative creativity went ambulatory in the world in a way that intensely foretraced pragmatic movements in urban potential.

These processual differences are far more crucial to understanding Mahlerian and Irwinian expressive events as aesthetic techniques of existence than is any conventional analysis of their formal style or art-historical approach to their ostensible content. Processual differences *precede content* and *exceed formalism*. They precede content in the nascency of the experiential event. This nascency always concerns an avidity of appetition, a lure to intensity, an *activity* of coming-together, before it concerns the determination of a content (if it comes to that at all). They exceed form definition in the self-floating of a nonsensuous similarity that passes, the moment it is produced, into an extra-being of continual qualitative-relational differencing.

How can it not be recognized that these *aesthetic* processual differences are at one and the same time *political*? It makes a political difference whether a process revolves around a self-returning becoming or a becoming-other. It makes a political difference, when a process reaches its terminus, whether the surroundings remain composed-away, or whether the composing-away teaches itself to go-with so that the surroundings out back in. It makes a political difference to what extent a technique of existence negotiates its relation to its own activity: whether or in what way it extends itself into the perception-of-perception. It makes a political difference how it acts speculatively, which is to say, how it navigates the speculative-pragmatic duplicity of all experience.

Potentially. All of this makes a difference potentially. This is about potential politics. But then, a potential politics is a politics of potential. And what politics is not about potential? Qualitative-relational potential. Of forms of life in the making.

A form of life was defined earlier as "a complex manner of being/being able/knowing/wanting, appearing eventfully together in virtual mutual inclusion." "Under conditions of change" is implicit in the definition. Also understood was that the "being" was its own event: a being of becoming. A technique of existence is the operator of a form of life as a mode of becoming. The events that are according to its operation, are its creatures. The operation of a technique of existence is a mode of composition. The compositional process is *ontogenetic*: concerning the *appearing* of forms of

life. If politics is about the potential animating forms of life, then it is essentially bound up with the operation of techniques of existence. That its activity is compositional and ontogenetic makes it more fundamentally creative than regulative, inventive more than interpretive. The notion that the complex manner constituting a form of life appears in "virtual" mutual inclusion immediately raises the question of amodal experience and non-sensuous similarity—placing the problem of *lived abstraction* at the heart of the political.

We are now speculatively-pragmatically beyond the point of no return for separating the aesthetic from the political. Political vocabulary will have to expand to deal with issues such as how qualities of movement detach from combinations of objective forms in encounter. How the movement of events continues virtually "behind" where it goes, and "beyond" where it stops. How nonlocal linkages spontaneously detach from the changing location of things. How they enter into qualitative-relational congress in a universe of their own constitutional order. How the world is governed by a double order of synchresis and concrescence playing on and off each other. How all being is integrally both: double play, double existence. This gives a whole new meaning to the term "political duplicity."

The "politics of aesthetics" does not only have to do with "distributions of the sensible" (Rancière 2006). More intensely, more inventively, and more powerfully, it has to with distributions between the sensible and the nonsensuous: the double aesthetico-political economy of experience. Aesthetic issues of how the world's double synchretic/conscrescent ordering is creatively negotiated, such as those just mentioned concerning self-returning, becoming-other, and the occurrent self-referentiality of pure acts of expression, become core criteria for thinking the political. They do not only apply to activities conventionally categorized as belonging to the actual domain of art (as defined in relation to recognized art institutions and the art market). They apply to all domains, including those defined as political in the conventional sense (electoral politics, grassroots politics, the media through which political images and discourses circulate). These aesthetically *political criteria* relevant to all techniques of existence in what-ever domain add up an aesthetic *criterion of politicality* at the core of the speculative pragmatist approach. The speculative-pragmatic criterion of

politicality concerns the most basic *technical* question raised by the events of the world's double ordering.

That question is, what is to be done? .... with content. In what way will the technique of existence play content between synchresis and concrescence? Will it empty its process of content, suspending itself in its content-readiness, and if so, to what nonsensuous ends? If the technique suspends its process in content-readiness, how far will it take the suspension and how long will it maintain it? Into what Time of transformation will the technique of existence compose its content away? To the intensive end? Will it plant ways for its buds to resprout? If so, into what new concrescences, following what new world–lines, will they bourgeon? Or will the process revert to existing world-lines, tried and true?

The speculative-pragmatic "what is to be done?" orients the question in starkly contrasting directions to Lenin's question of the same wording. Lenin's question begged for an answer along the (party) lines of: order from without. The force of the speculative-pragmatic question orients toward the bringing to expression of immanent forces of existence. Lenin's question was political in the way in which it admitted of only one "correct" solution, gesturing to quite a different sense of "force." The speculative-pragmatic question is not a political question in the same way. It is a question of politicali*ty*. Its answers are potentially many, each self-deciding from within a process's immanent movement of self-formation. The speculative-political criterion of politicality concerns the *intensity* with which a process lives itself out. It is not concerned with how the process measures up to a prefixed frame of correct judgment applied to it from without. It concerns the intensity of a form of life's appetite to live qualitative-relational abstraction creatively, as an immanent measure of its changing powers of existence: forces for becoming. The "aim at intensity of feeling" as part of a "creative advance" into novelty understood as "an aesthetic fact" is, after all, Whitehead's "ultimate" criterion for all process (Whitehead 1978 20, 277–279). Politicality in this sense is not incidental to the metaphysical reality of process. It is no add-on or afterthought. It comes flush with the ultimate metaphysical questions. These, as he repeatedly asserts, are of a cosmological order. This implies there is politics even where there is no human. He famously refers to the "democracy" of trees (1967a, 206.) At the limit,

speculative-pragmatic politicality plays itself out in relation to the more-than human: *cosmopolitics* (Stengers 1997).

## The Processual Poverty of Making Statements

If the intensity of a form of life's grappling with the eternal return of content constitutes its politicality, then techniques of existence that fail to grapple with it, or refuse to, are apolitical. The more political a technique of existence is, the more inventively iterative it is. It self-phrases, following a rhythm of repeated differencings with a characteristic momentum. It phases, dephases, and rephases, taking its own time, setting in as it will. It eventfully *self-expresses*. A technique mobilizing less intense politicality *makes statements* instead. It's all "about." It purports to express in extra to its own occurrence—as opposed to in the excess of it. It is content to point to extra-elements as lying outside its process, often as if they lay outside of *all* process. Common sense and good sense do this. Opinion does this. Doctrine does it also. They go on "about" things. They refer and represent, designate and demonstrate, symbolize and signify. They point the finger and pound the fist. They go on as if pure demonstration were possible. This amounts to a demonstrative denial of process. It is to take things as already where they are and what they are, already made, sitting pretty in a preassumed form, determinately and determinedly just taking up space in a crowded world, slothfully residing on location, if not still, then not moving too fast to point the finger at, before any thinking even begins to be felt. If change is on the agenda, ways must be found to add it back in. The sloth of the world must be stirred to action, following a demonstratively sound program "realistically" taking as its point of departure the prelocated "where" and predefined "what" of things, rather than the "how" and "which" of the process (of everything always already under transformation). Apoliticality starts from general statements like "That's just the way it is" and "Be realistic." If it moves ahead from there, it is on the shuffling crutches of a tired "ought"—one often reflecting a sense of how things used to be, in the old days when they were really sitting pretty. "That's the way things were"/"that's that way things ought to be" . . . so stop fidgeting and be realistic, already. Apoliticality's arc, in its conservative expression, is from the inertia of the real back to the future. In its revolutionary expression, it is equally concerned with backing the future into

conformity with a past: just a recent past of directive decision by a vanguard. In either case, the appetite is for subordinating activity to statement, and statement to program. This way of doing "politics" is at best program proud. It is always process poor—and for that reason, qualifies speculative-pragmatically as apolitical (acosmopolitical).

The provocation of the speculative-pragmatic criterion of politicality is that it evaluates what conventionally passes precisely as political as intensities of the apolitical: programmatic statement. This characterizes ideological and party platforms, reform programs, concrete goal-oriented lobbying efforts, doctrine-centered movements, as embodying the acosmopolitical, to one degree or another, however "political" they are in stated aim and however "revolutionary" they may be in programmatic content. The challenge of speculative-pragmatism's criterion of politicality to political thinking is that it does not obey the traditional categories of the Right-Left, radical–conservative, that are conventionally applied to programmatic-statement based techniques of existence. With the respect to language, the criterion of politicality pertains much less to its usefulness for making statements than to the degree to which a technique of existence avails itself of its *imaginative powers*: its ability to marshal powers of the false, not in order to designate the way things are but to catalyze what's to come, emergently, inventively, un-preprogrammed and reflective of no past model. This is the power of language to perform *virtual events of foretracing*. Its speculative-pragmatic power to produce *a* truth. It is a directly performative power, compelling without the crutch of the programmatic. It is an invocative power. A "magic" power to invoke relational realities into world-lining.

What language handles, as a technique of existence for the production of virtual events, are not semantic contents. Neither are they are codes of content or syntaxes for content formation. Nor symbolic meaning. Nor metaphorical associations. What language as a technique of existence processes, directly and immediately in lived abstraction, is the eventful singularity of vitality affects, and the mode of their mutual transformative inclusion in generic affective tonalities. Politicality is always, on its leading edge, *affective* (Massumi 2005; Massumi 2009, 157–158, 173; Massumi 2010a). The Right has radically understood this, parlaying its strongly performative thinking-feeling of affective politicality into a thirty-year march that has many a produced pragmatic truth to show for the

processual effort, and shows no signs of losing speculative momentum. The "apolitical" may well be conservative, but the "conservative" Right can be outright radical.

Praising the aesthetico-political powers of language performance is in no way a dismissal of the power of other techniques of existence, in other registers, to produce virtual events of a political kind. The audiovisual image register is of arguably greater power today, thanks to the ever-intensifying integration of the activity of its "aliveness engines" into every aspect of life (through cable and satellite television, the Internet, cell phones, and all manner of digital platforms for their technical convergence). The important consideration is that all registers or modalities of experience already virtually contain each other in bud, and that all of the technologies contributing to the iterative production of their infinitely repeated events of variation, as well as all of the techniques of existence working through these technologies, only perform by forming nexuses of their coming-together to experiential effect. Politicality is always an ecological question of mutual inclusion which, given the infinity of elements on offer, is always vitally selective: involving an event-economy of taking-in and out-treating, to determinate experiential effect. The extent to which and the way in which the occurrent perceptual effects are determined to be human-channeled is a key evaluative variable. It is the variable that connects the processual ecology of forms of life to ecology in the environmentalist sense.

## Art Statement

Art, we all know, is quite capable of making statements too, and often does. One traditional way it does this is by affixing programmatic language to itself in the form of an "artist's statement" accompanying the artwork and extra to its event. Another is the manifesto. There is also the gesture of including political messages within the work. Taking the speculative-pragmatic criterion of politicality at the letter, these techniques would not be accounted as particularly political. In relation to the speculative-pragmatic criterion of aesthetic force (the fusion-effect constituting a semblance), they would not come off a particularly artistic either. They may well be ways of not grappling with the eternal return of content, the litmus test of politicality for this approach.

They may well be depoliticizing—not in spite of their content but because of their stating it. But this should not be prejudged solely on the basis of the form the use of language takes. It is important not to prejudge according to *any* preset criteria, *especially* the speculative-pragmatic ones. For the issue for this approach is not the form of the work per se (its recognized genre or conventional gestures), nor even its pointing outside itself toward extra-event content as such. Whatever elements enter the event, the issue is the *force* of their becoming immanent to it, toward the self-detachment of a fusional effect having a dynamic form and affective tonality, animate quality and intensity, singularly-generically its own. Whether the work has this depends not on the "what" of the different elements that enter, but on the "how" of their differential coming-together. This cannot be prejudged, only experienced. The ways in which the conditions have been prepared will have a lot to say about it performatively. The strategies of composing-away and composing-with, and the economy of *their* mutual coming together (and holding part), will also be determining. The mere presence of statement says nothing of semblance. It must be remembered always that evaluative "criteria" are just that—criteria for evaluation, not rules of judgment. The criteria suggested here are heuristic devices for evaluating the aesthetic intensity and politicality of an expressive event. The evaluation bears on the occurrent singularity of the *process*, not on the value of the product by any conventional measure or yardstick of taste or correctness. If these be rules, they are rules of thumb, not instructions for finger pointing.

### The "Beautiful Semblance"

Benjamin's theory of the semblance, from which the present essay took off many unfolded phases ago, is quite conscious of the traditional equation in the history of aesthetic theory between beauty and semblance, and between beauty and truth. He accepts the "famous tenet that beauty is semblance" (Benjamin 2002, 137). He even accepts that semblance is inseparable from truth (Benjamin 1996c, 224). But not, of course, without discomfort. For a beautiful thing has "semblance *because it is alive* in one sense or another" (1996c, 283; emphasis added). The problem is that there are devitalizing truths: *the*-truth truths.

Benjamin suggests concealment as the criterion for distinguishing between enlivening and deadening semblances. It is a question, again, of

content. Semblances of a certain artistic kind make gestures of revealing a content that lies beneath their surface. They reveal that depth in the very gesture of veiling it. For theirs is a surface beauty in the sense of a "mere" appearance. It is only significant for what lies behind it. So mere is its appearance that in one sense it covers the true content. But its superficiality is at the same time the only way of accessing the depth of truth. Its semblance is an uncovering cover for a demure truth.

The depth of truth is reticent because it is nonsensuous, in a certain way. Not the singularly occurrent way that has been the concern of this essay. It is nonsensuous in the unchanging way of a truth eternal. This is the kind of art that critics will say reveals something "universal" about the human condition. The truth will typically be of the human predicament, of what it "means" to be a person. It could, however, be a truth of nature's "universal" order (its acosmopolitial order). Or a sovereign truth. Whatever. But whatever the truth is of, it is of it in the utmost general sense. The truth is not really in a necessary state of concealment because of its nonsensuous character—but rather due to its utmost generality. As we have seen, the nonsensuous is precisely that which *appears*. The occurrent singularity of a nonsensuous similarity that detaches from a sensuous surface to float in a "space" that is a Time of change, can be (cannot but be) perceptually felt. The "universal" generality of the truth beneath the surface can never be so felt. It is of the general kind of abstraction that holds no immediacy, so heavily it sits in its eternity. It cannot intensely return to the surface *through* gesture. It can only be gestured *to*, superficially. It can only be indirectly evoked, the more portentously the better. The surface sensuous forms of the artwork's composition are the only perceptual mode of access to the depths. They must point to a beyond of their world—but not to a qualitative-relational universe of transformation that is duplicitously one with the event.

What makes these truth-revealing sensuous forms evocative is their beauty, defined in a specific way: as a *harmony* of the sensuous forms involved (Benjamin 1996c, 224). The harmony of sensuous forms *recalls* the perfect order of the eternal truth beneath and beyond. It repeats its *form*, and in so doing brings its principle of order to sensuous experience. The *beauty renders perceptible a hidden content in a formal resemblance*. This makes the harmony of sensuous forms the *symbol* of the truth. Deadening semblance is formally-contentful symbolic semblance.

Semblance, made symbolic, forgets again that resemblance is produced and that it pertains only to the singularity of events. Operating symbolically, beauty presupposes, in harmony, a principle of formal resemblance that is generally prior to the artwork, which then takes this general precedence as its organizing principle. Composition becomes subordinated once again to an a priori principle of resemblance. Resemblance comes before the event, and takes precedence over it. It takes a certain amount of acquired interpretive skills, what Irwin called "articulate reading," for the viewer to become a competent party to the symbolic reference. With the precedence of resemblance comes the dominance of *interpretation*. When the meaning uncovered through interpretation is said to be "universal," read "generally legible": truly evocative to a typical member of a given community, of a given class, with a given educational level, in a given period. With the dominance of interpretation comes the consensual tyranny of cultural standards as applied to art.

Benjamin comments that the beautiful semblance, as mere appearance providing an uncovering cover for a universal truth, already belonged to a bygone age at the time of his writing in the first half of the twentieth century. Yet it remained an issue for him, and he came back to the question of the beautiful semblance over many years. Presumably, this was because there were contemporary practices that still owed something to this manner of semblance-making. There still are. Echoes of the beautiful semblance can be heard loud and clear in the words of Martha Graham quoted earlier. Any work that primarily defines its effect as simply or purely evocative—as "poetic" in a symbolic sense or as "metaphorical"—is in the business of the beautiful semblance. Its "universality" and "depth" will be praised to high consensual heaven. In the twentieth and twenty-first centuries, the truths uncovered are almost invariably of the human condition, with a first-person address. The exhortation is to "identify" : the principle of resemblance still takes precedence, and is still taken by the artwork as its organizing principle, but now the resemblance is to be taken personally, in the first-person universal (I, Everyman). Truth morphs into "authenticity." Articulate reading becomes far less important. To identify, all you need is personal feeling, and everybody human of any station presumably has that. Personal feeling: emotion. The universal reign of emotional generality claims the content of art.

Benjamin comes back to the issue of the beautiful semblance because his discomfort with it is political. The issue here is that of failing or refusing to grapple with the paradox of content with respect to the semblance, with deadening effect on the politicality of art.

### Quivering Life

There is not just one kind of beautiful semblance. There are different "degrees" of beautiful semblance, of very different aesthetic and political force. The scale is "determined not by the greater or lesser degree of beauty but by the extent to which a thing has more or less the character of semblance" (Benjamin 1996c, 224, all quotes below 224–225). There is in beauty a sliding scale of semblance that moves between two poles. At one end is the apoliticality of the semblance whose beauty evokes *the*-truth of its content. At the other end, there is the "semblance in which nothing appears"—which *is* its own appearing, and whose appearing isn't a "mere" appearance but a sui generis event.

The scale is the scale of *aliveness*: "In an artifact of beautiful semblance, the semblance is all the greater the more alive it seems." Semblance and aliveness are indissociable. There is always "life quivering" in the event of the semblance. Bare activity (James 1996a, 160–162; Massumi 2009, 170–173; Massumi 2010a). Pure activity of life, abstractly appearing with all the reality of an intensive event.

"Quivering life is never symbolic." But it can be forcibly contained in harmony and its symbolic associations. When it is, the harmony "trembles" with life, but does not release it. It channels it toward the truth, to which it gives a sheen, a beautiful shimmer. Symbolism contains abstract life-intensity in the truth. It slides the artwork toward the deadening apolitical pole of the scale. Art, and life, must then be wrenched from that pole by "critical violence."

Critical violence consists in "arresting" the beautiful semblance. "Interrupting" its trembling for truth. "Petrifying" it, "paralyzing" it, holding it "spellbound." The retrograde movement of the truth is *suspended*. The expression of the truth hesitates, unable to complete the evocative retreat into the depths of reference. The a priori principle of resemblance waivers. Harmony is no longer guaranteed and authorized by it, so the truth is no longer uncovered by its surface veil. Symbolism and metaphor are

composed-away. The dialectic of covering-uncovering ceases. Life quivers all the more intensely perceptually-felt, in a "compelling" openness of indetermination regained.

Life again unlimited, its semblance no longer under sentence to express a general truth or personal feeling. Art at the highest degree of the "expressionless." Bare activity of expression. "No definite direction, no actor, no aim" other than its own intensity (James 1996a, 160). The unlimiting of life's quiver releases the force of all the intensity that had been contained. The opening onto bare activity is explosive, "shattering" the work "into fragments, reducing it to the *smallest* totality of a semblance." A smallest totality, explosively produced: a totally singular dynamic unity. Benjamin's "expressionless" is what was here called "pure expression": an intensity-expressing experiential event that is wholly and only its own self-floating occurrence.

The theory of the beautiful semblance, Benjamin says, is not just about art in the narrow sense. He makes it clear that it is also about politicality, and says explicitly that is "essential for metaphysics" as well. In his explosive fragment of a semblance as "smallest totality," we can see James's *little absolute* of "immediately given relation" (James 1996b, 280; see this book's introduction). The semblance was defined in chapter 2 as a little absolute, which was in turn affirmed as the fundamental metaphysical reality from the perspective of a radical empirical philosophy and its twin sister speculative pragmatism. The little absolute, James was quoted as saying, includes its own other in its event in such a way that any identity it might be attributed, by whatever means, symbolic or otherwise, "telescopes and diffuses into other reals" (James 1996b, 272). Metaphysico-politically. Cosmopolitically.

Benjamin seems to agree. But he insists on the metaphysico-political point, also grappled with by radical empiricism and speculative pragmatism, that immediately given relation is a nonrelation. "The expressionless," Benjamin writes, is that critical violence which, "while unable to separate semblance from truth in art, prevents them from mingling." The composing-away of truth and content is actually a kind of separative composing-with: together, but separate, disjunct, in differential tension. Intensely, duplicitously. Synchretically-conscrescently.

Is "critical violence" but a duplicitous way of explosively holding in reserve buds of content for a blossoming to come? Does the "the power of

the expressionless" tend already toward a "telescoping and diffusing into other reals"—coming potentials a world-walk away from that explosive non-place of art as a place only of changes? Might the suspension of the beautiful semblance give the expressionless legs? The better to world-line with? Does quivering life struck with "critical violence" bleed expanding life?

## Conclusion

"No work of art can appear *completely* alive without becoming mere semblance, and ceasing to be a work of art" Benjamin (1996c, 224).

# Notes

## Introduction

1. Although Whitehead and James privilege the concept of activity in highly consonant ways, they differ on the vocabulary of "bare activity." Whitehead uses the term in a sense opposed to James's and adopted here from James. Whitehead uses "bare activity" to refer to the Newtonian notion of matter, according to which matter can be understood purely in terms of its occupancy of space and its extensive movements in space at an instant. By this reckoning, matter can be understood "without reference to any other instant, or to any other piece of matter, or to any other region of space." It is essentially without relation, and being without relation is of itself without importance (Whitehead 1968, 146–147). This is the "fallacy of misplaced concreteness" mentioned later in this introduction. Its effect is to separate matter from life. Both James and Whitehead agree in their refutation of this approach in favor of concepts of event, change, potential, and creativity that implicate matter in life and life in matter, and both in mentality, such that neither can be purified of its involvement in the other. For a recent approach moving in consonant philosophical directions, see Bennett (2010).

2. One of the most compressed expressions of this in Whitehead is: "The process through which a feeling passes in constituting itself also records itself in the subjective form of the integral feeling" (Whitehead 1978, 226). Compare Deleuze and Guattari's "second synthesis" of process, that of the "production of recording" (the third being the culmination of "enjoyment") (Deleuze and Guattari 1983, 9–21).

3. Another paradox is not dealt with extensively in what follows but bears mentioning for reasons of precision regarding Whitehead's vocabulary. It concerns the concept of change. If an occasion of experience is absolutely its own event of self-creation, then it is misleading to refer to it as a change (Whitehead 1978, 35). Considered in itself, in its little-absoluteness, it has only its own sheer becoming, as the mutual inclusion of its phases in each other. To call it a change implies a comparison between a before and an after. But an occasion of experience is all in its own occurrence. It is entirely absorbed its own singularly happening sheerness.

An occasion of experience is unchanging *because* it is absolutely its own becoming: sheer production of novelty. Strictly speaking, for Whitehead, "change" makes sense only as applied to how novel occasions of experience succeed one another. Change occurs between occasions of experience, and it is the differential between them that allows it to be said that a change has taken place, which is what constitutes an event. For Whitehead, an occasion of experience considered in its own dynamic unity of becoming is not the model for the concept of event. A single occasion of experience, Whitehead says, is a limit-case event: a "limit type of event with one member" (Whitehead 1978, 73). The occasion of experience's becoming is but the minima of happening. Even so, a limit-case event is still an event, however minimally. Actual occasions are after all called *occasions*. As important as these precisions are metaphysically, they are not focused on in this book. The technical Whiteheadian distinctions between event and experience of occasion, and between becoming and change, were not necessary for its project. The usage here conforms more to Deleuze and Deleuze and Guattari, for whom event, becoming, and change come together (Deleuze 1990; Deleuze and Guattari 1987). Whitehead's "sheer individuality," its Jamesian little-absoluteness, are also read in a way that does not exclude infoldings of chance encounters intervening during an occasion's becoming. The Whiteheadian justification for this is the doctrine that an occasion of experience includes in its own constitution the "more" of the world that lies beyond its individuality: "each entity, of whatever type, essentially involves its own connection with the universe of other things" (Whitehead 1968, 66). The only way the inclusion of the more-beyond can belong to the constitution of the occasion is in the form of *capacities* of infolding (and techniques for bequeathing the formative activity of this occasion to others—diagrams). The only way capacities can infold is if they are at the same time *affectabilities*. Given the durational nature of the occasion of experience (Whitehead 1978, 125) and the always going on around of other durations, the affective capacity for infolding must be operative on the fly. There will always be "smaller" durations knocking against the window like the wings of moths. The aim of Whitehead's principle of "conceptual reversion" is to take account of this. According to this principle, "there is a secondary origination of conceptual feelings with data which are partially identical and partially diverse from" the data in the primary phase. "In this second phase the proximate novelties are conceptually felt." "There is a conceptual contrast of physical incompatibilities." This leads to a "subsequent enrichment" of the occasion (Whitehead 1978, 249). This is not in contradiction with the occurrent unity of the occasion's sheer individuality. The unity of an experience is the tendential arc of its occurrence through its phases. An occasion of experience is not "itself" in the sense of a bounded unity or a closed totality. It is a constitutively open dynamic unity, which is a function of its capacity to open itself to self-modulation. Activist philosophy transforms monadism into *transmonadism* (Guattari 1995, 112–116) and in the same stroke, converting "autopoiesis" into "heterogenesis" (33–57). The phasing of the event of experience cannot be indifferent to interference encountered en route. These must be taken up in the

event's momentum as affordances. as reenergizations of its initial impulse as it arcs toward its self-creative terminus. But it must be remembered that it is not the "data" that are perceived in any usual sense of the term. The subjective form of the datum is perceptually felt. In other words, what is "perceived" is the form of its activity. The form of its activity strikes as interference and is taken in as *resonance* (see the discussion of resonance in chapter 2). The concept of resonance enables a theorization of secondary originations of an occasion on the fly without contravening the principle of the contemporary independence of actual occasions. Here, the conversion of interference into resonance involves a nonsensuous perception by the event under way of its affective co-implication with other events—an intuition of their mutual immanence in each other's arising. In Deleuze's reading of Leibniz, the corresponding concept to the affective capacity of resonant infolding is the vinculum (bond)—the "unlocalizable primary link that borders the absolute interior" of a monad with its outside; "a supple and adherent membrane coextensive with everything inside" that enables the event of experience to "recover the other side, not as exterior to the monad, but as the exterior or outside *of* its own interiority" (Deleuze 1993, 111).

4. Deleuze and Deleuze and Guattari converge with Whitehead on this point:

Sensation fills out the plane of composition and is filled with itself by filling itself with what it contemplates: it is 'enjoyment' and 'self-enjoyment.' It is subject, or rather an *inject*. Plotinus defined all things as contemplations, not only people and animals but plants, the earth, rocks. These are not Ideas we contemplate through concepts but the elements of matter that we contemplate through sensation. The plant contemplates by contracting the elements from which it originates—light, carbon, and the salts—and it fills itself with colors and odours that in each case qualify its variety, its composition: it is sensation in itself. It is as if flowers smell themselves by smelling what composes them. (Deleuze and Guattari 1994, 212; see also Deleuze 1994, 74–75)

5. This reference to nonactualized potentialities complicates arguments that interpret Whitehead's philosophy as an actualism in stark opposition to Deleuze's virtualism. These general categories—like all general categories—are far too gross. They fail to capture the complexity of these thinkers, or their kinships and divergences. Whitehead's reference to nonactualized potentialities is related to his concept of negative prehension. Negative prehension is the selecting-out of potentials that will not be positively taken into an occasion of experience's unfolding. Whitehead remarks that the exclusion of a potential, while not positively figuring in the experience's composition, has a "definite" impact on its subjective form. The potentials are *outed-into* the dynamic unity of the forming experience. They are actively abstracted out, but not without leaving a dent. This gives them a certain status in the occasion's actuality, qualifying them as being "in act" in definite trace form. They still qualify as fully real, because Whitehead's definition of reality states that everything that is real is positively exemplified somewhere, if not here and now. This raises the question of the status of these excluded realities when they are elsewhere and elsewhen. The category of pure potential is needed to account for this.

The virtual fulfills the same function in Deleuze's philosophy. Pure potentialities, or virtualities, even when they are elsewhere and elsewhen, exert an abstract pressure on the actual. They are always-everywhere knocking on the door of actuality for admission, and must be actively selected out if they are not to make ingress. In Whiteheadian terms, we are talking about "eternal objects." The corresponding term in Deleuze is singularities, as defined in *Logic of Sense* (1990). The key passage in Whitehead on the topic of negative prehension: "An actual entity has a perfectly determinate bond with each item in the universe. This determinate bond is its prehension of that item. A negative prehension is the definite exclusion of that item from positive contribution to the subject's own real internal constitution. This doctrine involves the position that *a negative prehension expresses a bond.* . . . Those eternal objects which are not felt are not therefore negligible. For each negative prehension has its own subjective form, however trivial and faint. It adds to the emotional complex, though not to the objective data. The emotional complex is the subjective form of the final 'satisfaction'" (Whitehead 1978, 41; emphasis added). A negative prehension has the paradoxical status of an *unfelt factor in feeling.*

## Chapter 1

1. Deleuze (1994, 245, 251–53) calls the object under this aspect the sign of a "remarkable point" in the course of a "dramatization."

2. For an excellent study of James's philosophy consonant with this perspective (and to which this account owes much), see David Lapoujade (1997).

3. This concept of belief as eventful, participatory immersion in the world's ongoing is shared by Gilles Deleuze, who calls it "belief in this world": "If you believe in the world you precipitate events, however inconspicuous, that elude control, you engender new space-times, however small their surface or volume" (1995, 176; see also Deleuze 1989, 172–173).

## Chapter 2

1. On the world's recasting as a "gamespace" through the interaction between digital media with life at large, see McKenzie Wark (2007).

2. The distinction between seeing an object and seeing its likeness as developed here corresponds roughly to Damasio's distinction between "feeling" and "feeling feelings" (1999, 278–281).

3. Erwin Panofsky, in his classic study of perspective, also emphasizes that we "see through" the materiality of the pigment and canvas to experience in vision a semblance of an infinite geometric order of space: "*Perspectiva* is a Latin word which means 'seeing through.' . . . We shall speak fully of a 'perspectival' view of space not when mere isolate objects, such as houses or furniture, are represented in

'foreshortening,' but rather only when the entire picture has been transformed—to cite another Renaissance theoretician—into a 'window,' and when we are meant to believe we are looking through this window into space. The material surface upon which the individual figures or objects are drawn or painted or carved is thus negated, and instead reinterpreted as a mere 'picture plane.' Upon this picture plane is projected the spatial continuum which is seen through it and which is understood to contain all the various individual objects" (Panofsky 1991, 27).

4. Simondon (2007, 208) speaks of the immanence of relation in the context of technical invention in terms that recall a number of the points about connectivity and contemporary independence made here. He calls the immanence of relation the dynamic "ground" (*fond*) of technical objects and their associated milieus: "Perpetually overlooked, the ground is what holds the dynamisms. It is what allows the system of forms to exist. Forms do not participate with other forms, but rather participate in the ground. The ground is the system of all forms or rather the common reservoir of the tendencies of forms before they even exist as separate entities and are constituted as an explicit system. The relationship of participation connecting the forms to the ground is a relation that straddles the present and imbues it with the potential influence of the future, with an influence of the virtual on the actual. For the ground is the system of virtualities, potentials, and forces on the way, whereas the forms constitute the system of the actual. Invention is a taking in charge of the system of actuality by the system of virtualities. It is the creation of one system from these two systems. Forms are passive inasmuch as they represent actuality. They become active when they organize themselves in relation to the ground, thus actualizing prior virtualities."

5. Readers able to read French are encouraged to refer to the original. The translation seriously obscures the complex play of Deleuze's philosophical vocabulary around the key concepts of "actual/actualization" (terms which tend to fall out) and "real/realization" (variously translated). The original passages in question are in Deleuze (1988b, 107–108).

6. For an account of an abstractly lived-in movement that is not abstract in the sense of eschewing figuration, but that doubles a figurative scene (primarily of landscape), see Massumi (2003) on the panoramic photography of Luc Courchesne.

7. For a rethinking of touch itself in a way that recognizes the centrality of kinesthesia to all sensory experience, not only vision, see Manning (2007).

**Chapter 3**

1. For an interlocking account of color in its relation to other senses that focuses on the relation to language, see Massumi (2002, 162–176).

## Chapter 4

**First Movement: To Dance a Storm**
1. This is what Whitehead calls a "conceptual prehension," in contradistinction to a "physical prehension." The basic difference is that a physical prehension entails a "conformation of feelings" and a conceptual prehension introduces "novelty" (here construed in terms of the production of a "nonsensuous similarity") (Whitehead 1978, 26, 33, 238 and passim).

2. "Universe" here alludes to Félix Guattari's concept of "incorporeal universes" (also called "consciential universes," "universes of value," and "universes of reference"). By "reference" Guattari means not a semantic content or designated object but rather a "meta-modelization of transassemblage relations" (Guattari 1989, 31). The "archive" of nonsensuous similarity as analyzed in this essay is such a meta-modelization, as directly lived. Guattari develops the theory of universes of reference throughout *Cartographies schizoanalytiques* (1989). See also *Chaosmosis* (Guattari 1995), where the universe of reference is defined in terms of "non-discursive incorporeal complexity" (60). Guattari's concept of "universes" is closely allied to Ruyer's concept of "virtual domains" (Ruyer 1952).

3. "Form of life" is being used here in a sense close to Agamben's (2000), where thought and vitality are one: "by form-of-life . . . I mean a life that can never be separated from its form, a life in which it is never possible to isolate something such as naked life" (3–4). "I call *thought* the nexus that constitutes forms of life in an inseparable context as form-of-life. I do not mean by this the individual exercise of an organ or of a psychic faculty, but rather an experience, an *experimentum* that has as its object the potential character of life and human intelligence. To think does not mean merely to be affected by this or that thing, by this or that content of enacted thought, but rather at once to be affected by one's own receptiveness and experience in each and every thing that is thought a pure power of thinking" (9).

4. The genericness of the affective tonality is the nonconscious bud of what are called the "categorical affects." Categorical affects are genre of affective experience that have come to be consciously named and identified, and as a result are understood as the subjective content of certain moments of experience. This separates them from their eventness, from their sheer occurring, and makes them a noun. This substantivizing as *content* renders them in certain respects communicable independently of their event (disqualifying them from the status of form-of-life, as defined by Agamben in note 3 above). Their separation from their own event delivers them to techniques of *mediation*. Mediatable affect is what in earlier work I have termed "emotion" (Massumi 2002, 27–28). Emotion is a particular mode of abstraction from the full affective dimensionality of affective attunement. Its mediatability makes it more accessible to conventional expression and manipulation, which in many everyday situations makes it more salient. This can obscure the primacy and

ubiquity of vitality affects. In fact, their very ubiquity tends to background them in many habitual situations. "Vitality forms are hard to grasp because we experience them in almost all waking activities. They are obscured by the felt quality of emotions [the affective tonality that delivers them to content] as it accompanies them" (Stern 2010, 20). For a more prolonged discussion of the transition from affective vital-eventness to emotional life-content, see Massumi (2005, 37–39). The singular-generic was discussed above (chapter 2) in terms of the "likeness" of an object to itself that makes each singular encounter with the object teem with a belonging to others of its kind (the object as semblance). The discussion of the singular-generic was aimed at understanding the way in which an object is actually of the nature of an event (an iteration in an event-series, or developing world-line). In this chapter, it is a question more directly of events, and semblances of events. The "regions" of the nonsensuous universe of qualities of life are Ruyer's virtual "domains" (which he similarly defines in terms of nonlocal linkage, or in his vocabulary "nonlocal liaisons") (Ruyer 1952, 95–131). Stern uses a concept of the singular-generic without calling it that.

5. The parent-child example should not be misunderstood as suggesting a developmental origin for amodal perception in the life of the individual. Quite the opposite. Direct, nonsensuous perception of relation is the condition of emergence of the individual itself. That condition of emergence follows the individual at every step, doubling each objective coming-together of forms she encounters or participates in with a "sui generis" experience of relation. From one encounter to the other, the experience of relation changes—composing a sui generis experience of *becoming*. This nonsensuous feeling of becoming is the *feeling of being alive*: vitality (Stern 2010). On the developmental question, Stern cites research demonstrating that amodal perception is innate (1985, 38–42). His approach to developmental psychology appeals to amodal perception to explain how a "sense of self" emerges relationally, with the capacity to continue to become.

6. The creative power of language and thought can be considered *hallucinatory* as opposed to delusional. There is a hallucinatory dimension to every experience to the exact extent to which it is creative, and thus has no preconstituted object (Deleuze 1993, 93). This hallucinatory power is the "power of the false" discussed later.

7. The focus in this chapter on the ways in which language and thought go together should in no way be read to imply that they *must* go together: that they are necessarily bound to each other by nature. As the rest of this chapter will attempt to show, nonsensuous event-traces can be manipulated nonverbally (in ritual, in dance, in music, among other ways). These nonverbal operations qualify as thought every bit as much as language-borne operations involving vitality affects and nonsensuous similiarities do. There is true thought in nonverbal beings. This applies as much to animals as to nonverbal humans, such as so-called "low-functioning"

autists. On animal thought, see Massumi (forthcoming a). On autistic thought and experience, see Manning and Massumi (forthcoming a) and Manning (forthcoming a). When thought and language do go effectively together, it is because each has the power in its own right to operate virtually, and mechanisms are in place to effectively combine their virtual powers. It should be noted that just as there are modes of thought that are nonverbal, there also are uses of language divorced from thought. Among these are conventional uses of language (of the kind falling under the rubric of common sense), and uses of language for personal expression in a way that is free of both delusion and effective ambulation (opinion).

8. There is not the space in this book to ground this discussion of ritual in a particular ritual tradition, which properly should be done in order to respect the singularity of techniques of existence. The understanding of ritual expressed here does, however, come out of an engagement over many years with a singular ritual tradition, through my long collaboration with Kenneth Dean. Dean is an ethnographer of esctatic popular religious practices of Fujian province in southern China. He has followed in painstaking empirical detail the revival of the unique syncretism of the region since the end of the Cultural Revolution (Dean 1998). He has recently supplemented his scholarly publications with a documentary film, *Bored in Heaven: A Film About Ritual Sensation,* for which I served as an adviser during the on-location shooting and editing (Dean 2010). The discussion of ritual here doesn't begin to do justice to the complexity of ritual practice and its creation of really experienced virtual spaces that are eventfully productive of their own pragmatic truths. In the case of Chinese ritual, one of its most egregious omissions on the speculative front is the interplay between microcosmic and macrocosmic dimensions of cosmological space enacted in bodily performance. On the pragmatic side, the worst omission is the actuality of the practices—the fact that they are not archaic holdovers but are actively, integrally, and co-constitutively intertwined with contemporary events associated with the penetration of global capitalism into what was one of China's first "special economic zones" opened to lead the transition from communism.

### Second Movement: Life Unlimited
9. This is meant also to be taken as a critique of the principle of "openness through closure" upon which the theory of autopoiesis is founded. The critique is that autopoiesis recurs to a theory of formal constitution (albeit of a nonrepresentational variety) that is at philosophical odds with its ambition to theorize lived, and living, genesis. What it lacks, for an effective theory of lived genesis, is a principle of nonformal (qualitative-relational) experience as immediately ingredient in every operation of the world's constitution. This could only be a principle of feeling (perceptual feeling) understood as primary in relation to logical form, as well as any notion of objective ordering it might authorize or guarantee. The philosophies of Peirce, Whitehead, and Deleuze/Guattari are the most thorough-going metaphysical constructions mobilizing this principle: that the world is literally *made* of feeling,

uncontained by any a priori form or order, but at the vanishing point where feeling enters into a zone of ontogenetic indistinction with thought.

10. What is being called a semblance here corresponds in many respects to what Deleuze in *Logic of Sense* (1990) calls a "simulacrum" or "pure effect." In *Anti-Oedipus*, Deleuze and Guattari (1983) give a distinctly ontogenetic spin to this concept of simulation: "Simulation . . . expresses those nondecomposable distances always enveloped in intensities that divide into one another while changing their form. . . . Simulation . . . is . . . strangely polyvocal, flush with the real. It carries the real beyond its principle to the point where it is effectively produced . . . the point where the copy ceases to be a copy in order to become the Real *and its artifice* . . . an intensive real as produced in the coextension of nature and history" (1983, 87). Echoes of the present vocabulary's "differential attunement," "mutual inclusion" in change, and transformational "nonlocal linkage" are audible in this passage.

11. This connects back to Deleuze's concept of "cleaving things asunder" (Deleuze 1995, 86) and making a "Sahara" of them (Deleuze 2004b, 82, 128), discussed in chapter 2.

12. It is on the concept of the "space of the body" that the present account departs most significantly from José Gil's brilliant theory of dance (Gil 2006), which is in many other respects consonant with the approach suggested here.

13. Erin Manning in her work on dance emphasizes that this emptying of human meaning and intention can free the nonhuman to dance. She develops the nonhuman dimension of dance events by elaborating on William Forsythe's concept of a "choreographic object": an object that activates dance around itself. The choreographic "object" is not an object in the usual sense. It is a catalyzer of a field of movement. Any human bodies involved are involved only to the extent that they are moved by the field as much as they are self-moving (Manning 2009b, forthcoming b). In Guattari's vocabulary, the choreographic object is a nonhuman "nucleus of expression" (1995).

### Third Movement: The Paradox of Content

14. Whitehead discusses the affective tonality, or generic feel, specific to vision in terms of a background awareness of a "withness" of the eyes immanent to every visual perception (Whitehead 1978, 64). There is a "withness" of every sense, and of the body as a whole (312–313), ingredient in every experience, and to which the singular-genericness of the varying modes of experience is in large part owing.

15. See Andrew Murphie (2004) for a theory of "differential media."

16. Whitehead (1967a, 236): "The word Concrescence is a derivative from the familiar Latin verb, meaning to 'grow together.' It also has the advantage that the participle 'concrete' is familiarly used for the notion of complete physical reality. Thus Concrescence is useful for conveying the notion of many things acquiring

complete complex unity. But it fails to suggest the creative novelty involved. For example, it omits the notion of the individual character arising in the concreteness of the aboriginal data [the ingredient elements]." The words synchresis, fusion-effect, and nonsensuous similarity are used here to include the notion of the "individual character"—the qualitative-relational singularity—of the complex unity of an event of experience. The word "together," Whitehead continues, " is one of the most misused terms in philosophy." The problem is that it is used "as though it conveyed one definite meaning," and also as if there were togetherness outside of experience. In these uses, it is "sophistical." For in fact "no things are together except in experience; and no things *are*, in any sense of 'are,' except as components in experience or as immediacies of process which are occasions of self-creation." *Esse est sentiri*: to be is to be felt. To be is to be experienced. Or more radically: to be is to be *experience*. Experience is not confined to the human, but is distributed across the nature-culture continuum. Every thing is a being of experience. One of the implications for the present approach of this way of thinking "together" is that, by Whitehead's criteria, what is termed "interaction" is a sophistical concept because it is not used to connote "immediacies of process." To the contrary, interaction is defined in terms of objectively describable actions and reactions (technological functions) that *mediate* experience (see chapter 2).

17. "*The Category of Subjective Intensity*. The subjective aim, whereby there is origination of feeling, is at intensity of feeling in the immediate subject, and in the relevant future" (Whitehead 1978, 27). The "ultimate creative purpose" is that "each unification shall achieve some maximum depth of intensity of feeling, subject to the conditions of its concrescence" (249). This "is the category whereby novelty enters the world" (249, see also 277–278).

### Fourth Movement: Composing the Political
18. Deleuze and Guattari develop the principle that the multiple is always most intensely and transformatively attained by creative subtraction (1987, 6, 21): "Subtract and place in variation, remove and place in variation" (104). Deleuze (2004b) charts this process at length in the work of the painter Francis Bacon.

19. Philosophically speaking, the notion of appetition and subjective aim assert the need to add the long out-of-favor concept of "final causation" to the metaphysical picture again. In the present essay, final causation comes back in the form of the nonsensuous "tending-toward" a "terminus." In reintroducing a certain notion of final causation, however, it is important to underline that the terminus as final cause is not sufficient cause. It is co-causal, requiring the contribution of objective conditions ("data" in Whitehead's terms) combined just so. It is this setting in place of objective conditions, taken-together in a tending-toward a terminus, that constitutes what is being called here a "technique of existence." Of itself, the setting in place of objective conditions is not an efficient cause. The resulting theory of

causality is best described as a theory of "quasi-causality" (a hybrid between efficient and sufficient causation, objective and final causes; Massumi 2002, 225–228).

20. On the question "What else?" as asked by William Forsythe of dance, see Erin Manning, "Choreography as Mobile Architecture" (in Manning forthcoming a).

21. In *What Is Philosophy?*, Deleuze and Guattari (1994) ask the "what else?" question of philosophy. They theorize what is singularly generic about the activity of philosophy, precisely in order to resituate it within a creative ecology of synchretic relation with its "non-philosophical" outside. It is misreading the book to see it as an argument for the "particularity" of philosophy: what makes it philosophy *as opposed to* art, or logic, or science. The aim of the book is the opposite: to return philosophy to an ecology of the what-else. To make a creative event of philosophy as one technique of existence composing-with any number of others. *A Thousand Plateaus* is the most intense example of this philosophical composing-with in their combined works (Deleuze and Guattari 1987).

# References

Agamben, Giorgio. 2000. *Means without Ends: Notes on Politics*, translated by Vincenzo Binetti and Cesare Casarino. Minneapolis: University of Minneapolis Press.

Artaud, Antonin. 1996. "50 dessins pour assassiner la magie" (1948). *Antonin Artaud: Works on Paper*, edited by Margit Rowell, 32–37. New York: Museum of Modern Art.

Ashby, Arved. 2010. *Absolute Music, Mechanical Reproduction*. Berkeley: University of California Press.

Barthes, Roland. 1977. "The Photographic Message." *Image-Music-Text*, translated by Stephen Heath, 15–31. New York: Hill and Wang.

Barthes, Roland. 1988. *Camera Lucida: Reflections on Photography*, translated by Richard Howard. New York: Hill and Wang.

Benjamin, Walter. 1996a. "Analogy and Relationship." *Selected Writings*. Vol. 1, *1913–1926*, 207–209. Cambridge: Harvard University Press.

Benjamin, Walter. 1996b. "Beauty and Semblance." *Selected Writings*. Vol. 1, *1913–1926*, 283. Cambridge: Harvard University Press.

Benjamin, Walter. 1996c. "On Semblance." *Selected Writings*. Vol. 1, *1913–1926*, 223–225. Cambridge: Harvard University Press.

Benjamin, Walter. 1999a. "A Little History of Photography." *Selected Writings*. Vol. 2, *1927–1934*, 507–530. Cambridge: Harvard University Press.

Benjamin, Walter. 1999b. "On the Mimetic Faculty." *Selected Writings*. Vol. 2, *1927–1934*, 720–722. Cambridge: Harvard University Press.

Benjamin, Walter. 2002. "The Significance of the Beautiful Semblance." *Selected Writings*. Vol. 3, *1935–1938*, 137–138. Cambridge: Harvard University Press.

Benjamin, Walter. 2003. "The Work of Art in the Age of Its Technological Reproducibility. Third Version." *Selected Writings*. Vol. 4, *1938–1940*, 251–283. Cambridge: Harvard University Press.

Bennett, Jane. 2010. *Vibrant Matter: A Political Ecology of Things*. Durham: Duke University Press.

Bergson, Henri. 1988. *Matter and Memory*, translated by Nancy Margaret Paul and W. Scott Palmer. New York: Zone Books.

Bourriaud, Nicolas. 2002. *Relational Aesthetic*, translated by Simon Pleasance and Fronza Woods with Mathieu Copeland. Dijon: Les Presses du Réel.

Chion, Michel. 1994. *Audio-Vision: Sound on Screen*, translated by Claudia Gorbman. New York: Columbia University Press.

Cunningham, Merce. 1998. "You Have to Love Dancing to Stick with It" (1968). In *The Vision of Modern Dance: In the Words of Its Creators*, 2nd ed., edited by Jean Morrison Brown, Naomi Mindlin, and Charles H. Woodford, 88–91. Princeton: Princeton Book Publishers.

Damasio, Antonio. 1999. *The Feeling of What Happens: Body and Emotion in the Making of Consciousness*. New York: Harcourt.

Dean, Kenneth. 1998. *The Lord of the Three in One: The Spread of a Cult in Southeast China*. Princeton: Princeton University Press.

Dean, Kenneth. 2010. *Bored in Heaven: A Film About Ritual Sensation*. BluRay/DVD. Documentary film.

Deleuze, Gilles. 1978a. "Deleuze/Kant. Cours Vincennes: Synthesis and Time." March 14. http://www.webdeleuze.com/php/texte.php?cle=66&groupe=Kant&langue=2.

Deleuze, Gilles. 1978b. "Deleuze/Kant. Cours Vincennes." March 21. http://www.webdeleuze.com/php/texte.php?cle=67&groupe=Kant&langue=2.

Deleuze, Gilles. 1986. *Cinema 1: The Movement-Image*, translated by Barbara Habberjam and Hugh Tomlinson. Minneapolis: University of Minnesota Press.

Deleuze, Gilles. 1988a. *Foucault*, translated by Séan Hand. Minneapolis: University of Minnesota Press.

Deleuze, Gilles. 1988b. *Le pli. Leibniz et le baroque*. Paris: Minuit.

Deleuze, Gilles. 1989. *Cinema 2: The Time-Image*, translated by Hugh Tomlinson and Robert Galeta. Minneapolis: University of Minnesota Press.

Deleuze, Gilles. 1990. *Logic of Sense*, translated by Mark Lester with Charles Stivale and edited by Constantin V. Boundas. New York: Columbia University Press.

Deleuze, Gilles. 1993. *The Fold: Leibniz and the Baroque*, translated by Tom Conley. Minneapolis: University of Minnesota Press.

Deleuze, Gilles. 1994. *Difference and Repetition*, translated by Paul Patton. New York: Columbia University Press.

Deleuze, Gilles. 1995. *Negotiations*, translated by Martin Joughlin. New York: Columbia University Press.

Deleuze, Gilles. 1997. *Essays Critical and Clinical*. Minneapolis: University of Minnesota Press.

Deleuze, Gilles. 2004a. *Desert Islands and Other Texts 1953–1974*, translated by Mike Taormina. New York: Semiotext(e).

Deleuze, Gilles. 2004b. *Francis Bacon: The Logic of Sensation*, translated by Daniel W. Smith. Minneapolis: University of Minnesota Press.

Deleuze, Gilles. 2007. *Two Regimes of Madness: Texts and Interviews 1975–1995*, translated by Ames Hodges and Mike Taormina. New York: Semiotext(e).

Deleuze, Gilles, and Félix Guattari. 1983. *Anti-Oedipus*, translated by Robert Hurley, Mark Seem, and Helen R. Lane. Minneapolis: University of Minneapolis Press.

Deleuze, Gilles, and Félix Guattari. 1987. *A Thousand Plateaus*, translated by Brian Massumi. Minneapolis: University of Minneapolis Press.

Deleuze, Gilles, and Félix Guattari. 1994. *What Is Philosophy?*, translated by Graham Burchell and Hugh Tomlinson. London: Verso.

Descartes, René. 1996. *Meditations on First Philosophy*, translated by John Cottingham. Cambridge: Cambridge University Press.

Eisenman, Peter. 1994. "House VI." In *House VI: The Client's Response*, edited by Suzanne Frank, 21–24. New York: Whitney Library of Design.

Eisenman, Peter. 1999. *Diagram Diaries*. London: Thames and Hudson.

Forsythe, William. 2008. Conversation with the author. Amsterdam, June 3.

Foucault, Michel. 1970. *The Order of Things: An Archeology of the Human Sciences*, translated by A. M. Sheridan Smith. New York: Pantheon.

Foucault, Michel. 2008. *The Birth of Biopolitics: Lectures at the Collège de France 1978–1979*, translated by Graham Burchill. New York: Palgrave-Macmillan.

Genosko, Gary, and Andrew Murphie, eds. 2008. "Metamodeling" (special issue). *Fibreculture*, no. 12. http://twelve.fibreculturejournal.org.

Gibson, James J. 1986. *The Ecological Approach to Visual Perception*. Hillsdale, NJ: Lawrence Erlbaum.

Gil, José. 2001. *Movimento Total. O Corpo e a Dança*. Lisbon: Antropos.

Gil, José. 2002. "The Dancer's Body." In *A Shock to Thought: Expression after Deleuze and Guattari*, edited by Brian Massumi and translated by Karen Ocana, 117–127. London: Routledge.

Gil, José. 2006. "Paradoxical Body," translated by André Lepecki. *TDR: The Drama Review* 50, no. 4: 21–35.

Goethe, Johann Wolfgang von. 1972. "Confessions of a Color Enthusiast." *Journal of Color and Appearance* 1, no. 3 (November–January): 32–37.

Graham, Martha. 1998. "Artist's Statement" (1937). In *The Vision of Modern Dance: In the Words of Its Creators*, 2nd ed., edited by Jean Morrison Brown, Naomi Mindlin, and Charles H. Woodford, 49–53. Princeton: Princeton Book Company.

Guattari, Félix. 1989. *Cartographies schizoanalytiques*. Paris: Galilée.

Guattari, Félix. 1995. *Chaosmosis: An Ethico-Aesthetic Paradigm*, translated by Paul Bains and Julian Pefanis. Bloomington: Indiana University Press.

James, William. 1950. *Principles of Psychology*. Vol. 2. New York: Dover.

James, William. 1978. *Pragmatism and The Meaning of Truth*. Cambridge: Harvard University Press.

James, William. 1996a. *Essays in Radical Empiricism*. Lincoln: University of Nebraska Press.

James, William. 1996b. *A Pluralistic Universe*. Lincoln: University of Nebraska Press.

Katz, David. 1935. *The World of Colour*. London: Kegan, Paul, Trench, Trubner.

Klee, Paul. 1950. *On Modern Art*. London: Faber and Faber.

Lamb, Trevor, and Janine Bourriau. 1995. *Colour: Art and Science*. Cambridge: Cambridge University Press.

Langer, Susanne. 1953. *Feeling and Form*. New York: Scribner's.

Lapoujade, David. 1997. *William James: Empirisme et pragmatisme*. Paris: PUF.

Manning, Erin. 2007. *Politics of Touch: Sense, Movement, Sovereignty*. Minneapolis: University of Minnesota Press.

Manning, Erin. 2009a. *Relationscapes: Movement, Art, Philosophy*. Cambridge, MA: MIT Press.

Manning, Erin. 2009b. "Propositions for the Verge: William Forsythe's Choreographic Objects." *Inflexions: A Journal for Research-Creation* no. 2. http://www.senselab.ca/inflexions/volume_3/issues.html.

Manning, Erin. 2009b. *Relationscapes: Movement, Art, Philosophy*. Cambridge: MIT Press.

Manning, Erin. 2010. "Always More Than One: The Collectivity of a Life." *Body & Society* 6, no. 1: 117–127.

Manning, Erin. Forthcoming a. *Always More Than One: Individuation's Dance*. Durham: Duke University Press.

Manning, Erin. Forthcoming b. "Waltzing the Limit." In *Fascism in All Its Forms: Negotiating the Political Legacy of Gilles Deleuze and Félix Guattari*, edited by Bradley Evans and Julian Reid. London: Routledge.

Manning, Erin, and Brian Massumi. Forthcoming a. "Coming Alive in World of Texture." In *Thought in the Act: Passages in the Ecology of Experience*.

Manning, Erin, and Brian Massumi. Forthcoming b. "Propositions for an Exploded Gallery." In *Thought in the Act: Passages in the Ecology of Experience*.

Manovich, Lev. 2005. "Understanding Meta-Media." *C-Theory.net*. October 26. http://www.ctheory.net/articles.aspx?id=493.

Marcel, Anthony. 1998. "Blindsight and Shape Perception: Deficit of Visual Consciousness or of Visual Function?" *Brain* 121, pt. 8: 1565–1588.

Marks, Laura U. 2002. *Touch: Sensuous Theory and Multisensory Media*. Minneapolis: University of Minnesota Press.

Massumi, Brian. 2000. "Expressing Connection." In *Vectorial Elevation: Relational Architecture No. 4*, edited by Rafael Lozano-Hemmer, 183–208. Mexico City: National Council for Culture and the Arts.

Massumi, Brian. 2002. *Parables for the Virtual: Movement, Affect, Sensation*. Durham: Duke University Press.

Massumi, Brian. 2003. "Luc Courchesne. Journal panoramique." *CVPhoto*, no. 60 (April): 26–28. http://cielvariable.ca/archives/en/component/customproperties/tag.html?tagId=256.

Massumi, Brian. 2005. "Fear (the Spectrum Said)." *Positions: East Asia Culture Critique* 13, no. 1: 31–48.

Massumi, Brian. 2009. "National Enterprise Emergency: Steps toward an Ecology of Powers." *Theory, Culture & Society* 26, no. 6: 153–185.

Massumi, Brian. 2010a. "Perception Attack: Brief on War Time." *Theory and Event* 13, no. 3. http://muse.jhu.edu/journals/theory_and_event/v013/13.3.massumi.html.

Massumi, Brian. 2010b. "The Future Birth of the Affective Fact." In *The Affect Reader*, edited by Greg Seigworth and Melissa Greg, 52–70. Durham: Duke University Press.

Massumi, Brian. Forthcoming. "Écrire comme un rat tord sa queue: animilité et abstraction." *Philosophie*.

Michotte, Albert. 1963. *The Perception of Causality*. London: Methuen.

Migayrou, Frédéric. 2004. *Non-Standard Architectures*. Paris: Editions du Centre Pompidou.

Murphie, Andrew. 2004. "The World as Clock: The Network Society and Experimental Ecologies." *Topia: Canadian Journal of Cultural Studies* 11 (Spring): 117–139.

Noë, Alva. 2004. *Action in Perception*. Cambridge: MIT Press.

Panofsky, Erwin. 1991. *Perspective as Symbolic Form*, translated by Christopher S. Wood. New York: Zone Books.

Peirce, C. S. 1992a. *The Essential Peirce: Selected Philosophical Writings*. Vol. 1, edited by Nathan Houser and Christian Kloesel. Bloomington: University of Indiana Press.

Peirce, C. S. 1992b. *Reasoning and the Logic of Things*. Cambridge: Harvard University Press.

Peirce, C. S. 1997. *Pragmatism as a Principle and Method of Right Thinking: The 1903 Lectures on Pragmatism*. Albany: State University of New York Press.

Rancière, Jacques. 2006. *The Politics of Aesthetics: The Distribution of the Sensible*, translated by Gabriel Rockhill. London: Continuum.

Ruyer, Raymond. 1952. *Néo-finalisme*. Paris: PUF.

Ryle, Gilbert. 1949. *The Concept of Mind*. New York: Barnes and Noble.

Simondon, Gilbert. 1989. *Du mode d'existence des objets techniques*. Paris: Aubier.

Simondon, Gilbert. 2005. *L'individuation à la lumière des notions de forme et d'information*. Grenoble: Million.

Simondon, Gilbert. 2007. "Technical Individuation." In *Interact or Die!*, edited by Joke Brouwer and Arjen Mulder and translated by Karen Ocana with the assistance of Brian Massumi, 206–215. Rotterdam: V2/Nai.

Stengers, Isabelle. 1997. *Cosmopolitiques, Vol. 7: Pour en finer avec la tolérance*. Paris: Les Empêcheurs de Penser en Rond.

Stern, Daniel. 1985. *The Interpersonal World of the Infant*. New York: Basic Books.

Stern, Daniel. 2010. *Forms of Vitality: Exploring Dynamic Experience in Psychology, the Arts, Psychotherapy and Development*. Oxford: Oxford University Press.

Valéry, Paul. 2003a. "De la danse." *Dessin Danse Degas*, 27–37. Paris: Gallimard.

Valéry, Paul. 2003b. "Le dessin n'est pas la forme." *Dessin Danse Degas*, 205–207. Paris: Gallimard.

Valéry, Paul. 2003c. "Voir et tracer." *Dessin Danse Degas*, 77–82. Paris: Gallimard.

Wark, McKenzie. 2007. *Gamer Theory*. Cambridge: Harvard University Press.

Weschler, Lawrence. 1982. *Seeing Is Forgetting the Name of the Thing One Sees: A Life of Contemporary Artist Robert Irwin.* Berkeley: University of California Press.

Westphal, Jonathan. 1987. *Colour: Some Philosophical Problems from Wittgenstein.* Aristotelian Society Series. Vol. 7. Oxford: Basil Blackwell.

Whitehead, Alfred North. 1964. *The Concept of Nature.* Cambridge: Cambridge University Press.

Whitehead, Alfred North. 1967a. *Adventures of Ideas.* New York: Free Press.

Whitehead, Alfred North. 1967b. *Science and the Modern World.* New York: Free Press.

Whitehead, Alfred North. 1968. *Modes of Thought.* New York: Free Press.

Whitehead, Alfred North. 1978. *Process and Reality.* New York: Free Press.

Whitehead, Alfred North. 1985. *Symbolism: Its Meaning and Effect.* New York: Fordham University Press.

# Index

Absolute. *See also* Monarchy, absolute; Music, absolute
  great, 60
  little, 20–21, 58–59, 61, 64, 179, 181–182
Abstract art, 69–72, 137–138, 159–162
Abstract cause, 60–61
Abstraction, 57, 63, 65, 93, 97, 99, 110, 125, 129, 161–162
  concreteness and, 27, 70, 100–101, 148
  diagram and, 14–15, 99–103
  force and, 56–57, 141
  formal, 130, 169
  language and, 116–118
  lived, 15–19, 26, 28, 42–43, 49, 74, 83, 103, 116, 126, 129–130, 143, 146–158, 173 (*see also* Semblance)
  nature and, 25, 82
  object as, 6, 16, 27, 41–43, 74, 117, 185n3
  self-, 44, 49, 53, 124, 125, 133, 140–141, 143, 148–149
  vision and, 43–44, 97, 133
Abstract line, 17, 134. *See also* Edge
Accident, 62–63, 80
Action, 43, 66, 76, 117, 119, 125
  nascent, 114–115, 120, 121, 122, 139, 160
Action-reaction, 44–47

Activation (energizing), 16, 71–72, 137, 159–161, 163
Activation contour, 107, 109–113, 115, 122–125
Activist philosophy, 1–28. *See also* Radical empiricism; Speculative pragmatism
  on actual-virtual, 16–17, 183–184n5
  nonhuman and, 25–26
  as nonobject philosophy, 6
  paradox and, 18–19
Activity, 1–6, 8, 16, 21, 26, 69, 84, 122, 169, 173, 183. *See also* Bare activity; Interactivity
  elemental, 24
  general vs. special, 2, 13, 22–23, 28
  of relation, 89–93, 97, 102, 104
Actual
  as the "in-act," 16, 18
  virtual as inseparable from, 16, 18–19, 33, 58, 88, 90, 98, 150, 183–184n5, 185n4
Adorno, Theodor, 16
Aesthetic, 2, 24–25, 39–40, 77, 171. *See also* Force, of expression (aesthetic)
  criteria of evaluation, 145, 170–175
  effect, 49, 56, 73, 131, 134, 154–155, 174
  political and, 12–13, 21, 28, 53–54, 56–64, 68, 70–71, 79–80, 82, 121, 127–128, 154–155, 169–179